Kuwait by the First Photographers

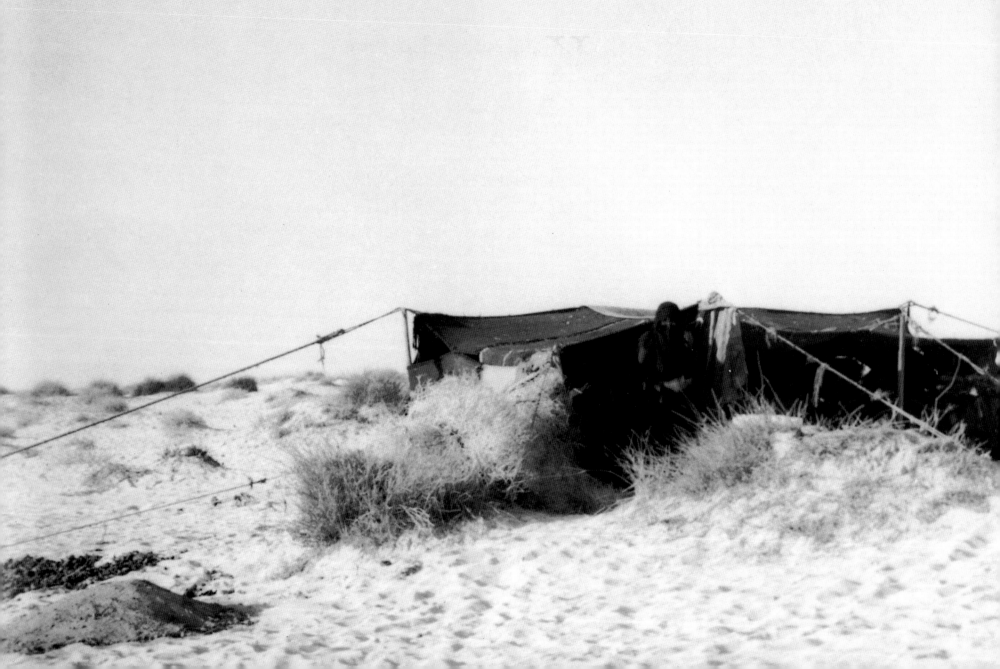

Kuwait

by the First Photographers

William Facey and Gillian Grant

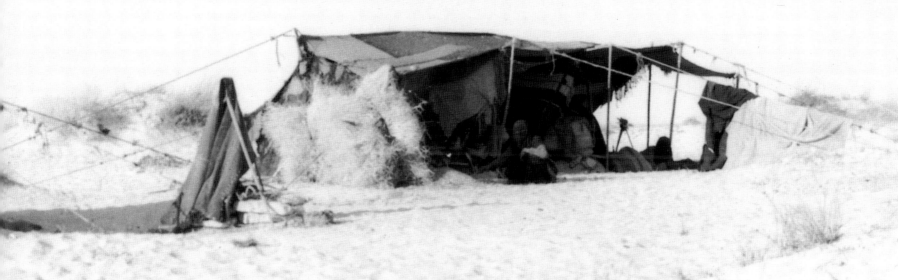

I.B. Tauris

LONDON • NEW YORK

Published in 1999 by I.B.Tauris & Co Ltd
Victoria House, Bloomsbury Square, London WC1B 4DZ
175 Fifth Avenue, New York NY 10010

In the United States and Canada distributed by St. Martin's Press
175 Fifth Avenue, New York NY 10010

ISBN 1 86064 271 3

A full CIP record for this book is available from the British
Library
A full CIP record for this book is available from the Library of
Congress

Library of Congress catalog card available

Designed and edited by *Allen* Lebon, London

Digital artwork and typesetting by Falcon Electronic Imaging,
Unit 11, Barnwell Drive, Cambridge

Origination by Newsele srl., Milan, Italy

Printed by Industrie Poligrafiche Friulane. SpA, Maniago, Italy

Previous page **Bedouin tents in the Kuwait hinterland,
photographed by Alan Villiers, 1939.**

Contents

Kuwait: the Past Reflected, 1900-1950

… Kuweit is emphatically a town of the desert and sea, without any arable or garden ground whatever. … To the mixture of seafaring men and nomads in its population, to both of whom digging and planting are uncongenial, it is owed that Kuweit is just a place of clay between steppe and sea.

Barclay Raunkiaer, 1913

Between desert and sea

Without its thriving town, Kuwait would be no more than a place where the desert meets the sea. Once, the barren headland of Ras 'Ajuzah, now on the central waterfront of the modern city, was a waterless promontory, no different from the rest of the arid, featureless coastline of north-east Arabia. It lacked even the wells and pasture which made some of Kuwait's hinterland seasonally attractive to the tribespeople and their flocks. Kuwait as a whole was a place with absolutely no natural resources – until, of course, the discovery of oil in 1938.

Kuwait provides us with an extreme example of a settlement where natural resources play no part whatsoever in explaining its existence and prosperity before modern times. Instead, the explanation has to be sought entirely in its geopolitical position at the head of the Gulf. Kuwait was close to the markets of Mesopotamia and yet just outside the political reach of its rulers. It had a fine natural harbour at a convenient point on the coast for the overland trade of northern Arabia to meet the trade of the Gulf and Indian Ocean.

There is always something fascinating about communities living, like the Kuwaitis, at the very margin of their environmental possibilities and overcoming their disadvantages. Right up until the 1940s they had to fetch by dhow even something as basic as fresh water – from the Shatt al-'Arab, that stretch of river which takes the combined waters of the Tigris and Euphrates to the sea. Except for fish and the produce of their own and the bedouin's goats, all their food had to be imported. Their treeless land provided no ship-building timber, yet by importing timber from India they made themselves into prolific builders of almost every type of Gulf craft, from majestic ocean-going *baghlah*s and *boum*s for the trade to India and East Africa, to *battil*s, *baqqarah*s and *shu'ai*s for the pearl banks, and to small fishing boats and *lanch*es for inshore and harbour work.

Writings such as those of Alan Villiers, who saw at first hand the rigours of seafaring, trading and pearling and recorded them in his classic *Sons of Sindbad*, show that there was a price for Kuwait's success which was paid in hard physical work, privation and shortened expectation of life. The photographs make a vivid complement to such written descriptions of what the old way of life was like for Kuwait's people – its seafarers, dhow-builders, pearl-divers, fishermen and bedouin, not to mention its rulers and merchants.

The first photographs were taken of this remarkable place right at the beginning of the 20th century, by which time it had reached its apogee as a traditional port. They depict a society at the height of its triumph over such odds. In fact it was by now perhaps the

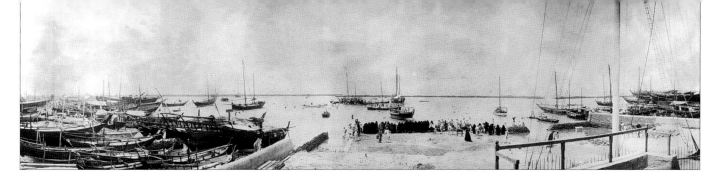

busiest port in the entire Gulf, busier, some said, even than Muscat. Photographs continued to be taken sporadically for the next fifty years. They tell us a great deal about this small country as it was before modernisation. They also show us the first small intimations of what was to follow, as it began to adapt to the first changes which were to transform it completely after the Second World War and sweep away the old ways for ever.

Kuwaitis lived on the edge of political survival too, because their land lay at the point where the shifting spheres of influence of various larger neighbours and outside powers met. The recent invasion and occupation of Kuwait in 1990–1 was notable more for the scale of its brutality and stupidity than for the fact of its occurrence. The prospect of being swallowed up has been one that Kuwait has had to face throughout its history, and one of the roles of its rulers has been to avoid such a fate by any means available. This they have done by performing a series of adroit balancing acts: by playing neighbours off one against the other, and by astute choice of protector. The photographs bring to life the many reports we have of Kuwait's rulers, as their authority evolved from the paternalist tradition of the 19th

century to one in which, in the 20th, the state's independence was protected by Britain and, as a by-product, the ruler's position was bolstered by his relationship with the protecting power.

Origins

Kuwait town itself is a relatively recent foundation. In all likelihood there was a small settlement there in the 17th century, perhaps of 'Awazim tribespeople making a living from the sea. Their dwellings were clustered round a small fort or walled enclosure of the type known as a *kut* or, in its diminutive form, a *kuwait*. This fort is thought to have belonged to a shaikh of the Bani Khalid, the powerful tribe which at that time held sway over north-east Arabia from its chief town of al-Hofuf in Hasa Oasis.

Between 1620 and 1676 central Arabia was ravaged by a series of droughts which forced many of the settled people to emigrate in order to survive. Many such groups headed for eastern Arabia, among them one which came to be known as the 'Utub. This group of families left the Aflaj area of southern Najd, migrating to the Hasa coast and settling in Qatar, where they took to a life of fishing, pearling and

Above Where the desert meets the sea: Kuwait harbour photographed on a panoramic camera from the British Political Agency, December 1913.
Shakespear 1913

Below Kuwait's hinterland is flat but provides good grazing in winter and spring: these camel-men, part of the geologist Arnold Heims' party, are riding across the terrain north of Burqan, to the south of Kuwait town.
Heims, April 1924

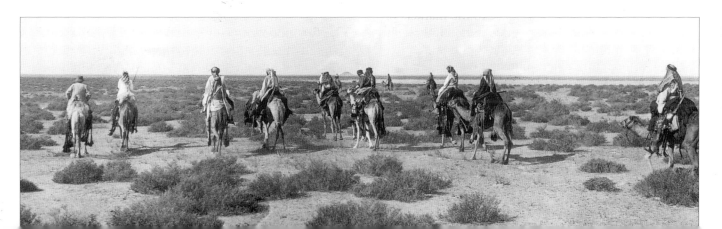

seafaring, and it is here, some 300 miles away, that Kuwait's love affair with the sea began. In 1701 they were driven from Qatar and, taking to their boats, which already numbered a remarkable 150 small craft, they made for Basra, where they appealed for Ottoman protection. This was not forthcoming, and from Basra they migrated the short distance to Kuwait Bay.

Quite when this took place is not certain. The first written mention of Kuwait dates to 1709 when it was described by a Syrian visitor returning from a pilgrimage to Makkah. This gentleman, Murtada bin 'Ali bin 'Alwan, describes a bustling little port bearing a remarkable similarity to the old Kuwait we know from photographs, down to its streets giving directly onto the harbour, its market-place and even to its towers, perhaps along a town wall. This place was known by the name al-Kuwait, and also by the other name more commonly used at this time, al-Qurain (often written in European accounts as "Grain" or "Grane"). It is possible that the 'Utub had already arrived and developed this place, but Murtada does not mention them.

In the early 18th century, according to local accounts, the community's government was entrusted to three families of the 'Utub, each with its own area of responsibility. The wealthy Al Khalifah were in charge of trade and pearling, the Al Jalahimah of the boats and naval protection, while the Al Sabah provided the ruling Shaikh who took care of law and order and handled Kuwait's relations with its Bani Khalid overlords and the other bedouin tribes.

Under the 'Utub Kuwait emerged from beneath the shadow of the Bani Khalid. The first independent ruler is held to be Sabah I, who ruled c.1752–6. He is credited with having built a wall around the town. By

then the 'Utub had grown, for a Dutch report of 1756 states that the 'Utub had "300 vessels, but almost all are small because they employ them only for pearl diving. This and fishing during the winter is their only occupation. They number about 4,000 men armed with swords, shields and lances." The 'Utub had acquired the right in the 1750s to fish for pearls on the Bahrain pearl banks. By 1758 Kuwait had an established overland caravan link with Aleppo. In 1765 Niebuhr was told that Kuwait had 800 ships and 10,000 inhabitants, and a regular caravan trade with Syria.

Most important of all, Kuwait had begun to exploit its favourable position as an alternative port to Basra. From time to time piratical tribesmen on the Shatt al-'Arab, and heavy customs dues, rendered Basra a costly place to trade, and Kuwait began to compete with it. Kuwait's particular pattern of development, as a town sandwiched between its long, busy waterfront on the one side, and the open area on the landward side known as the Safat, where goods were loaded onto caravans and bedouin came to trade, was now established.

Kuwait's emergence into its unique position in the trade of the Gulf and Indian Ocean was guided by Shaikh Sabah I's successors. At some time in the 1760s the community suffered a setback with the departure of the wealthy Al Khalifah and nautical Al Jalahimah branches of the family to Qatar and then Bahrain, where the Al Khalifah were later to establish themselves as the ruling family. But by 1800 Kuwait had still developed into a major boat-building centre, as its merchants' profits were invested in larger ships. These early reigns were marked, like those of later rulers, by a robust opportunism, as the predatory seafaring Bani Ka'b from the Shatt al-'Arab were subdued, and alliances were made at different times

with Kuwait's more or less threatening neighbours. Thus at one point or another Kuwait was found to be in league with the zealous reformists of the First and Second Saudi States, with the Qawasim of the southern Gulf, and with the Ottomans and the British East India Company. If these alliances might seem confusing to those unused to Arabian politics, they become less so when it is realised that Kuwait's existence was usually at stake, and its survival was its rulers' guiding principle. They managed to preserve

Kuwait's prosperity even in the early 19th century, when the Gulf was seething with competition amongst its various littoral rulers.

The reign of Jabir I, who ruled 1814–59, was characteristic. A typical paternal ruler in the Arabian mould, Jabir was known for his generous support of Kuwait's poor. He took care to maintain good relations with the British, whose suppression by 1820 of the Qawasim "pirates" of the southern Gulf and

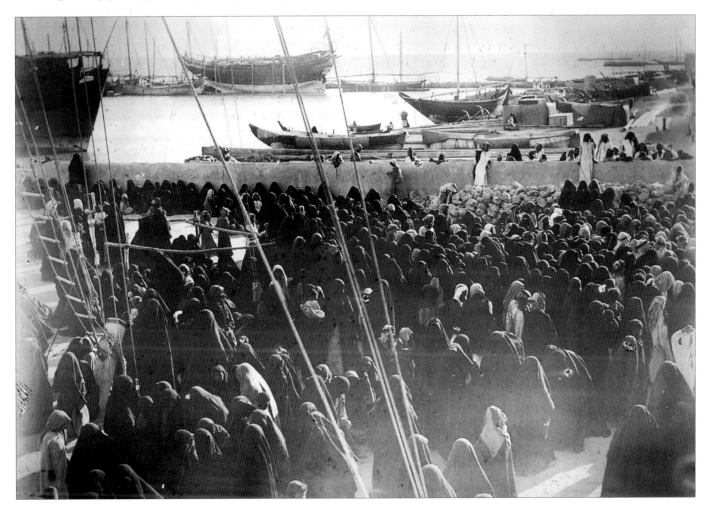

The support of the poor was a duty no Arabian ruler could ignore if he wished to maintain his legitimacy, and Kuwaiti rulers were generous. Shaikh Jabir I was especially renowned among Kuwait's early rulers, earning the nickname Al-'Aish ("Jabir the Rice", "Jabir the Staff of Life"). Here alms are being distributed to the people of Kuwait on 22 June 1911. *Shakespear 1911*

pacification of Gulf waters were greatly to the advantage of Kuwaiti trade. In the 1820s he paid the Ottomans a small annual tribute. This appears, however, to have amounted to no more than the nominal recognition routinely offered by Arabian shaikhs as a device to fend off a closer involvement by Turkey and so to keep their effective independence. Crucially, there is no mention of Ottoman officials or representatives resident in Kuwait, at this or at any other time. He was not above courting the Egyptians, vassals of the Ottoman Sultan but in fact emerging as rivals to him, on the two occasions when they occupied the Saudi State and entered into brief relations with Gulf rulers. In between, in 1831, he helped the Saudi Imam Turki when he was powerful. He then blockaded Ottoman Basra but, in 1837, assisted the Ottomans in destroying the port of Muhammarah, a rival to both Basra and Kuwait. These apparently contradictory moves were dictated by good sense under the circumstances: Kuwait's survival depended upon a shrewd application of realpolitik, which expressed itself in non-alignment and appeasement. In 1838 the Ottomans, so far from claiming Kuwait and demanding tribute, actually awarded Shaikh Jabir extensive date groves on the Shatt al-'Arab, the idea being that Kuwait should protect the port of Basra.

Shaikh Jabir's riskiest move came in 1838 when he allowed the Egyptians, during their second conquest of Najd and al-Hasa, to send a representative to reside in Kuwait. For a while Kuwait became a vital channel of supplies to the invaders who, it seemed, were about to throw off their Ottoman allegiance and create their own empire in Arabia, Iraq and Syria. These dreams came to naught in 1840 and the Egyptians withdrew from Najd. After 1843 a cautious Second Saudi State took care not to offend the Ottomans or the British, and an independent Kuwait was allowed to pursue its commercial ventures in peace. At about the same time Shaikh Jabir delegated his authority to his son Sabah II, who took over the reins of government on his father's death in 1859 and ruled until 1866.

Kuwait's early relations with Britain

Kuwait's links with Britain can be traced back almost as far as the establishment of the rule of the Al Sabah. As the East India Company's interests in the Gulf grew in the late 18th century, the British were concerned to safeguard their political and commercial communications via the Gulf between India and the eastern Mediterranean. For this, good relations with the Ottoman Turkish authorities in Damascus, Baghdad and Basra were essential as a matter of general policy.

But local conditions in the Shatt al-'Arab were not always reliable. In 1775–9, owing to the Persian occupation of Basra, the East India Company Factory there moved its desert mail terminus to Kuwait, and from then on the British seem to have been aware of Kuwait's excellent harbour. In 1793–5 the Basra Factory moved to Kuwait because of difficulties with Ottoman officials. When Kuwait was attacked during that time by a Wahhabi war party, the East India Company ship Viper helped fend it off – only the first of many occasions when the British intervened to protect the shaikhdom. Kuwait's prosperity received a boost from Britain's war with France, which meant that it was safer for the British to entrust their mail and goods to Arab boats. Cargoes and mail could be landed safely at Kuwait and taken overland by camel caravan to Aleppo.

Relations between Kuwait and Britain remained for the most part cordial during the 19th century. The

10

British bore Kuwait in mind as a possible location for their Basra operations, but only once, in 1821–3, does it seem that the Factory was moved there, to Failaka Island. The first half of the century was marked by the East India Company's deepening involvement in ensuring the safety of Gulf waters for its trade and communications. To this end, between 1806 and 1820, the British embarked on a series of seaborne campaigns against the "pirate" Qasimi shaikhdoms of the southern Gulf. These were followed by successive treaties with these "Trucial States" (now the United Arab Emirates), which were to culminate, in 1861, in the Perpetual Treaty of Maritime Peace, which also included Bahrain.

Since Kuwait had never posed a threat to the peace at sea, it was not included in the Perpetual Treaty. However, during the Egyptians' occupation of Najd and al-Hasa in 1837–40, the gifted British Political Resident in the Gulf, Samuel Hennell, feared that Kuwait's fleet might be used in the Gulf in support of them. In 1841 he induced the Kuwaiti ruler to join the maritime treaty. But this was for one year only. Apart from this the British studiously held off from entering into treaty relations, and managed to do so until 1899. Successive Residents at Bushire (Abu Shahr on the Persian coast), however, kept an eye on Kuwait, and Hennell's report to his superiors paints a graphic picture of the place at this time:

This Town presents a singular instance of commercial prosperity, although wanting in almost every advantage excepting its magnificent Harbour. Its population is large, as it can produce about six thousand men capable of bearing arms, which at a moderate average would make the total number of inhabitants nearly twenty-five thousand individuals … The energy and courage of the people, who are closely united, and free from feuds and factions, render them

respected by all the other Maritime Tribes … The government of Shaikh Jabir is of a truly mild and paternal character … The small revenue realised by him … [is] … expended in keeping up a sort of public table of a plentiful but coarse description to which everyone appears to be welcome. This liberality together with the utter absence of all pretension of outward superiority renders Shaikh Jabir and his Son, Soobah [Sabah] … most popular among his subjects.

To this the Assistant Resident, Kemball, added in 1845 that Kuwait had thirty-one ocean-going *baghlah*s and *battil*s from 150 to 300 tons, trading constantly with India, fifty smaller boats engaged in Gulf trade, and about 350 pearling boats. "The Shaikh Subah [Sabah], to whom the management of affairs has been made over by his father Jabir, collects no taxes or customs, the port being entirely free; a small duty, levied upon the sales and purchases of the Bedouins who resort to the town, constitutes the only revenue realised by him, amounting to about 3,000 dollars annually."

British visitors clearly regarded Kuwait as a small maritime utopia under benevolent shaikhly rule, and there is no reason to doubt their accounts. By mid-century we see a vigorous, united community whose trade had benefited from the maritime *Pax Britannica*. The pearling industry, in which the Kuwaiti fleet played a major part, had expanded greatly. The main exports were dates (from Iraq to India) and horses (from Najd to British India). Imports and exports included wheat, ghee, coffee, rice, sugar, wood for ship-building and house-building, spices, cotton cloth, dried fish, dried fruit and tobacco. By 1860 Kuwait's merchant fleet had become the largest in the Gulf, bigger even than Bahrain's, and in the 1860s the British explorer William Palgrave was able to describe Kuwait as

"the most active port on the Persian Gulf" – a remarkable achievement for a state with no natural resources of its own other than the skills and enterprise of its people.

By the 1860s the accelerating technological revolution in Europe, of which the invention of photography in 1839 was one facet, was beginning to make itself felt in the Gulf. As steam took over from sail, naval patrols became capable of a more rapid response. A fortnightly steamship service between Bombay and the Gulf, calling at Kuwait, was introduced by the British Indian Steam Navigation Company in 1862, providing an important new means of trade and communication, although the bulk of Gulf cargoes continued to be carried by Arab craft. The steam-ships' calls at Kuwait led to a decline in Basra's trade, which alarmed the Ottomans and perhaps some of Kuwait's own dhow captains too. Shaikh Sabah II, taking care to trim his sails to Ottoman interests, requested the steamship company to suspend its visits. But in 1866 he declined an Ottoman offer to appoint him *Qaimmaqam* (local provincial governor) of Kuwait.

Steamships or no, the volume of trade was on the rise, and manufactured goods reaching the *suq*s of eastern Arabia increased, particularly textiles. In 1864 the British laid the first maritime telegraph cable in the Gulf, running from Karachi to Jask on the Persian coast, and on to Bushire and Fao via the Musandam Peninsula. Such developments naturally deepened the British interest in keeping Gulf waters tranquil and ensuring good relations with coastal rulers. By the 1860s the British were intent on preserving their supremacy in what seemed almost an exclusive sphere of influence, which they had built up by means of a hands-off policy, without the inconvenience and expense of colonisation.

Midhat Pasha, the ambitious and active Ottoman governor of Baghdad, was responsible for the Turks renewing their occupation of al-Hasa after a break of two centuries.

Kuwait, Britain and Turkey, 1871–96

Right up until the outbreak of the First World War in 1914, Britain's policy of maintaining peaceful communications with India was founded upon good relations with the Ottoman Turks and recognition of Ottoman interests in the Middle East. This posed no problem in the Gulf so long as the Ottomans did not disturb the status quo there. Though Bahrain and Muscat provided uncomfortable exceptions, by and large the British were able to stand by their guiding principle never to get involved in disputes on land in eastern Arabia, while ensuring as far as possible a pro-British stance among the independent rulers of the Arabian shore. The official British view saw Kuwait as an independent state within the Ottoman sphere of influence, which explains the British reluctance to enter into any kind of formal relations with Kuwait's rulers. In practice, however, they were as wary of the Turks as of any other power threatening their maritime security, and encouraged the perception among Gulf rulers that their local independence could best be preserved by adhering to the framework of the maritime peace.

In 1871 the fragile balance in the Gulf was upset when the Ottomans invaded eastern Arabia and took control of al-Hasa. It seemed unlikely in the light of the new Turkish forward policy that Kuwait should avoid being swallowed up, sandwiched as it was between the province of Basra and the new province in al-Hasa, oddly but sinisterly called by its new rulers the "Province of Najd". Kuwait was shorn of its ally the Saudi state – indeed it was the latter's collapse into faction-fighting after 1865 which had drawn the Turks into al-Hasa – and Ottoman expansion into eastern Arabia was the big ambition of Baghdad's energetic governor, Midhat Pasha. Shaikh Abdullah II of Kuwait (r.1866–92) could hardly do other than

offer himself as a loyal ally of the Turks. He did well to extract a pledge, in exchange, that Kuwait should continue to enjoy administrative autonomy.

With that guarantee Kuwait took a full part in the Ottoman expedition to al-Hasa in 1871, contributing 300 ships as transports and some cavalry. The Turks set up their capital at al-Hofuf in Hasa Oasis, and proceeded to incorporate al-Hasa fully into the Ottoman administrative system, as they had in the 16th century. Shaikh Abdullah accepted the title of *Qaimmaqam*, while Kuwait remained independent and its merchants prospered from the supply of goods to the Turks in al-Hasa. However, Midhat Pasha's declaration, wishful thinking though it might be, that the rule of Al Saud had now ceased in Najd, alarmed the Al Sabah who were as ever anxious to avoid direct Ottoman rule.

Until Shaikh Mubarak assumed the rule in 1896, co-operation with the Turks seemed the only prudent course to take, particularly in view of the ruling family's vulnerable date groves on the Shatt al-'Arab. When Muhammad I succeeded Abdullah II in 1892, he and his brother Jarrah, with whom he was virtually co-ruler, continued the pro-Ottoman stance, supported by a powerful pro-Turkish merchant, Yusuf Al-Ibrahim, who also owned large estates in Iraq. The policy, however, created division amongst Kuwaitis, some of whom turned to a third brother, Mubarak bin Sabah, for help.

Shaikh Mubarak

At this time Mubarak was part of a ruling triumvirate, having been placed by his two brothers in charge of military affairs – effectively the town militia and its bedouin allies. Feeling isolated from the centre of power, he nonetheless drew strength from this power-base. In the only violent bid for the rulership in Kuwait's history, Mubarak and his sons Jabir and Salim (both future rulers) assassinated Muhammad and Jarrah early one morning in May 1896.

Shaikh Mubarak's accession was a blow against pro-Ottoman leanings in Kuwait, and his reign was marked by the insight that Britain was the key to protecting Kuwait against the other regional forces which might overwhelm the little principality. His calculation was shrewd for, whatever else British imperial aims might be, they did not include depriving Kuwait of its independence. In the 1890s Kuwait had not only the Ottomans as a source of disquiet, but also the ambitions of a new power in central Arabia: the Al Rashid, lords of Ha'il in northern Najd, who had since the 1880s made themselves masters of central Arabia, even, in 1891, causing the Al Saud to abandon their seat of government at Riyadh to go into exile. Early in Mubarak's reign both the Ottomans and the Al Rashid were being courted by Yusuf Al-Ibrahim, anxious to reinstate himself in Kuwait.

Although the Turks saw a British plot behind Mubarak's takeover, the evidence is lacking, and the British did not change their policy over Kuwait until 1899. Mubarak immediately petitioned the Ottoman Sultan for recognition as *Qaimmaqam* in the same manner as his predecessors. The Turks wanted to impose direct authority over Kuwait, but Mubarak finally got his way, and Kuwait was confirmed as an independent *qaza* (lesser district) of a *sanjaq* (district) of the *vilayet* (province) of Basra – a distinctly arm's length relationship. As a precaution, Mubarak made overtures, initially unsuccessful, to the British Resident at Bushire to be placed under British protection. Thus his reign began as it was to continue: a masterly balancing act by which, as occasion

demanded, he could present himself as an Ottoman official, an independent ruler or under British protection. Only by such gyrations was success possible, and it is not for nothing that he is respected as Kuwait's most resourceful ruler. By the end of his reign in 1915, Kuwait figured on the geopolitical map as never before, its territory covered a larger area than ever, and he had deservedly become known as "Mubarak the Great".

The British at first stood by their reluctance to get involved formally with Kuwait. But the 1890s saw an unprecedented interest by the great powers of the day in the Gulf, and Britain had become uneasy not just about Turkey, but also about Russian, German and French plans to extend their influence there. Kuwait had suddenly acquired a new strategic importance. In the light of rival Russian and German schemes to build a railway linking Turkey with Baghdad, with a terminus on the Gulf at Kuwait, the British finally concluded an agreement with Mubarak in 1899. Even so it was a secret agreement, and the Ottomans did not at first know about it.

The British–Kuwait Agreement of 1899 offered Kuwait protection, in exchange for Shaikh Mubarak's assurance that Kuwait would not cede any territory to a foreign power without the prior agreement of Britain. He thus ensured Kuwait's independence of Turkey, at the cost of placing control of his foreign affairs in British hands.

For Mubarak the Agreement created new opportunities. Having given refuge to the exiled House of Saud from Riyadh in 1896, he now sought to extend Kuwait's influence into the hinterland of Arabia. The Agreement gave him the protection he needed, and he campaigned with his Saudi guests against Ibn Rashid of Ha'il, who had links with the

Ottomans and with Yusuf Al-Ibrahim. When disaster struck at the Battle of Sarif in northern Najd in 1901, Kuwait was threatened by both Turkish and Rashidi invasion, but both threats were warded off by the intervention of British gunboats. Turkey then became aware of Britain's secret Agreement with Shaikh Mubarak, and the exchange of letters known as the "status quo understanding" took place, which recognised both sides' interests in Kuwait. The young 'Abd al-'Aziz Ibn Saud went on to turn the tables against Ha'il in January 1902 when he mounted his daring raid on Riyadh and recovered the hereditary Saudi capital. An attempt by sea on Kuwait by Yusuf Al-Ibrahim was seen off by the British later the same year.

From 1900 till 1903 Russia joined France in challenging British hegemony in the Gulf, and a series of Russian warships visited Kuwait. Lord Curzon, the Viceroy of India from 1899 till 1905, was an ardent campaigner against the growing rivalry of other powers in the Gulf, but had to balance this against the larger need not to alarm Turkey. Curzon's Gulf tour of 1903 was aimed at bolstering Britain's influence among the rulers of the Arabian shore by reassuring them that their best interests lay in maintaining their independence under benevolent British protection. As a result, for the first time, a British Political Agent was posted to Kuwait in 1904. This man, Knox, had to tread a fine line between promoting Britain's interests and maintaining the status quo with the Ottomans.

The years up to 1914 and the outbreak of war between Britain and Germany were marked by Britain's deepening involvement in the internal affairs of the Gulf shaikhdoms. Russian schemes in the Gulf were curtailed in 1903 by the growing tension in the Far East which led to the Russo–Japanese War. At the same time, hostile French designs were brought to an

Opposite Shaikh Mubarak sits in the centre of a group of Al al-Sabah and Al Saud, on the verandah of the British Political Agency, Kuwait. 'Abd al-'Aziz bin 'Abd al-Rahman Al Saud ("Ibn Saud"), at that time Amir of Riyadh, sits on Shaikh Mubarak's right, while between them stands his brother Sa'd bin 'Abd al-Rahman Al Saud. The picture was taken in March 1910 when the Saudis paid a visit to Kuwait to join in a campaign into northern Najd. This was the occasion on which Shakespear first met 'Abd al-'Aziz Ibn Saud, the creator of Saudi Arabia and later to be its first King. *Shakespear 1910*

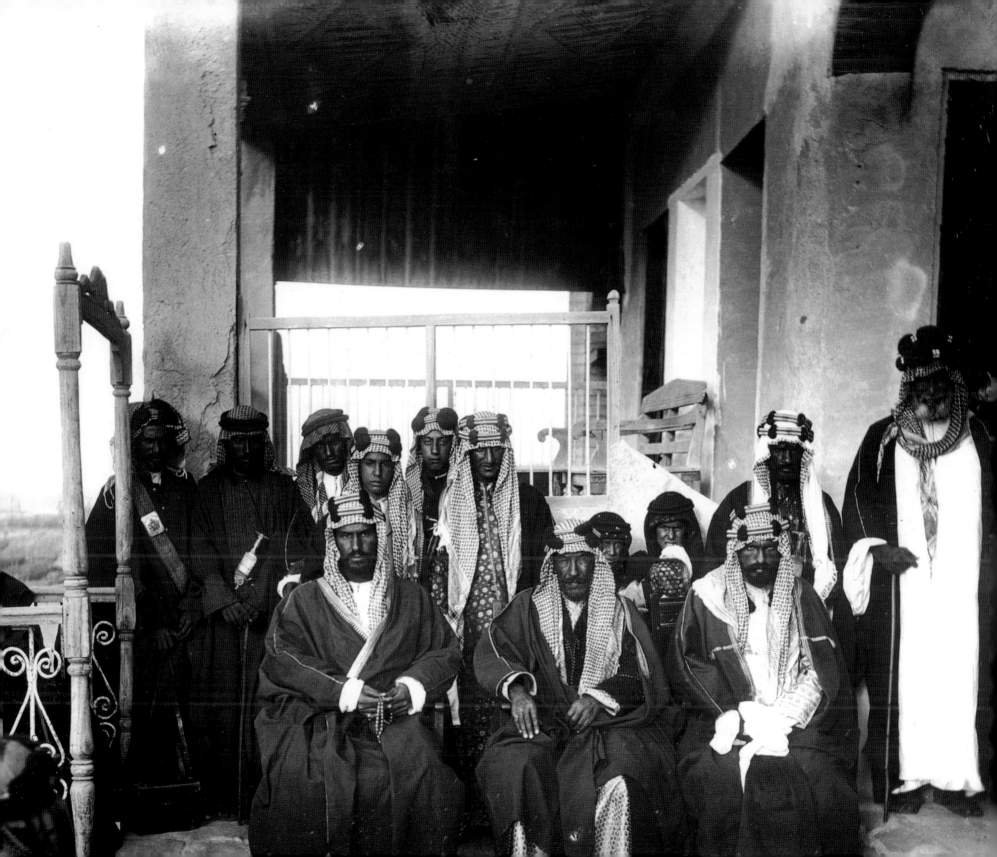

end in 1904 by the Entente Cordiale between Britain and France. However, German and Ottoman threats to Britain's exclusive sphere of influence in the Gulf were to disappear only in 1918 with the end of the First World War.

During the period up to 1914, the Anglo–Kuwaiti relationship deepened as further agreements were concluded: to prohibit the traffic in arms (1900), to establish a post office (1904), and not to agree to pearling or sponge-fishing concessions without prior consultation with the Resident (1911). In 1912 Mubarak agreed to the setting up of a telegraph station, and in 1913 undertook to show Admiral Slade "the place of bitumen in Burqan," and not to grant an oil concession except with British approval. Most significantly, in 1907 Mubarak agreed secretly with Knox to lease to Britain the land at Shuwaikh which would have been the obvious location for the terminus of the railway to the Gulf, and not to lease any land in Kuwait to any other foreign interest whatsoever. Britain thus acquired the power of veto over the extension of the railway to Kuwait; alternatively, if it was decided that the railway should proceed, Britain had gained a valuable bargaining counter in its efforts to acquire a major share in the scheme, negotiations over which were still continuing.

In 1903, after Curzon had left Kuwait, Mubarak was quick to reassure the Ottoman government of his continued loyalty, and Turkey ceased trying to enforce direct rule over Kuwait. Mubarak was careful not to trumpet his independence, retaining the title of *Qaimmaqam* and continuing to fly the Turkish flag over his palace. He was quite as able to stage a welcome for the Turks as for anyone else: Raunkiaer noted the grand reception he gave them in 1912, when they came to award him the Order of the Mejidiyeh. At the same time he flourished under British protection. Trade prospered, and he extended the Seif Palace on the waterfront in Iraqi style with baked bricks, expanded his bodyguard, acquired a steam yacht, and increased his taxes on the Kuwaiti merchants. Meanwhile he developed a close friendship with Shaikh Khaz'al of Muhammarah, and the latter built himself a guest palace in Kuwait.

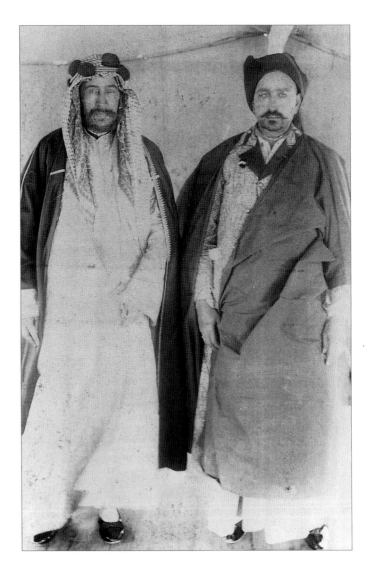

Right **Shaikh Mubarak of Kuwait (left) with his good friend Shaikh Khaz'al of Muhammarah.**
A.N. Gouldsmith 1907–9

The camera arrives

The early years of Shaikh Mubarak's reign saw the first cameras arrive in Kuwait. By the time the first known photographs were taken in 1900, photography was already sixty years old. The first successful process had been announced in 1839 by the Frenchman Jacques Mandé Daguerre, but it was to take another half-century of experimentation before this new technology became widely available.

In its early days photography was a serious and expensive business, which remained the preserve of the newly emerged industrial middle-class of Europe and the United States. Elsewhere photographic efforts reflected the absence of this large middle-class and its wealth. There was, for example, some experimentation with early processes in Russia, where progress in Britain and France was closely monitored by the St Petersburg Academy of Sciences but, in general, the profession was not able to expand here until some forty years after its debut.

The Europeans who had witnessed the birth of photography were adventurous, and cameras were soon to be in every corner of the world. Some forty photographers from Europe are known to have visited the Middle East before 1880, and others went to India and the Far East, following imperial routes to document Europe's expanding empires. The equipment they carried with them in these pioneering days was often of monumental proportions. It took, for example, forty-two porters to carry the two large wooden cameras, 650 glass negative plates, two crates of photographic chemicals, and two tents used by the English photographer Samuel Bourne on one of his Indian photographic expeditions. Bourne needed the full backing of the Government of India to undertake such enterprises.

It is not surprising, therefore, that no photographs of Kuwait were taken during the early days of photography. Western imperial routes did not pass that way, and the Ottomans, although by the 1880s already using photography to document their dominions and achievements, had no official presence there.

The situation began to change as the 19th century drew to a close. Turkey's imperial decline and the possibilities this offered to the European imperial powers of Britain, France, Germany and Russia resulted in an increased interest in the Gulf and the shaikhdoms along its shores. Kuwait in particular, with its superb natural harbour and strategic location, became a focus of attention.

These changes coincided with two major breakthroughs in photography. The first was the gelatin dry-plate process, first published by R.L. Maddox in 1871. The new emulsion, unlike its predecessors, lasted for some time once applied to a glass plate, and this meant that negatives could now be manufactured commercially. By 1880 several brands were available, as were many smaller and cheaper cameras. As a result photography began to broaden its base, and to penetrate beyond the safe imperial routes. Ten years later the pace was quickened by the introduction of George Eastman's Kodak camera with its revolutionary roll film, which enabled the user to take a series of photographs without the trouble of loading a new negative for each shot. Photography was now within anyone's reach.

The first photographers in Kuwait came, not surprisingly, from the same four imperial powers mentioned above – Britain, France, Germany and Russia – and they all arrived hard on each other's heels just as the century began. First were the French,

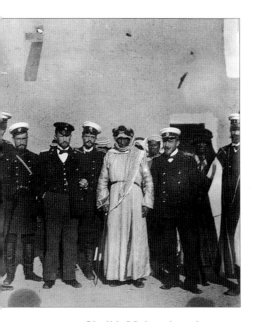

Shaikh Mubarak and officers of the Russian cruiser *Varyag*, December 1901, photographed by a member of the crew.

Right Shaikh Mubarak (seated) with members of his family and household, including his son Shaikh Jabir (left), who played a prominent role in receiving foreign visitors to Kuwait and was to succeed his father in 1915.
H.J. Whigham 1902–3

whose store ship *Drôme* was reported by the British to have visited Kuwait on 14 October 1900. Its captain went ashore to be received by Shaikh Jabir and one of its officers was reported to have taken photographs. Unfortunately these pictures have not yet come to light and may not have survived.

Barely a year later, in December 1901, the Russian cruiser *Varyag*, on passage to China, called in at Kuwait as part of its tour of Gulf ports on both sides of the Gulf. The *Varyag* had at least two cameras on board. Photographs were taken at almost every stop, and they were eventually filed away amongst the voluminous records of Central Naval HQ at St Petersburg, where they have survived to this day. The Russian zoologist Bogoyavlensky visited Kuwait in 1902 and, in February 1903, the Russian cruiser *Boyarin* arrived, and more photographs were taken, though these have not yet come to light.

The next two recorded photographers were Britons, H.J. Whigham and Lord Curzon. Whigham like Lord Curzon was strongly in favour of a vigorous British response to Russian ambitions in the Gulf. He accompanied the Gulf Resident Lt-Col Kemball on his usual winter tour of the Gulf in 1902–3 and visited Kuwait; a fine posed portrait of Shaikh Mubarak and his son Shaikh Jabir appears in his book *The Persian Problem*, published in 1903. Lord Curzon's famous visit followed later in 1903.

Germany was represented by Hermann Burchardt, who just missed Curzon's visit, arriving in December 1903, ostensibly to pursue ethnographic studies. It is not known whether he had an ulterior motive: Germany was keen to expand commercially in the Gulf at this time, and it is possible that Burchardt's information was used at a more official level.

As we have seen, this sudden flurry of international interest was shortlived as Britain reasserted its supremacy in the Gulf. Until the end of the First World War the photographic record of Kuwait is largely to be sought in British naval archives and in the collections of British officials – with the notable exceptions of the Danish traveller Raunkiaer in 1912 and the missionaries of the Reformed Church in America after that date. Some of the most remarkable photographs ever taken of Kuwait were those taken during this period by Captain William Shakespear, British Political Agent in Kuwait from 1909 till 1914.

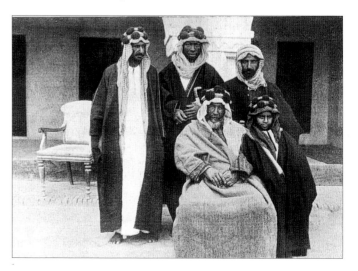

The First World War and after

Britain's deepening involvement in the affairs of Kuwait, combined with the Baghdad railway scheme and the Ottoman presence in al-Hasa, made a trusting relationship between the two powers ever more difficult to establish. An effort was made to define the British and Turkish spheres of influence in Arabia, and the outcome of this was the Anglo–Ottoman Convention of 1913. The Convention sought to regularise the status quo understanding of 1901

regarding Kuwait, and to demarcate British and Turkish spheres of influence in Arabia. As part of this, the Shaikh of Kuwait was given complete control of the area within the Red Line, indicated on the map on this page, including the islands. In addition, the tribes

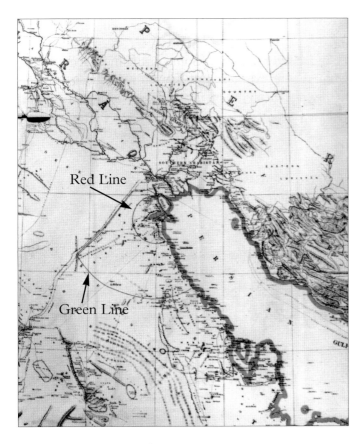

within a much larger area (enclosed by the Green Line) were "recognised as within the dependence of the Shaikh". At the same time, Kuwait was recognised as "an autonomous *qaza* of the Ottoman Empire", with Mubarak exercising control free of all Ottoman interference. But, to his great dismay, the Turks were given the right to appoint an agent to represent their interests in Kuwait.

However, an agent was never appointed; Ottoman influence in eastern Arabia was on the wane and, in May 1913, the Turks were ejected by Ibn Saud from al-Hasa. Nor was the Convention formally ratified because, in 1914, war broke out between Britain and Germany, and Turkey entered it on the German side. From now on, Britain worked to gain the support of rulers in Arabia against the Turks. At this point, Kuwait was unambiguously declared an independent Shaikhdom under the protection of Great Britain. In recognition, Kuwait received a second viceregal visitation, this time by Lord Hardinge in 1915.

Until his death in 1915 Mubarak assisted with the British war effort as the invasion of Mesopotamia by sea by Indian Expeditionary Force "D" got under way. Kuwait's merchants were to do well by trading supplies to Basra. They continued to do so during the short reign of Jabir bin Mubarak (1915–17), but their prosperity was undermined to some extent by British efforts to stop them trading also with the tribes of north-central Arabia, and so assisting the Turks. This blockade caused the merchants problems, even though neither Jabir nor his successor Salim could give their wholehearted support to it, and supplies continued to be traded. There was relief when Britain ended the blockade in 1919 after the War's end.

Jabir's accession was celebrated with a durbar at Kuwait on 19 November 1916, attended by Sir Percy Cox and 'Abd al-'Aziz Ibn Saud, both of whom arrived aboard HMS *Juno*, and by Shaikh Khaz'al of Muhammarah and other dignitaries. The three rulers swore to work with Britain, and went away decorated with assorted orders of the Indian Empire. Salim's accession was also celebrated with a durbar at Kuwait on 16 March 1917, at which he was presented with an official document from the Viceroy of India confirming his status.

Left The "Map to Show the Limits of Koweit and Adjacent Country" which formed part of the unratified Anglo–Ottoman Convention of 1913.

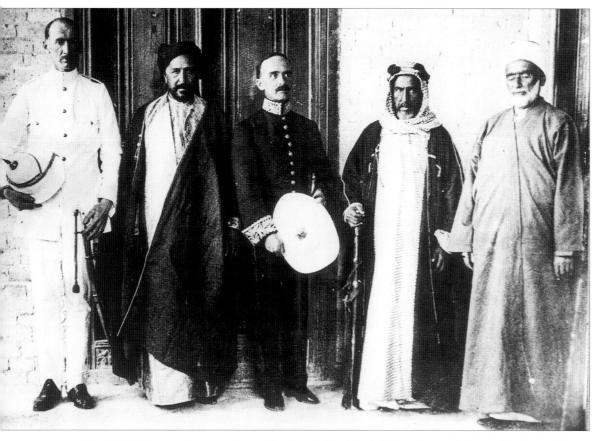

Shaikh Salim stands second from the right in this group. The European figure on his right is probably the British Political Agent, Kuwait. Next comes Shaikh Khaz'al of Muhammarah and a senior British naval officer. The exact date, place and photographer of this picture are unknown; most probably it was taken during the reign of Shaikh Salim, 1917–21.

Shaikh Salim bin Mubarak ruled from 1917 to 1921 during a turbulent time for Kuwait. He was a devout man who enforced strict rules of behaviour in the town, but he was distrusted by the British over the blockade. There was also friction between him and Ibn Saud and, when the campaigns to create Saudi Arabia as we know it today began once again at the end of the First World War, Kuwait found itself the target of the Ikhwan, the settled tribesmen whose zeal made them a feared fighting force throughout Arabia. In 1920 they marched into territory claimed by Kuwait under the terms of the Anglo–Ottoman Convention of 1913. It was at this point that Kuwait's town wall, so familiar from photographs, was hastily

erected. Salim himself took a force to Jahrah, where the Kuwaitis withstood several assaults by the Ikhwan on the Red Fort. Later that year a renewed assault on Kuwait seemed imminent. Help was summoned from the British, whose appearance with warships, planes and armoured cars caused the Ikhwan finally to withdraw. Tension between Kuwait and Ibn Saud was eased by Shaikh Salim's death in 1921. Yet another existential crisis in Kuwait's history passed off without permanent damage being done, as his nephew Shaikh Ahmad bin Jabir succeeded to the rule.

The reign of Shaikh Ahmad bin Jabir, 1921–50

With the defeat of Germany and the collapse of the Ottoman Empire at the end of the First World War, Britain during the 1920s reached the zenith of her power in the Middle East. The grant of League of Nations mandates for Palestine and Iraq gave international recognition of its power, which was further shown by its ability to establish the Emirate of Transjordan in 1921, and to instal a monarchy in Iraq the same year.

In the Gulf Britain was unchallenged by pre-War rivals. Moreover, the possibility of oil discovery gave it for the first time the prospect of a direct economic interest there. Determining the frontiers of the newly emergent states of Iraq, Kuwait and Najd (or, as it was to become in 1932, Saudi Arabia), had become an urgent priority, partly to give stability to the new order, but particularly in order to clarify sovereignty over concession areas to be leased to the prospecting companies who were expressing an interest in eastern Arabia.

The negotiations over Kuwait's southern frontier were led by Sir Percy Cox in his customary magisterial

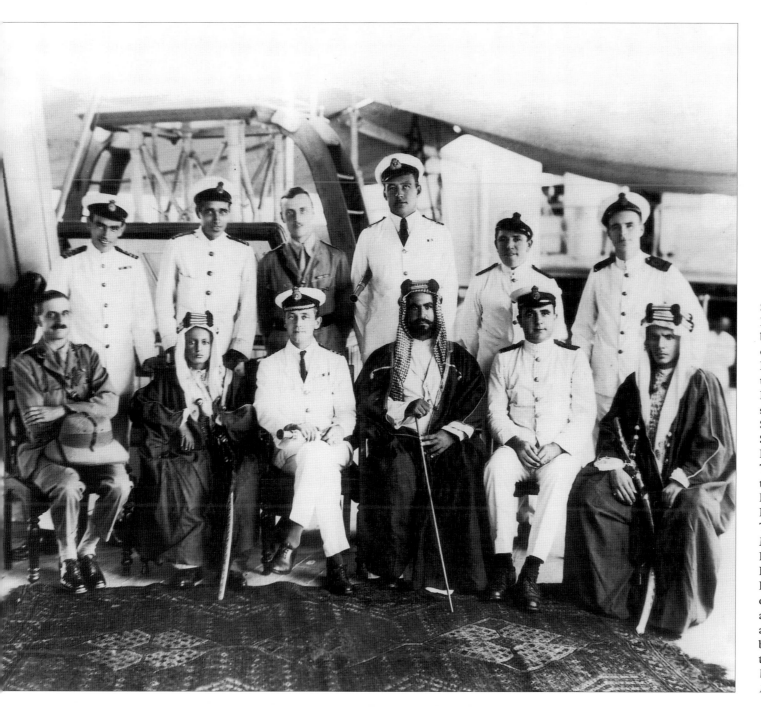

Shaikh Ahmad bin Jabir, Kuwait's future ruler, sits between two British naval officers. The group on board RIMS *Lawrence* includes the fourteen-year-old Amir Faisal (second from left), son of 'Abd al-'Aziz Ibn Saud and future King of Saudi Arabia. The young Faisal's adviser Ahmad al-Thunayyan Al Saud sits to the extreme right, while the British official Humphrey Bowman sits on the left. The party formed the 1919 Mission from Najd and Kuwait, organised by Britain at the end of the First World War as a gesture of goodwill for its wartime allies, and also because the affairs of Arabia needed to be discussed, particularly the question of the Ikhwan. *Vernon and Co., Bombay 1919*

style. There have been many accounts of the celebrated meeting at al-'Uqair, the port of al-Hasa, in 1922, between Cox and Ibn Saud, the upshot of which was that Cox awarded Ibn Saud much of the territory within the Green Line where, in 1913, the tribespeople had been considered as dependent on Shaikh Mubarak. Shaikh Ahmad bin Jabir, who had succeeded his uncle Salim in 1921, was understandably aggrieved, but had to accept the inevitable. As Cox said, had he not conceded the territory, Ibn Saud could easily have taken it for himself. It was *realpolitik*; and Kuwait assumed the shape on the map that it occupies to this day.

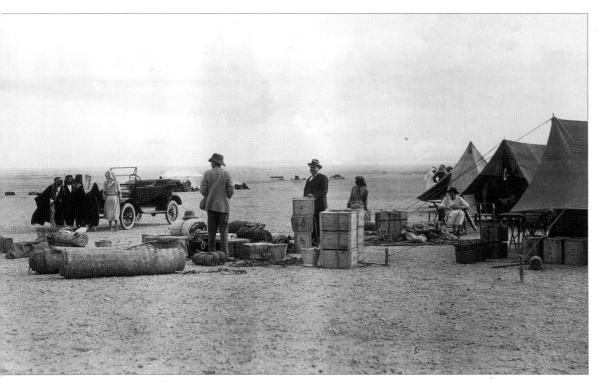

Major Frank Holmes, the ebullient mining engineer who to this day is remembered by Gulf Arabs as the "Father of Oil", was present at the 'Uqair

Conference, and soon after negotiated the Hasa concession with Ibn Saud, giving the London-based Eastern and General Syndicate the right to prospect for oil in much of today's Eastern Province of Saudi Arabia. It was as a result of Holmes' success in obtaining concessions that the geologist Arnold Heims came to Kuwait in 1924 to carry out his preliminary exploration of Kuwait, al-Hasa and Bahrain for oil, during which he took his excellent photographs. Meanwhile, the Anglo-Persian Oil Company (APOC, later British Petroleum), which had begun producing oil in commercial quantities before the War at Masjid-i-Sulayman, resumed its exploration activities in the 1920s. Arnold Wilson, who had served under Cox and for a time had been Civil Commissioner in Iraq, had in 1923 become General Manager of APOC at Muhammarah/ Abadan, and visited Kuwait in that year to present Shaikh Ahmad with APOC's concession proposal to rival that of Holmes. Wilson was a man of legendary energy and organisational ability who recorded his travels on a snapshot camera. Alas, whatever photographic talent he had is not evident in his few surviving images of Kuwait, which are far outshone by those of Heims.

These early oil company overtures to Kuwait came to no immediate conclusion, and negotiations for the concession were to drag on until 1934. The 1920s were dominated by relations with 'Abd al-'Aziz Ibn Saud, now Sultan of Najd and its Dependencies, and the Ikhwan. At the root of the problem with Ibn Saud were customs dues at Kuwait. Ibn Saud argued that duty was payable to him on goods sold to Najdi bedouin which passed through Kuwait into his territory. In 1923, pending a resolution, he placed an embargo on Kuwaiti–Saudi trade. Negotiations failed, and the embargo was to remain in force until the British finally succeeded in having it removed in

1937. Inevitably the embargo meant hardship for Kuwait, made worse by the Great Depression and the slump in the pearl trade of the 1930s caused by the Japanese invention of the cultured pearl.

Just as serious for Kuwait as for the nascent Saudi Arabia was the Ikhwan rebellion of 1927–30. The newly negotiated frontiers were regarded by the Ikhwan as an affront to the traditional bedouin freedom to roam in search of pasture, and they objected to territorial limits being placed on their raids. The threat to Kuwait called for British intervention in 1928, in which HMS *Emerald* played the part which is described below. Shaikh Ahmad

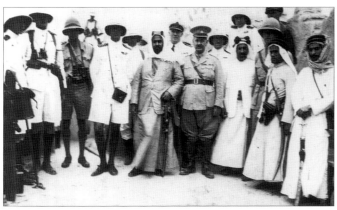

resisted the overtures of the Ikhwan leaders who were intent on setting up an independent state in northern Arabia, and the crisis was eventually resolved in 1929–30 by King 'Abd al-'Aziz's military suppression of the movement – a resolution that paved the way for the Kingdom of Saudi Arabia to be proclaimed in 1932.

If the 1930s were poor, they were at least free of external threats, and there were signs of positive economic development: the air route and oil discovery. The development of an air route to India

deepened British interest in Kuwait's security, and the search for a viable route and suitable landing-grounds generated the first aerial photography there. In 1927 the British had tried initially to establish a route via the Arabian side of the Gulf, with stops at Kuwait, Bahrain, Abu Dhabi and Suhar. When this was deemed too risky because of trouble in the hinterland of the Trucial Coast, a new route was agreed in 1929 along the Persian side of the Gulf. This had to be abandoned in turn at Persian insistence after 1931. From 1932 a new Arabian route came into being, via Kuwait, Bahrain and Sharjah.

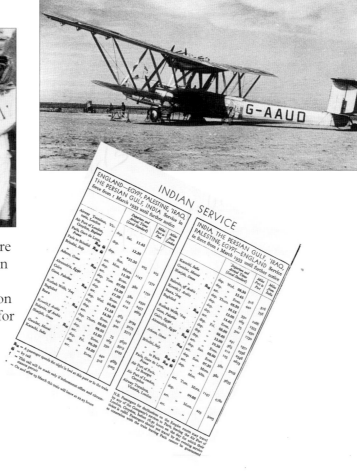

Far left Shaikh Ahmad bin Jabir, Ruler of Kuwait, and Major J.C. More, Political Agent at Kuwait 1920–9, take centre stage in this photograph taken during the *Emerald* incident, February–March 1928. With them are Sayyid Hamid Al-Naqib, the Captain, Commander and Lt-Commander of the *Emerald*, and, partially hidden on the right in a solar topee, Gerald de Gaury, then on intelligence and liaison duties during the Ikhwan crisis.

Left An Imperial Airways Handley Page biplane at Kuwait in March 1934. A service between Karachi and Baghdad began in 1932, and between Karachi and London in 1933. The three planes which served the route became a familiar sight on their weekly runs and were known as "Hannibal", "Hengist" and "Horsa".
*C.J. Edmonds 1934.
Timetable: British Airways Archives*

An aerial photograph of Kuwait town shot on 12 August 1927. It shows clearly the relationship between the waterfront, the town, the open space within the wall, the wall itself, and the desert beyond. By the late 1920s the population of Kuwait town was some 40,000, including a considerable Persian community who lived in a quarter of their own and had done for several generations. The European population in Dickson's time as Political Agent (1929–35) numbered only eleven: the PA himself, the Agency doctor, their families, and a small group of American missionaries.

Since the failure of the early 1920s in eastern Arabia, oil had nonetheless remained on the agenda. It had been discovered in northern Iraq in 1927, and in Bahrain in 1932. Because of the loss of territory as a result of the 'Uqair Conference in 1922, Shaikh Ahmad had been reluctant to award the Kuwait concession to a British company, but agreements in force bound him not to award one without British approval. Meanwhile there was pressure on Britain by the United States of America to allow USA interests

to compete, in accordance with the open-door policy which had allowed them into Bahrain and Saudi Arabia. Eventually a compromise was reached. In 1933 the two rivals, Anglo–Persian (represented by A.H.T. Chisholm) and the US company Gulf Oil of Pittsburgh (represented by Major Frank Holmes), formed the Kuwait Oil Company (KOC), each holding a 50 per cent share and, in 1934, Shaikh Ahmad awarded the concession to the new company. Prospecting began in 1936 at Bahrah on the north side of Kuwait Bay, which Heims had investigated in 1924. But results were disappointing, and it was decided to try instead at Jabal Burqan, to the south of Kuwait town. Heims had also passed by here but KOC had better luck, for oil was struck in

commercial quantities in 1938. However, the outbreak of the Second World War in 1939 intervened before production could begin, and the first export shipment of oil was not to be loaded until 1946.

At the end of the 1930s, in an effort to restore something of the old 19th century balance between notables and ruler, some leading citizens put pressure on Shaikh Ahmad to allow them a greater role in government. This led in 1938 to the formation of an elected Legislative Assembly with British support, and the election of Shaikh Abdullah Al-Salim (later Abdullah III, r.1950–65) as its president. The assembly was shortlived as, in seeking a return to the traditional consensus politics of the 19th century, it posed a challenge to the Ruler's powers accumulated since then, and Shaikh Ahmad forced its closure in December 1938. The trouble which ensued was inflamed by the Arab nationalist thinking which was influencing many young Kuwaitis and other Arabs at the time, and which expressed itself in support for Iraq. But they lacked the support of the majority of Kuwaitis, who saw the Al Sabah rulers as their traditional protectors against exploitation by the merchants and captains, and by mid-1939 Shaikh Ahmad had asserted full control.

The Second World War caused severe hardship in Kuwait as it did in the other Gulf shaikhdoms. The new well-heads had to be closed down and oil operations were suspended. Disruption of imports caused serious food shortages and inflation, bringing many, especially among the bedouin, to the brink of starvation. Only in 1946, with the reopening of well-heads and the first commercial shipment of oil, did the era of real modernisation begin. By Shaikh Ahmad's death in 1950 Kuwait had suddenly become one of the richest countries per capita in the world, entering under Shaikh Abdullah Al-Salim

The first drilling rig in Kuwait: Bahrah no.1 in 1936.

Left Shaikh Ahmad bin Jabir stands at the centre of a group at the Bahrah rig in 1936. With him from the left are Harold Dickson, J. Patrick (General Manager, KOC), Davies (Gulf Oil), Major Frank Holmes, L.D. Scott (General Superintendent, KOC) and Captain Gerald de Gaury (British Political Agent). *Gerald de Gaury 1936*

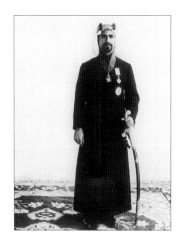

Above Shaikh Ahmad bin Jabir Al-Sabah on his investiture on 28 November 1930 with the Order of the Knight Commander of the Indian Empire (KCIE), awarded by the British for remaining neutral during the Ikhwan crisis. Shaikh Ahmad made his first visit to London as Amir of Kuwait in 1935. In 1937 he assumed the title His Highness, and was awarded the KCSI in May 1944.
Dickson 1930

Above right HH Shaikh Ahmad bin Jabir turns the silver-plated tap to start the first loading of oil for export, June 1946. With him from left to right: Abdullah Mullah Salih, Ezzat Gafaar, Shaikh Abdullah Mubarak, C.P. Southwell and D.A. Campbell.
BP photographer

a period of accelerating transformation which consigned the old way of life with all its hardships to the past.

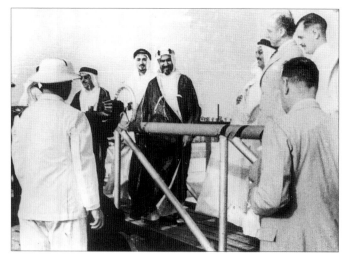

The "early photography" of Kuwait

By the 1920s cameras had become as commonplace as typewriters in both Europe and America. Ever more complex and expensive models were being used by those professionals, scientists and scholars whose work involved the collection of visual data, for example Britain's Royal Air Force, the embryonic civil aviation companies, the oil companies, and archaeologists and anthropologists. Both the RAF and the oil companies undertook wide-ranging aerial photographic surveys in the Middle East during the 1920s and 1930s. At the same time snapshot cameras had become cheaper, and between 1914 and 1920 sales increased fivefold, a trend which was to continue, surprisingly, through the Depression years of the 1930s.

Photography's range was of course continuously being extended as it was put to new uses, and during the 1920s it entered a new phase as photographers began to concern themselves with social issues and scientific visual recording. The reputation of photography increased as advances were made in camera design – in 1924, for example, Oscar Barnack completed work on the Leica lightweight camera, which incorporated the means to control exposure, took thirty-six pictures, and had an astigmatic lens. This small, compact, yet exceedingly sophisticated camera offered both amateurs and professionals a combination of spontaneity and quality which had never been achievable in photography before. Thanks to such cameras photojournalism and the illustrated magazine later began to enjoy their heyday.

The trends in photography established during the 1920s continued in the 1930s. There was a further huge increase in the sale of snapshot cameras and film, while at the professional level many newspapers were now illustrating their reports with photographs. This was the decade that saw the launch of *Life Magazine* in America and *Picture Post* in Britain. Technical innovations included automatic exposure control, the flashbulb and colour photography. All of these developments were to influence the design of cameras for the popular market after the Second World War, and ushered in the era of modern photography. Travellers and explorers began to rely on their cameras as much as on their writings as a means of recording. As luck would have it, three famous ones visited Kuwait during these years: Freya Stark (1932 and 1937), Alan Villiers (1939) and Wilfred Thesiger (1945 and 1949).

The first export of oil in 1946 heralded not only the rapid modernisation of Kuwait, but also the end of the early photography of the area. The idea of the early photography of a place seems at first a simple notion, but closer inspection reveals it to be a

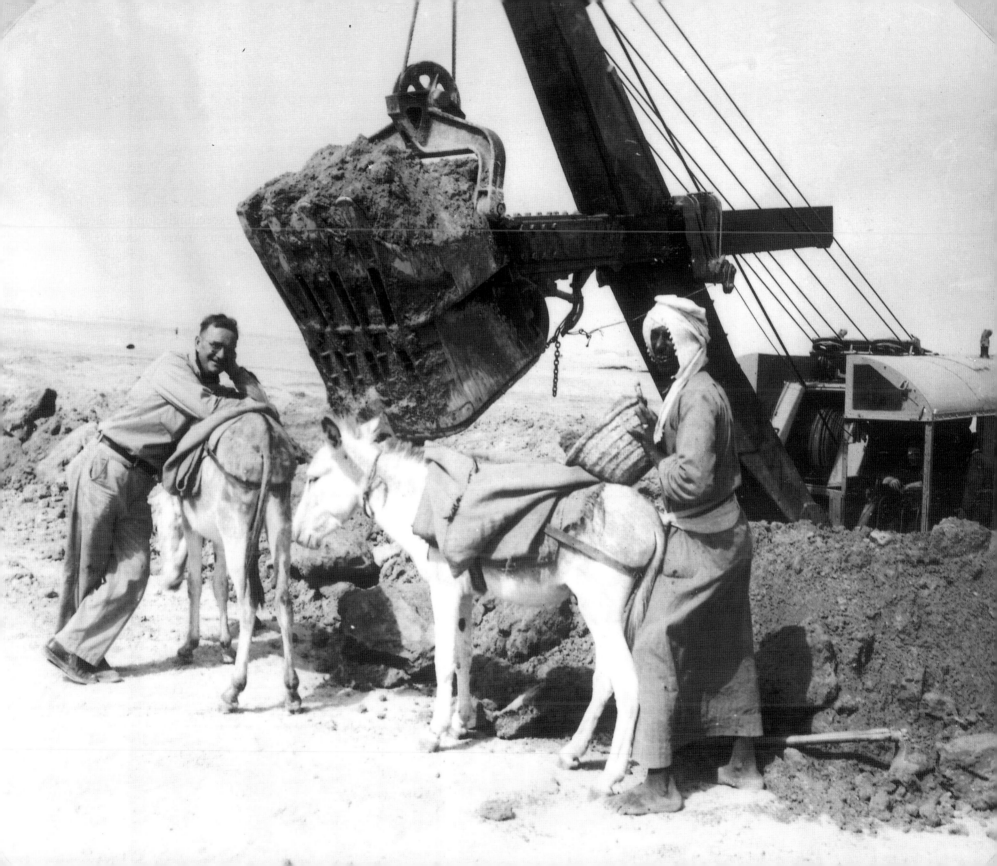

complex one. At first sight its meaning seems to hinge just on the technical progress of early cameras and the early growth of a class of amateur and professional practitioners of the young art. Naturally any definition includes those criteria, but they are not sufficient: the idea also includes the nature of the subject-matter. The early photography of Kuwait ends as Kuwait's transformation from a traditional shaikhdom into a modern state begins.

In short, we equate the early photography of Kuwait with the photography of pre-modern Kuwait. Kuwait's transformation is of course a topic worthy of photographic documentation, but it is not the focus of this book. For there is a sense in which the early photography of a society is bound to record the final throes of its pre-modern existence. That is because the first arrival of photography itself occurs as part of the beginning of modernisation.

Inevitably, therefore, the camera records things as they are about to change. It can be an instrument of nostalgia, constantly creating images of a past which is about to be lost. If photographs of old Kuwait seem to record something stable, persistent and ongoing, where any change was slow change, they also record the end of a time at which such slow change was possible. Today everything changes all the time. Rapid change is routine, and the recent past is constantly being swept away. Distance and difference create desire. It is easy to be hoodwinked by the nostalgia inherent in images of a lost past into thinking, uncritically, that life was somehow better then.

Old photographs attract us also because they are rare. They seem to offer a privileged glimpse into a hitherto unseen world. In fact they have to be treated with the greatest care, for they are only surviving fragments of the visual flux of life. We have to determine by other historical means whether they are significant fragments or just arbitrary ones.

Again, it is too easy to think that, because photographs record the way things looked, they therefore offer much in the way of true understanding. Historical photographs in fact offer little if any understanding on their own, without the information and interpretation which accompanies them. The best photos, for the social historian, are those which portray some abiding fact of life, some repetitive feature of the past, such as the activities in Kuwait's market or the unloading of water from the Shatt al-'Arab from dhows in the harbour. But the significance of the picture would be entirely lost without its explanation. Old photographs do not wear their meanings on their sleeves, and the meaning of a photograph is dependent on the context in which it is seen. During the lifetime of an old image its original meaning can drain away to be replaced by other meanings. Eventually it can end up as having no discernible meaning outside itself. Then it has become simply "art", a composition of light and shade. That, as far as historical pictures are concerned, may be a pleasant quality, but for historians it is probably their least interesting one.

Our selection of pictures finishes as the photography of Kuwait enters its modern phase, that is when the first professional photographers begin to appear with the oil company, and images start to proliferate. As images multiply and the world they show resembles our own more and more closely, it is inevitable that we are less and less moved by them. Today photographic images have to be quite extreme, either in content or technique, to catch our attention at all; image bombardment has brought on image fatigue.

Previous page Earth-movers old and new. The camera records change: its very presence is part of that change. And the two subjects of this picture, Arab and European, both show they know things are changing.
BP photographer, late 1940s

28

Yet, despite becoming progressively desensitised to the images around us, we continue to create new images at an ever-increasing rate. The camera's lens now no longer just reflects reality but has altered the way we experience ourselves, occasions and places. Many of us nowadays hardly feel that we exist fully unless we are photographed and, in extreme cases, publicised through the image. Photography somehow has come to validate existence and experience. For very many tourists, the act of photographing something has replaced the inconvenience of actually looking at it properly at first hand. As they take a picture and compose the view, they are already thinking ahead to seeing the picture, and the present is already in the past. In this way, by making an image of reality, photography can come between us and our experience. Even if we do not have a camera, we are constantly judging what we see in terms of whether it would make a good picture. Snapshots have made us tourists, not just in other people's experience, but even in our own. To take just one telling example from today, the writer Jenny Diski, who had inadvertently left her camera behind while on a cruise in Antarctica, supplies a vivid description of her fellow travellers photographing the view:

… what, I wondered, was the point of witnessing this sublime empty landscape and then passing on? That question was one reason, I suppose, for the rate at which the cameras clicked away. The photograph was evidence for oneself, not others really, that you'd been there. The only proof that anything had once happened beyond an attack of imagination and fallible memory. It also caused there to be an event during the moment of experiencing, as if the moment of experiencing doesn't feel like enough all by itself. If you merely looked and left, what, when you returned home, was the point of having been? It was not hard to imagine

such a landscape, to build one in your head in the comfort of your own home, and spend unrestricted time there all alone. In real life, you look, you pass through, you leave – you take a photo to make the activity less absurd.
Jenny Diski *Skating to Antarctica* pp.232–3

The early photography of Kuwait, sporadic as it is, shows us a portrait of a society in the throes of accelerating change during the half century after 1900. The portrait is composed chiefly of political, social, economic and environmental elements: the political events which shaped Kuwait during that time, the means by which Kuwaitis earned their livelihoods and how they went about their lives, and their physical surroundings. We are very far from having to deal with the extreme consequences of the camera's omnipresence today as described above. We have an additional advantage: pre-modern Kuwait is still within the living memory of many. For those who have experienced the past, the early photography helps to retrieve it, correcting tricks of memory and even, sometimes, revealing to them more than they knew by showing them things they had missed or taken for granted. For Kuwaitis, the early photography provides fertile ground for interpreting their past and, in so doing, for recovering their history.

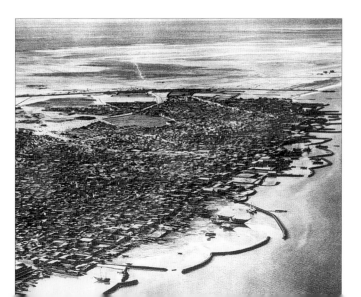

An aerial view of Kuwait looking across the western end of the town in 1946–48, on the eve of the rapid modernisation of the 1950s.
BP photographer 1946–48

The Photographs

Acknowledgements

Special thanks for their help with photographic research are due to Shaikha Hussa Al-Sabah, Patricia Anderson, the British Embassy in Kuwait, Aidan Broderick, Claire Brown, Ronald Clark, Emma Dean, Hanmer Dickson, Dr Gisela Dombrowski, David Hodge, Robert Jarman, Claudia Farkas Al-Rashoud, Rosemary Rendel, Efim Rezvan, Alan Rush, Joanna Scadden, Nancie Villiers, and especially to Dr Ya'qub Yusuf Al-Hijji whose *Old Kuwait – Memories in Photographs* has been a constant companion. Every effort has been made to trace and contact owners of copyright material. The authors and publisher gratefully acknowledge the following sources of photographs.

Picture credits

ETH – Bibliothek Zurich, Arnold Heims Album Arabia 1924 (Hs 494b:19): jacket front, jacket back, pp. 7 (bottom), 22, 62 (both pictures), 63, 64 (all 4 pictures), 65 (all 4 pictures), 66 (all 3 pictures), 67, 68 (both pictures), 69.

The Historic Photographs Section, National Maritime Museum, Greenwich, London: Villiers Collection: pp.2–3, 90 (top), 95, 96, 98, 99 (both pictures), 100, 101, 102 (all 3 pictures), 103, 104 (all 3 pictures), 105, 106, 107, 108, 109, 110, 111, 112, 113 (both pictures).
Lt Cmdr A.N. Gouldsmith: pp.16, 41, 42 (below left), 43.
HMS *Investigator*: p.42 (top).
Fellowes album: p.70.
HMS *Emerald*: pp.71, 72, 73 (both pictures), 74 (all 3 pictures), 75, 76 (all 3 pictures), 77.
G. Selous album: pp.78 (right), 79.
Capt. G. Ward-Smith: pp.78 (left), 80 (top left).

Maidstone Museum and Art Gallery, Maidstone Borough Council, UK: Admiral Bethell/HMS *Highflyer*: pp.42 (below right), 44 (both pictures).

The Royal Geographical Society, London:
W.H.I. Shakespear Collection: pp.7 (top), 9, 15, 45 (top left), 46 (all 3 pictures), 47, 48, 49.
De Gaury Collection: pp.23 (left), 25 (left), 90 (below), 91 (top), 92; A.R. and S. Lindt: pp.91 (centre and below), p.93

(all 3 pictures), 94.
Rendel Collection: pp.85, 86, 87 (both pictures).
M. O'Connor album: pp.114, 115.

William Facey: p.12.

The Russian State Naval Archives, St Petersburg: pp.18 (left), 33, 34 (left and right), 35 (all 3 pictures).

British Library, Oriental and India Office Collections: p. 19, 37 (both pictures), 38.

British Embassy, Kuwait: p.20, 45 (top right).

Middle East Centre, St Antony's College, Oxford:
Bowman Collection: p. 21.
Edmonds Collection: pp. 23 (top right), 83 (all 3 pictures), 84.
Dickson Collection: pp. 24, 26 (left), 80 (right above, centre and below), 81, 82.
Van Ess Collection: p.61 (all 3 pictures).
Freya Stark Collection: pp.88, 89 (all 3 pictures).

British Airways Archive: p. 23 (timetable).

BP Archive: pp. 25 (right), 26 (right), 27, 29.

Imperial War Museum, London: pp. 32, 116, 117, 118, 119.

Museum für Völkerkunde, Berlin, Hermann Burchardt Collection: pp. 39 (both pictures), 40 (all three pictures).

Cambridge University Library, Department of Manuscripts, Hardinge papers: pp. 52, 53 (both pictures), 54 (all 3 pictures), 55.

Neglected Arabia: pp. 56, 57 (both pictures), 58, 59 (all 3 pictures), 60 (below left).

© Sir Wilfred Thesiger (Pitt Rivers Museum, Oxford and Curtis Brown on behalf of Wilfred Thesiger): pp.120, 121, 123, 124.

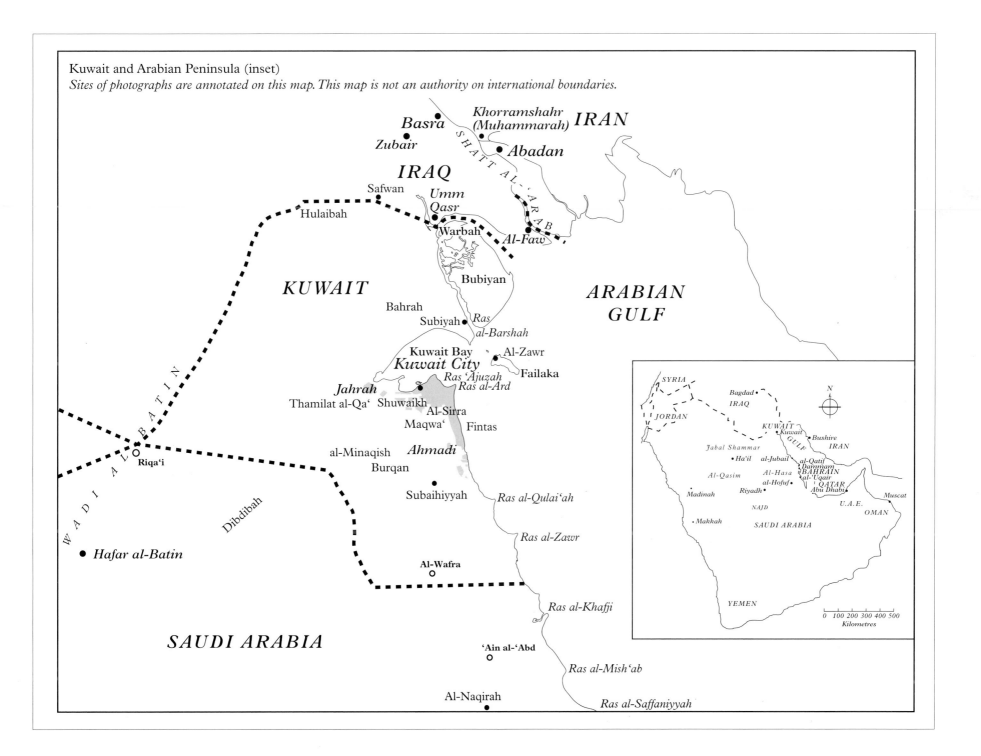

Kuwait and Arabian Peninsula (inset)

Sites of photographs are annotated on this map. This map is not an authority on international boundaries.

Basra
Khorramshahr (Muhammarah)
IRAN
Zubair
Abadan
IRAQ
Safwan
SHATT AL-'ARAB
Umm Qasr
Hulaibah
Warbah
Al-Faw
KUWAIT
Bubiyan
ARABIAN GULF
Bahrah
Subiyah
Ras al-Barshah
Kuwait Bay
Al-Zawr
Kuwait City
Failaka
Ras 'Ajuzah
Ras al-Ard
Jahrah
Thamilat al-Qa'
Shuwaikh
Al-Sirra
Maqwa'
Fintas
al-Minaqish
Ahmadi
Burqan
WADI AL BATIN
Riqa'i
Subaihiyyah
Ras al-Qulai'ah
Dibdibah
Ras al-Zawr
Hafar al-Batin
Al-Wafra
Ras al-Khafji
SAUDI ARABIA
'Ain al-'Abd
Ras al-Mish'ab
Al-Naqirah
Ras al-Saffaniyyah

SYRIA
Bagdad
IRAQ
JORDAN
N
KUWAIT
Kuwait
Bushire
Jabal Shammar
al-Jubail
al-Qatif
IRAN
Ha'il
al-Hasa
Dammam
BAHRAIN
al-Qasim
al-Hofuf
al-'Uqair
QATAR
Madinah
Riyadh
Abu Dhabi
Muscat
NAJD
U.A.E.
OMAN
Makkah
SAUDI ARABIA
YEMEN
0 100 200 300 400 500
Kilometres

Russian ships at Kuwait, 1900–1903

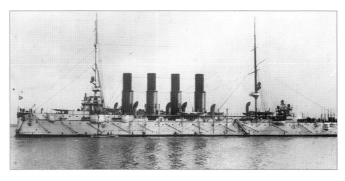

The Russian cruiser *Varyag*, seen here in 1902 shortly after her visit to Kuwait. *IWM Q22455*

Like other European powers, Russia at the turn of the century was seeking new spheres of influence. In particular the Russians wished to expand their relations with the Arab world, since both Russia and the Arabs shared a hostility to the Ottoman Empire. The Arabs in general also regarded Russia as a potential friend against the imperialist ambitions of Britain and France. Russia had a further good reason to involve itself in the Gulf: it wished to capitalise on its growing influence in Persia, which itself was seeking to bring its Gulf coast under closer control. British prestige meanwhile hit a low point in 1899 as a result of early setbacks in the Boer War. 1899 therefore seemed a propitious moment for those intent on creating new problems for Britain in the Gulf.

The Russian Foreign Ministry began cautiously as plans were laid that year to despatch the gunboat *Gilyak* to the Gulf:

> *... by showing the Russian flag in the Gulf, to indicate to the British and the local authorities alike that we consider the Gulf accessible to the ships of all nations, despite the wish of the British government to turn it*

into a closed sea within the sphere of its exclusive interests. So if the Gilyak *carries out the mission laid upon her, the purpose will be to make an impression with no aggressive intent or plans for territorial acquisition.*
Rezvan, *Russian Ships in the Gulf* p.4

Russian policy-makers painted an exaggeratedly sinister picture of British policy in the Gulf, the better to present their intentions as contrastingly benign. Britain's central aim in the 19th century had been to maintain peace at sea, chiefly of course for her own shipping, but not excluding that of other nations. In a sense, Britain had already created in the Gulf what the Russians believed should be there and claimed was not: independent rulers and a sea free for commerce. The captain of the *Varyag* gave the most balanced view of the position in his report of his visit in 1901: "As for any outward signs of British Government predominance in any of the ports I visited, I noticed none except the permanent presence of the ships stationed at Kuwait [the *Pomone*, at Kuwait to help Mubarak stave off an assault by Ibn Rashid of Ha'il], Bushire and Muscat."

However, British officials certainly looked with distrust on other powers seeking to beguile the local rulers in order to establish a foothold in Oman and the Gulf, and in 1892 and 1899 had gone so far as to make exclusive agreements with the shaikhs of the Trucial Coast and Kuwait respectively, making them protectorates in all but name. Though this fell very far short of an aggressive imperialist policy on Britain's part, Russians appearing in warships, however well-intentioned they might be, naturally caused alarm. So,

while not attempting to prevent Russian ships from sailing round the Gulf, British officials made their onshore dealings as difficult, behind the scenes, as they could.

They were unable, however, until Curzon's tour of 1903, to dent the great impression the Russians made on the people of the Gulf. The *Gilyak* arrived off Kuwait in February 1900, having already called at Bandar Abbas, Deir, Bushire, Muhammarah and Basra. Shaikh Mubarak of Kuwait, sensibly keeping

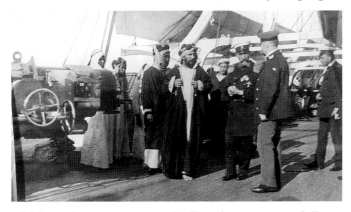

all his options open, gave the Russians an especially warm welcome, despite having only just the year before signed his secret agreement with Britain. The *Gilyak*'s captain somewhat naively remarked that the "Arab shaikhs understand the extent to which, with nominal Turkish rule, they were virtually independent, whereas a British protectorate would mean an end to independence of any kind". This view would have surprised those 19th century British officials who had seen their mission partly as one of upholding the coastal Shaikhs' independence with minimum interference.

In 1900 the Russians made plans to start a regular steamship link between Odessa and the Gulf ports and, in 1901, opened new consulates in Basra and

Bushire. This was followed by the visit of the four-funnel cruiser *Varyag* to the Gulf. The *Varyag* reached Kuwait on 8 December 1901, not long after the status quo understanding had been reached between Britain and Turkey. Shaikh Jabir bin Mubarak came aboard to greet the Russians, as Mubarak himself was at Jahrah with 3,000 troops, anticipating the assault with which Ibn Rashid was to follow up his victory at Sarif earlier in the year. The *Varyag*'s officers and Ovseyenko, the Russian consul at Bushire, went to Jahrah, where they were welcomed, inspecting the troops and being treated to displays of dancing and horsemanship. Though the captain's report does not mention photography, it is photographs of this visit which are preserved in the Central Naval Archive at St Petersburg and presented here.

Mubarak said he would turn to Russia if he needed help – again a case of keeping his options open, for Jahrah and Kuwait town were being defended with help from British guns supplied by the *Pomone*, stationed offshore, and Kuwaiti gunners had been trained on board. At that time Kuwait town was completely unfortified. The *Varyag* made an enormous impression with its powerful electric lights, huge guns, brass band, and general level of technology. Britain's immediate response was to fit lights to some of its vessels, and send the cruiser *Amphitrite* round the Gulf ports, but it did little to erase the impression of Russian superiority.

Apart from various traders who had now set up business with Kuwait, the next Russian to be received by Shaikh Mubarak was the zoologist N.V. Bogoyavlensky, who was carrying out studies in Muhammarah, Kuwait, Bahrain and Muscat on behalf of the Society of Lovers of Natural Science, Anthropology and Ethnography of Moscow University. Arriving in March or April 1902, he was

Left Shaikh Jabir bin Mubarak is shown round the *Varyag* by her Russian officers, December 1901.

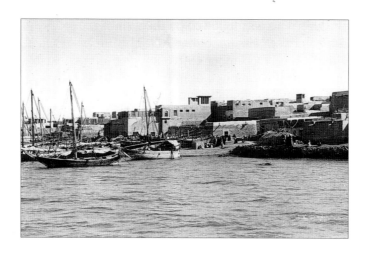

Right The earliest known picture of Kuwait's waterfront, taken by a member of the crew of the *Varyag*, December 1901.

Far right This view shows Kuwait town from the landward side, across the cemetery.
Varyag, *December 1901*

warmly received. "I consider the Russians as my brothers" declared Mubarak. As usual, the Shaikh expressed his alarm about the Turkish and German plan to build the Baghdad Railway with a terminus at Kuwait, which he thought, probably rightly, would spell the end of his independence: "I hope Allah will not let this misfortune come to pass." As it was to turn out, Mubarak's wish was granted. Bogoyavlensky took many photographs in Kuwait, according to a British report; if they survive, they have not yet come to light.

The biggest Russian ship of all to visit Kuwait was the five-funnelled cruiser *Askold*, which arrived on 1 December 1902 with a crew of 580 men. Shaikh Jabir bin Mubarak and his son Ahmad (the future ruler) went aboard to greet the Russians. The Turkish flag flew in front of the shore palace, then a spacious two-storey house with terraces on each floor, but the captain knew that "in reality the Shaikh refuses to recognise the Sultan's authority and pays no tribute". The Kuwaitis were astonished at the stupendous modern ship and specially impressed by the searchlights with which it lit up part of the town in the evenings.

The last Russian ship to arrive was the three-funnelled cruiser *Boyarin*, on 20–23 February 1903. Russia enjoyed an uneasy alliance with France based not so much on common interest but on joint opposition to Britain – France opposed Britain in Muscat and had a large investment in the Baghdad Railway project – and the *Boyarin* was accompanied by the French vessel *Infernet* on its voyage to the Gulf ports.

The *Boyarin*'s captain reported on the aftermath of the Battle of Sarif the year before, when Shaikh Mubarak had had to flee Jahrah in the face of Ibn Rashid's assault, and retire on Kuwait town. Since then, a trench had been dug round the town on the advice and instruction of British officers – a forerunner of the wall thrown up in 1920 against further attacks from the hinterland: "The trench starts from one end of the harbour, encircles the city, and ends at the other side of the shore. Clever use is made of wells and other structures that offer good protection. In some places in the trench it is possible to shoot from the knee and in others at man's height."

Most interestingly, 'Abd al-'Aziz Ibn Saud was in Kuwait with his brothers Muhammad and Sa'd, being

fêted by Mubarak for his daring recovery of Riyadh a year earlier. The young Saudi leader was in Kuwait collecting reinforcements of 1,400 men and supplies from Mubarak in order to continue the campaign against Ibn Rashid. Though he did not himself visit the *Boyarin*, his brothers Muhammad and Sa'd went aboard before leaving Kuwait on campaign.

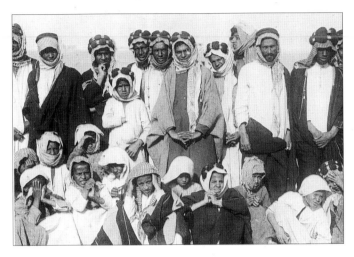

Unlike the *Varyag*'s, the *Boyarin*'s captain mentioned photography. One day the *Boyarin*'s mate went ashore with a camera, accompanied by officers from both ships, and rode on horseback into the desert for lunch with Shaikh Mubarak. Later they paid a visit to 'Abd al-'Aziz Ibn Saud. These photographs await discovery, if indeed they still exist.

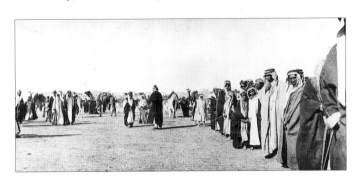

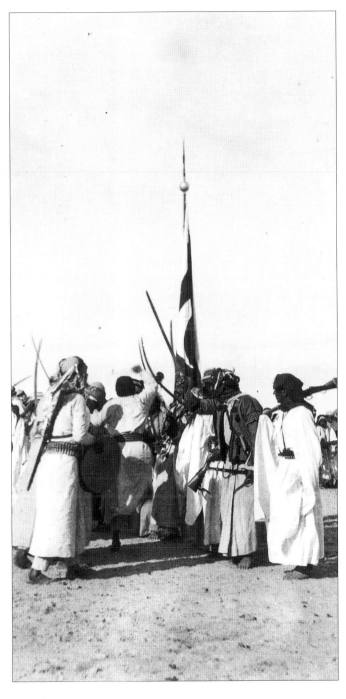

Top left Smiling for the unfamiliar camera seems to come naturally to this large group of young Kuwaitis.
Varyag, December 1901

Below left Kuwaitis in al-Safat, the large open space on the landward side of the town, look on curiously as the Russian photographer takes a picture.
Varyag, December 1901

Left A war dance was staged for the Russians' benefit at Jahrah, where Shaikh Mubarak was encamped with his forces.
Varyag 1901

35

Lord Curzon, 1903

Lord Curzon soon after his appointment as Viceroy of India in 1898.

The visit by Lord Curzon, Viceroy of India, to Kuwait took place in the wake of Britain's 1899 secret agreement with Mubarak and of the exchange of letters with the Ottoman government in 1901, which was intended to set Anglo–Turkish relations in regard to Kuwait on an agreed footing once the 1899 agreement had come out into the open. This exchange of letters, known as the status quo understanding, did little in the way of clarification. Curzon himself was scathing about its ambivalence: "It seems to me that we are now in the quaint situation of having admitted and denied the suzerainty of the Sultan, both accepted and repudiated his sovereignty, both asserted and given away the independence of the Shaikh."

The fact is that Kuwait's situation regarding Turkey and Britain was inherently contradictory, and no form of words could have embodied it to the complete satisfaction of both parties. Only Kuwait came out of it well, Shaikh Mubarak being able to present himself both as a loyal subject of the Sultan and as a protégé of Great Britain. For Britain, good relations with Turkey were a vital part of the long-term strategy to keep open communications with India, and Curzon was as anxious as anyone not to offend the Turks by questioning their perceived rights in Kuwait. He even went so far as to deplore Mubarak's efforts to extend his domain at the expense of the Al Rashid of Ha'il, then allied to Turkey. Ottoman designs on Kuwait continued unabated, however, and Curzon realised that a display of power would speak louder than any ambiguous agreement as a means of reassuring the Shaikh of Britain's intention to maintain his independence under its protection.

His famous voyage around the Gulf in 1903 was also directed against Russian, German and French ambitions in Oman and the Gulf as a whole. Curzon set forth from Karachi in a manner befitting this legendary champion of Britain's imperial interests. He made his tour aboard RIMS *Hardinge*, and his flotilla included HMS *Argonaut*, a large warship. This, with its four funnels and escort of five more ships, was deemed a display of sufficient potency to erase the impression made late the previous year by the five-funnelled Russian warship *Askold*. At a durbar on board the *Argonaut* in Sharjah he harangued the assembled shaikhs with this splendid declaration of paternalist imperial policy:

We were here before any other Power in modern times had shown its face in these waters. We found strife and we have created order. It was our commerce as well as your security that was threatened and called for protection. At every port along this coast the subjects of the King of England still reside and trade. The great Empire of India which it is our duty to defend lies almost at your gates. We saved you from extinction at the hands of your neighbours. We opened these seas to the ships of all nations and enabled their flags to fly in peace. We have not seized or held your territory. We have not destroyed your independence, but have preserved it. We are not now going to throw away this century of costly and triumphant enterprise; we shall not wipe out the most unselfish page in history. The peace of these waters must still be maintained; your independence will continue to be upheld; and the influence of the British Government must remain supreme.

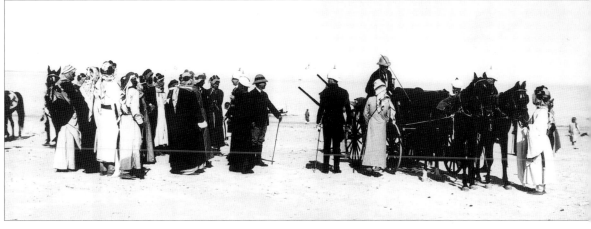

Mubarak knew how to welcome foreign officials to Kuwait, and he and his people gave Curzon a festive reception on his arrival in November. The photographs of the occasion show the Shaikh meeting the Viceroy on the beach, three miles from the town, while cavalry (both horse and camel) and footsoldiers stood by to provide an escort to the town. Mubarak and Curzon rode in Kuwait's only horse-drawn carriage, a newly acquired open victoria. Curzon's company included the British Minister to Tehran, who was mounted on a horse. Curzon takes up the story:

... the procession moved off in a cloud of dust. At this stage it apparently became necessary for the cavalry escort to express their rejoicing not merely by war-cries of the most blood-curdling description, but by firing ball cartridge promiscuously either into the air or into the ground at the feet of their prancing steeds. Others hurled their spears frantically into the air. The result was the wildest confusion. The air resounded with the fusillade, and the ground was a whirlwind of careering horses and yelling cavaliers and spurting sand. Some of the horsemen were bare-headed, and their plaited hair streamed in the wind as they dashed along; others wore flowing garments of orange and red and golden brown. The chief was clad in a broad-striped robe.

In the midst of the scene I saw the form of the British Minister shot clean over the head of his steed and deposited with no small violence upon the ground. Nothing daunted, he courageously resumed his seat and, amid a hail of bullets, continued the uneven tenor of his way.
Curzon, *Tales of Travel* pp.248–9

They proceeded into the town where the entire population had come out to greet them, the women ululating their welcome. The meeting with Mubarak took place on the first floor of the palace, "a modest edifice, built for the most part of sun-dried bricks and situated in a very narrow street or lane of the town". Like so many other visitors, Curzon was impressed by the Shaikh, calling him "by far the most masculine and vigorous personality whom I have encountered in the Gulf". Their parley was interrupted by shouts and confusion outside as the horses, unaccustomed to being harnessed between shafts, kicked the victoria to pieces. Afterwards, Curzon and his entourage returned to their ships on foot.

Above left Shaikh Mubarak in his striped *thawb* waits to welcome Lord Curzon and his party ashore, November 1903.

Above Lord Curzon gets aboard the victoria which was to convey him and Shaikh Mubarak into Kuwait town, three miles away, November 1903.

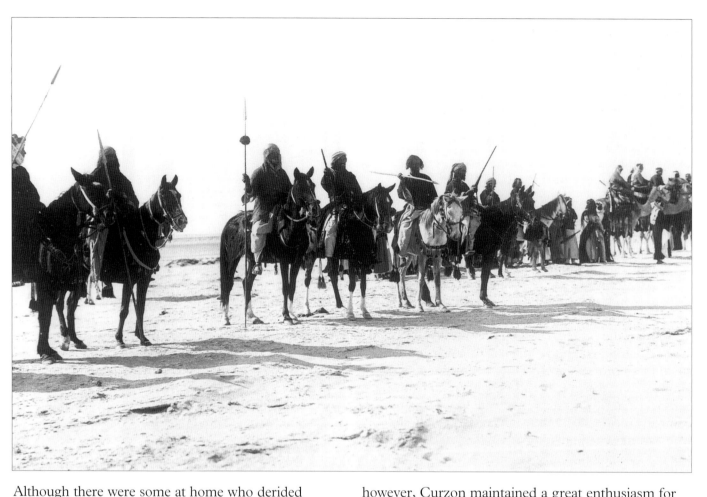

Although there were some at home who derided "Curzon's prancings in the Persian puddle", it was certainly due to him and his able acolyte Percy Cox, who as Gulf Resident from 1904 till 1913 kept a famously suave but firm hand on its affairs, that Britain's influence on Kuwait and the other Gulf shaikhdoms deepened in the years up to the First World War.

Curzon himself does not appear to have taken pictures at Kuwait, and the pictures shown here were probably taken by a naval officer. Throughout his life,

however, Curzon maintained a great enthusiasm for photography. In the early 1890s he began to use one of the new Kodak cameras which had been developed by George Eastman and which, by the turn of the century, had greatly reduced the cost and complications of photography. These small snapshot cameras with their celluloid roll film – which after 1891 could be loaded and unloaded in daylight – were an enormous success and brought thousands of newcomers to photography, including some of the British naval officers whose task it was to police the waters of the Gulf.

Hermann Burchardt, 1903

In December 1903 the German explorer Hermann Burchardt visited Kuwait. He came from a wealthy Berlin merchant family and therefore had the means to undertake long journeys to regions rarely visited by European travellers. He had worked for many years in his father's business but, finding little satisfaction there, took every available opportunity to travel, visiting remote corners of Asia, North Africa, the Middle East and Australia. During this period he developed a special interest in the Islamic east. Following his father's death in 1890, he enrolled at the Seminar für Orientalistik in Berlin in order to learn more about the region. In 1892 he left the Seminar with a good knowledge of Arabic and a keen interest in ethnography. He eventually settled in Damascus, which he used as a base for his extensive travels throughout Syria, Mesopotamia, Persia, the Arabian Peninsula and East Africa. In Arabia, as well as his journey down the Gulf in 1903–4, he made several journeys in the Yemen until his murder there in 1909. An accomplished scholar, Burchardt was also a capable photographer, working mainly on glass.

Burchardt's four-day visit to Kuwait was part of a longer journey down the east coast of Arabia which began at Basra and ended at Muscat. In order to see the whole of the coast he travelled by local craft, renouncing the comforts of the regular steamer service for the opportunity of seeing new places and observing the life of the people on board. Disembarking from a *boum* at Kuwait on 11 December, he went immediately to visit Shaikh Mubarak, whom he found holding his customary morning *majlis* in the audience-hall in the market-place. He was well

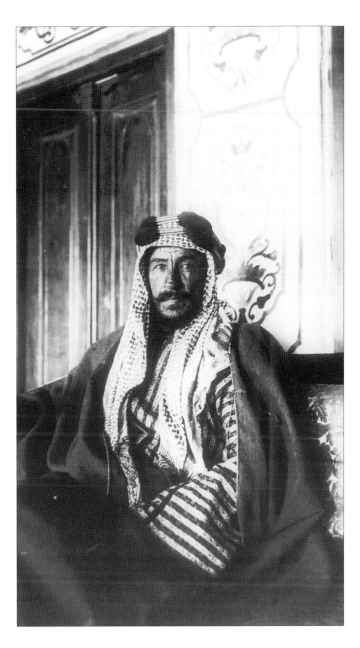

Above Hermann Burchardt in San'a, Yemen, shortly before his death in 1909. His photographic equpment probably included a camera stand and a quality folding camera taking half-plate glass negatives.
Burchardt

Left Shaikh Mubarak, photographed by Burchardt probably on the afternoon of 11 December 1903, when he was invited by Mubarak to a large room furnished in French style, with pictures of Queen Victoria and King Edward VII on the wall. Various matters were discussed, among them the Baghdad Railway, and Burchardt was much impressed by Mubarak, noting that "he seemed very well-informed ... he was also the only Shaikh I got to know on my travels who had something of the sovereign about him".

39

The Shaikh's falconer,
Kuwait.
Burchardt 1903

Above right The *Suq al-
fahm*, Kuwait, where char-
coal, mostly from Persia, was
brought from the harbour.
Burchardt noted that the
whole area was frequently
thronged with donkeys and
camels carrying palm-leaf
baskets full of charcoal. All
Kuwait's fuel, apart from
brushwood found locally, had
to be imported.
Burchardt 1903

Right Boats drawn up in
Kuwait's harbour, including a
fine cargo-carrying *baghlah*
or *ghanjah* (left). Burchardt
noted that the great majority
of Kuwait's sailing vessels
were used in the Bahrain
pearl fisheries, which took
place during the summer.
For most of the year, there-
fore, they would be drawn up
on shore until the approach
of the season, when the boat
crews would arrive from the
interior or from trading
vessels coming home.
Burchardt 1903

received by the Shaikh, who deputed one of his men
to act as Burchardt's guide around the town.

On returning to the palace, Burchardt found that a
large, comfortable room had been prepared for him,
and noted the consideration with which he was
treated. In the afternoon, he again met with Shaikh
Mubarak, and received information about Lord
Curzon's recent visit. The Shaikh also told him of the
visit of three fellow-Germans – one of them Consul-
General in Istanbul – who had come to investigate the
possibility of extending the Baghdad Railway as far as
Kuwait.

A few of the glass negatives he made in Kuwait have
survived, including well-composed shots of the *Suq
al-fahm* (charcoal market), the Shaikh's falconer and a
group of pearling boats drawn up on the shore. He
described the Kuwait of his visit as "… a very spread
out town with thirty thousand inhabitants and clean
streets which, I noticed, were regularly swept and
sprayed in the early morning. The Shaikh himself
inspects the town several times a day … and security

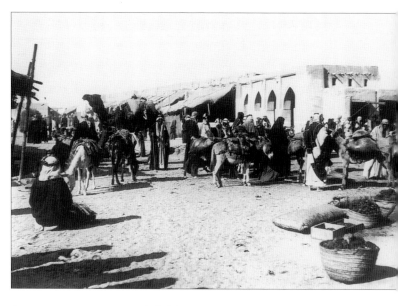

is paramount. … pearl-fishing, navigation and ship-
building are the main occupations of the inhabitants."
It was no doubt with some regret that Hermann
Burchardt bade farewell to Shaikh Mubarak, and
once again boarded the *boum* to continue his voyage
down the Arabian coast.

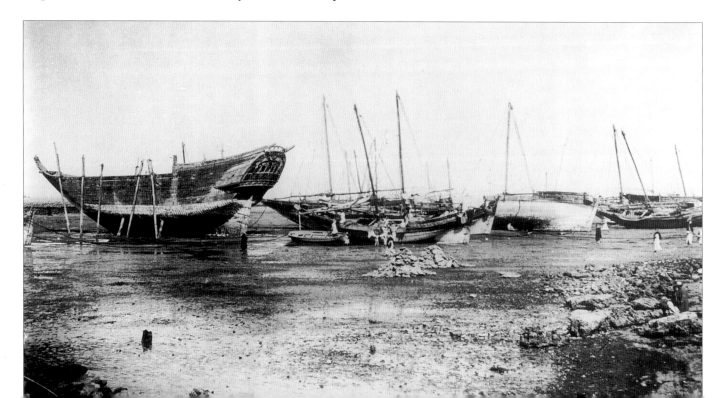

Showing the flag: the British navy, 1904–1912

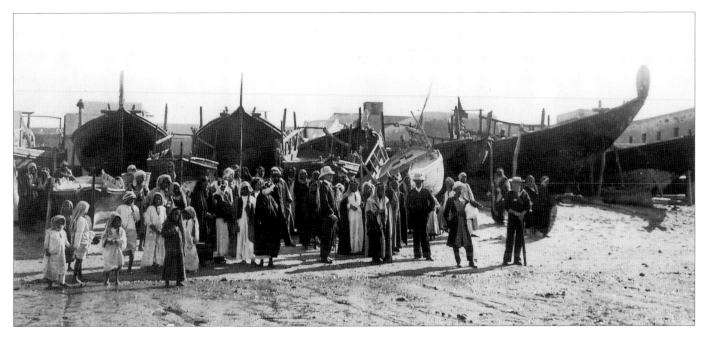

The British navy was quick to appreciate the value of photography, and a few officers who served aboard the ships which regularly patrolled the Gulf and its ports during the opening years of the 20th century have left behind some rare images of Kuwait.

Throughout the 19th century the navy had been at the forefront of scientific and technical advance as the old sailing ships gave way to the power of steam. In 1837 an engineering branch was created, and a naval gunnery school was opened in 1840; there was increasing professionalism and higher education for officers at the Royal Naval College in Greenwich. Hydrographic surveys grew in number, and some scientific expeditions were undertaken. In 1849 Sir John Herschel, himself one of the pioneers of

photography, edited the *Admiralty Manual of Scientific Enquiry*, which consisted of chapters written by some of the leading scientists of the day, and detailed how seafarers by careful observation and recording could add to scientific knowledge. The value of visual records was stressed throughout this work, and so it is not surprising that naval officers were among the first to carry cameras. This was especially the case after the opening in 1905 of the new Britannia Royal Naval College at Dartmouth, where photography was taught as part of the officers' course.

Photographs of Kuwait are known from three naval vessels during the years leading up to the First World War: HMS *Investigator* (1904–5), HMS *Lapwing* (1907–9) and HMS *Highflyer* (1912).

This group of Kuwaitis and British on the waterfront includes the unmistakeable figure of Percy Cox, wearing a solar topee and carrying a walking-stick, at its centre. One of the famous Kuwaiti pearling *battil*s, with its distinctive prow, is propped at the right.
A.N. Gouldsmith 1907–9

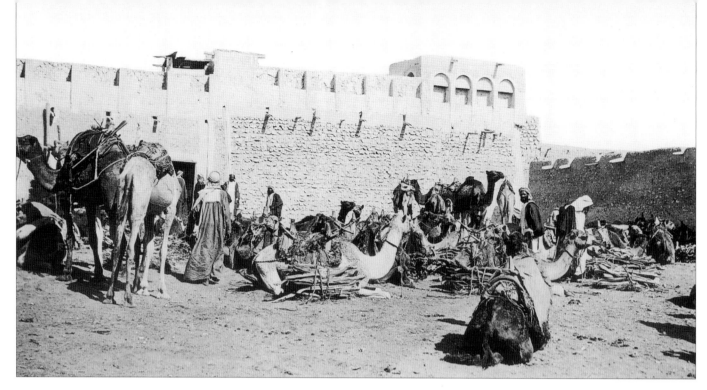

Right This picture of a caravan at Kuwait was taken by an officer on board HMS *Investigator*, probably when it visited Kuwait in 1904–5.
HMS Investigator

Below Shaikh Mubarak and Percy Cox cross the bridge joining the older part of the Seif Palace on the waterfront with the new building of baked bricks. This bridge is shown in Raunkiaer's picture of 1912. Cox was Political Resident in the Gulf 1904–1913.
A.N. Gouldsmith 1907–9

Below right This view of Kuwait's waterfront was taken from the Seif Palace in April 1912 on the occasion of the investiture of Shaikh Mubarak with the KCIE.
HMS Highflyer *1912*

Opposite Shaikh Mubarak holds an outside audience, sitting in the corner of a bench or *mastabah*, and attended by notables of Kuwait and two unnamed British officials. This fine picture was probably taken by Lt-Commander A.N. Gouldsmith, an officer on board HMS *Lapwing* from 1907 to 1909 when it called at Kuwait. The elderly figure sitting in the back row to the extreme right also appears in Shakespear's picture of Shaikh Mubarak and the Al Saud taken in 1910.
A.N. Gouldsmith 1907–9

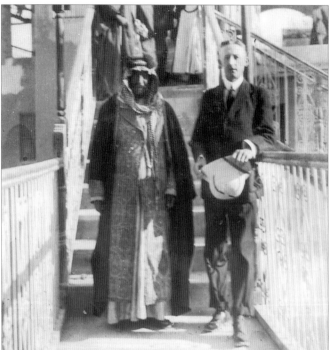

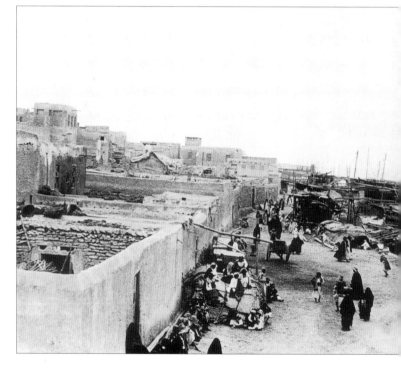

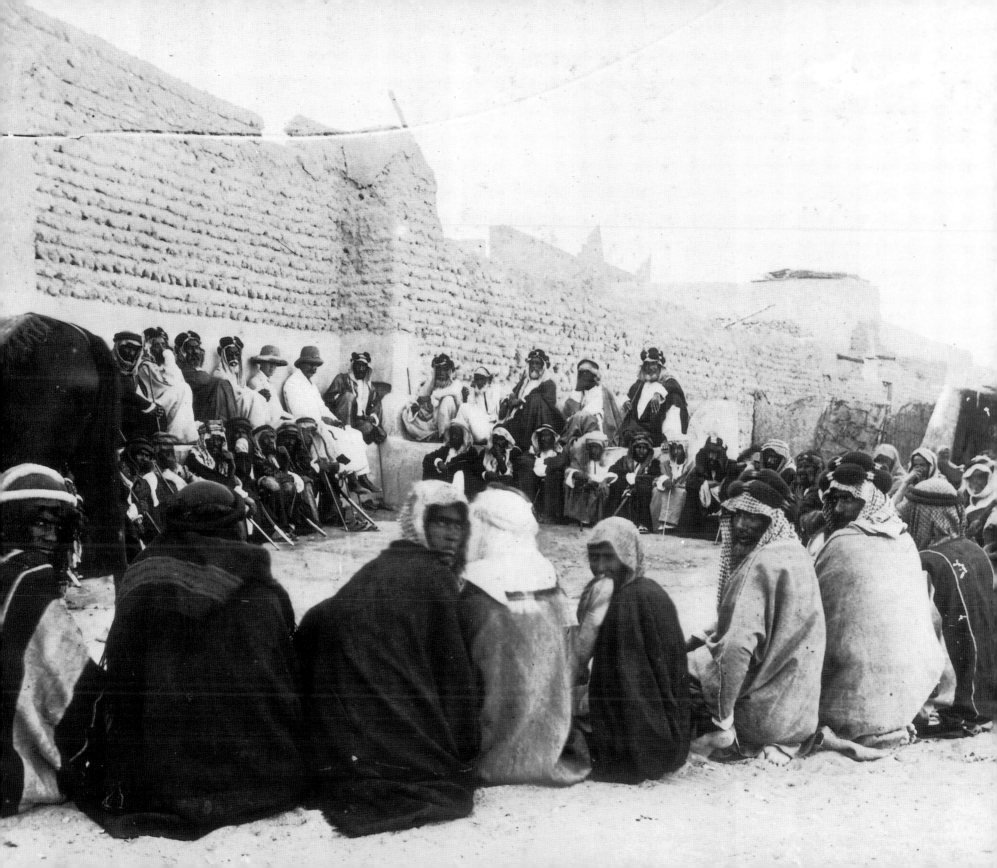

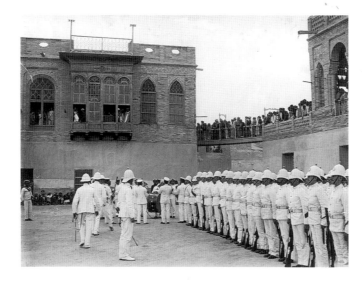

Top Shaikh Mubarak's investiture was accompanied by a Royal Marine guard of honour, and entitled him to a 15-gun salute. The KCIE was Britain's riposte to the Ottoman Sultan's award to Mubarak, a few months earlier while Raunkiaer had been in Kuwait, of the Order of Mejidie.
HMS Highflyer *1912*

On 16 April 1912, while Capt. Shakespear was Political Agent and less than two months after the Danish traveller Barclay Raunkiaer's departure, Kuwait was photographed in a more formal manner, when Admiral Sir Alexander Bethell, Commander-in-Chief of the Royal Navy in eastern waters, put in aboard HMS *Highflyer* to invest Shaikh Mubarak with a KCIE. The Admiral was met by Shaikh Jabir bin Mubarak and Capt. Shakespear as he came ashore, and taken to the Seif Palace, shown here.
HMS Highflyer *1912*

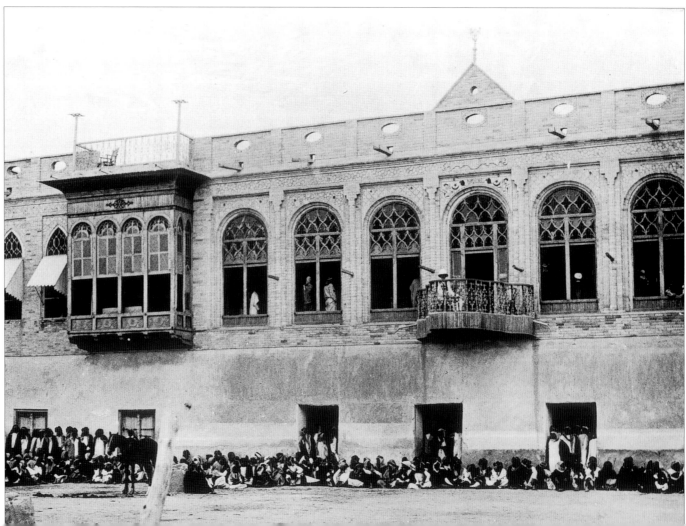

Captain W.H.I. Shakespear, 1909–1914

Today Captain William Shakespear's photographs are probably the best-known early images of Kuwait. He arrived in 1909 as the newly appointed British Political Agent – a post which had been created in 1904 in the wake of Lord Curzon's visit, and which Shakespear was to hold until 1914. He had already held consular posts at Bandar Abbas and Muscat, and combined talents as a linguist, horseman, sailor, explorer, negotiator and all-round man of action.

Shakespear grasped every opportunity to explore and document the territory in which he found himself. This, as much as his early aptitude for both chemistry and drawing, led him to develop his skill as a photographer. He worked with a large plate camera which was specially adapted to take panoramic views, and later acquired a Houghton's Ensignette – a small folding camera which took film negatives. His photography was limited only by the amount of equipment he could carry on his desert journeys, and he would often spend his evenings in camp trying to develop his own negatives in a Kodak Tank Developer, a procedure fraught with difficulties given the intense heat and the scarcity of clean water.

During his five years in Kuwait he was able to take many memorable pictures of the town, including a fine set of views of the harbour, which reflect his love of sailing and the sea. His real passion, however, was desert exploration, and he quickly acquired a well-trained hawk named Shalwa and a pack of saluki dogs. These he would take into the Kuwait hinterland, sometimes visiting a tribal shaikh *en route*. At first his camera caused some consternation because of its novelty: men he encountered would often run for

Above Captain William Henry Irvine Shakespear.

Top left Shaikh Mubarak's palace, photographed by Shakespear at sometime between 1909 and 1913. The Ottoman flag was routinely flown but, as Raunkiaer noted, this meant nothing in terms of real jurisdiction. *Shakespear 1909–13*

Left Shaikh Mubarak's new Seif Palace in 1909. *Shakespear 1909*

Top The British Political Agency, Kuwait 1909. When Shakespear arrived in Kuwait in 1909, he took up residence in this former merchant's house on the sea-front which his predecessor Knox had established as the Political Agency. This house was to remain the Political Agency until 1936, when a new Agency building was completed (now the British Embassy). The old house became the Dicksons' residence and remained so until Dame Violet Dickson's departure from Kuwait in 1991. It now awaits restoration as a public bulding devoted to the history of Anglo–Kuwaiti relations. *Shakespear 1909*

Centre Shakespear's bedouin escort on his journey in the Kuwait hinterland in November 1909. *Shakespear 1909*

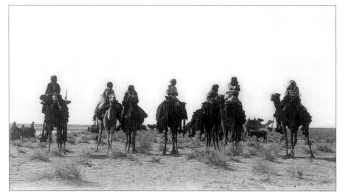

Right Kuwait harbour in April 1911. The *battil*s with their fiddle-headed prows were the most distinctive vessels in the Kuwaiti pearling fleet. *Shakespear 1911*

Opposite A shaikh's *majlis* at Sirrah, just south-east of Kuwait town.

cover at the sight of it. But on the whole he seems to have met with very little serious hostility to his photographic work.

From 1909 on, if we include a short foray into the Kuwait hinterland in 1912, Shakespear made seven journeys of exploration into eastern and central Arabia, culminating in his great crossing of Arabia from the Gulf to Suez via Riyadh in 1914. He returned to Arabia in 1915 as Political Officer on Special Duty, only to meet an untimely death with the forces of Ibn Saud at Jarrab in Najd in 1915. These journeys often combined political business with exploration, and were usually undertaken during the winter months.

In 1909 he explored some 200 miles of territory to the south of Kuwait Bay. In 1910 he went farther south, to the well of "as-Safa" (al-Lisafah), turning north-west to Hafar al-Batin and then returning along the Batin to Hulaibah and beyond, returning thence southwards to Jahrah. Both of these journeys kept within what was to be recognised by Britain and Turkey in 1913 as Shaikh Mubarak's sphere of influence; today a part of each route – in the case of

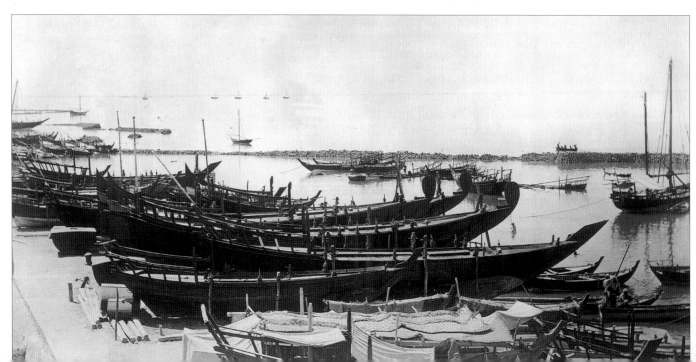

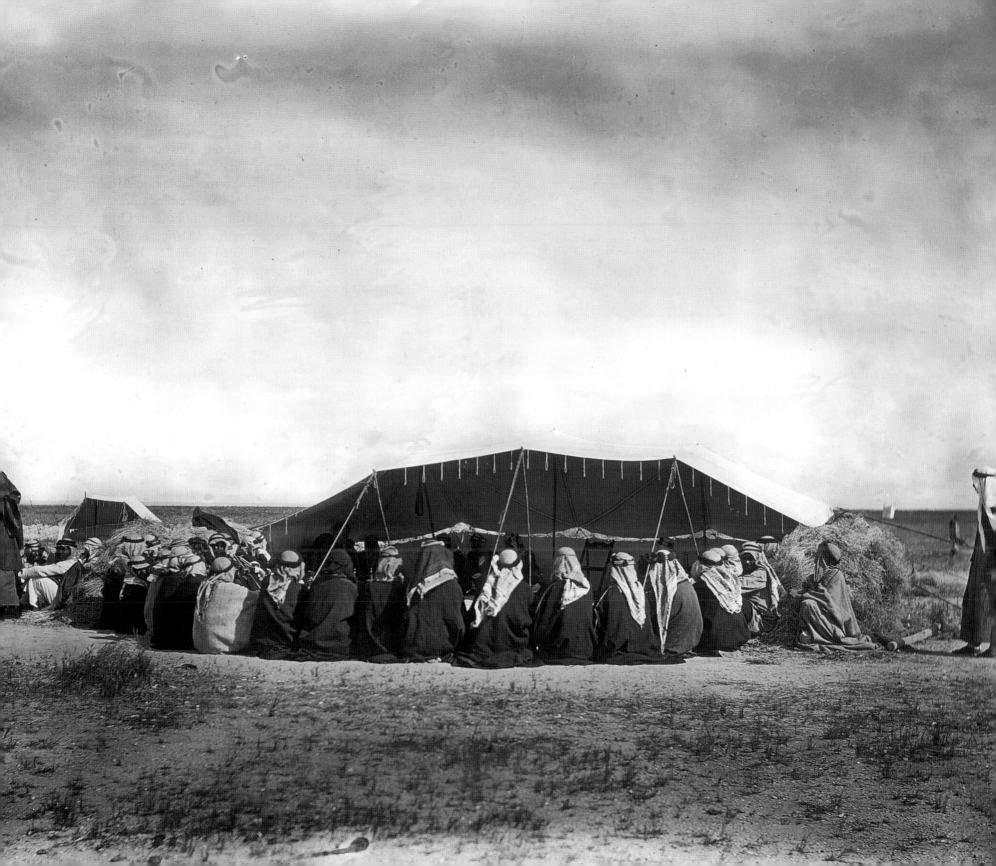

the 1910 journey a large part – falls within Saudi Arabia's Eastern Province. As we have seen, this state of affairs traces itself to Sir Percy Cox's frontier adjudication at the 'Uqair Conference in 1922.

Shakespear's great ambition was to establish relations with 'Abd al-'Aziz Ibn Saud, the Amir of Riyadh and rising star in central Arabia, and to visit Riyadh. He had met and taken a famous photograph of the young ruler in Kuwait in 1910. His 1911 journey took him south to the wells of Thaj, technically in Ottoman-controlled al-Hasa, where he conferred with Ibn

Saud. 1913 took Shakespear into Sudair, where he met Ibn Saud near Majma'ah. Shakespear recognised a great leader when he saw one, and promoted him vigorously as a potential ally against the Turks when the First World War broke out. The admiration seems to have been mutual. Years later, when asked by Glubb to name the most remarkable non-Muslim he had known, King 'Abd al-'Aziz replied unhesitatingly "Shakespear". But in Britain the Foreign Office view prevailed over that of the India Office, and British support was thrown instead behind Sharif Husain of the Hijaz with whom, through T.E. Lawrence, the Arab Revolt was organised.

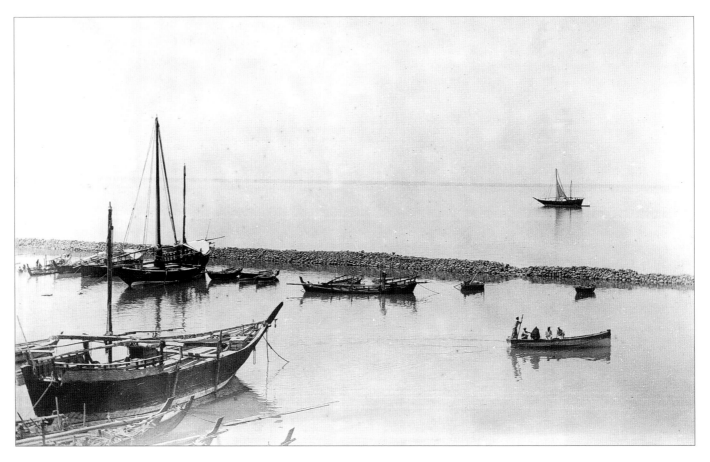

Shakespear's photographs of Kuwait harbour are unrivalled. In these two pictures he shows the view from the Political Agency: a nautical bustle which includes *boum*s and *baghlah*s or *ghanjah*s among the larger vessels, and *sambouk*s, *shu'ai*s and various harbour craft among the smaller.
Shakespear, October 1911

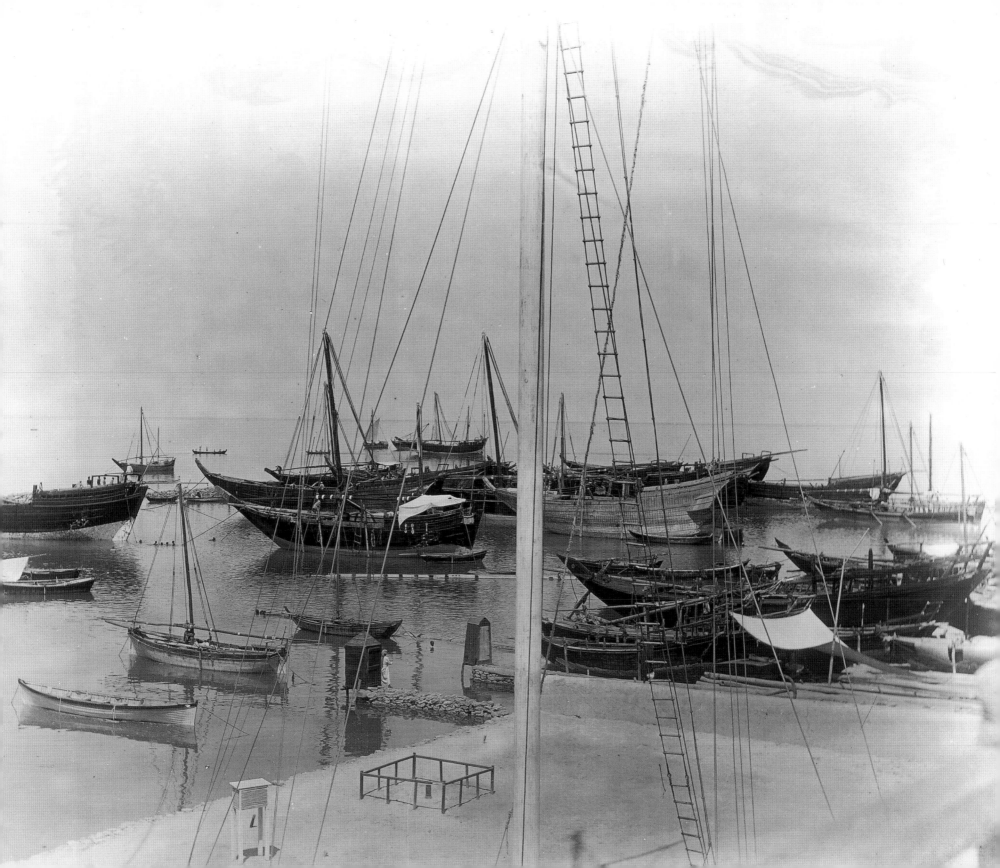

Barclay Raunkiaer, 1912

Barclay Raunkiaer in 1912, during his Arabian journey.
Raunkiaer 1912

Born in 1888, the only child of the distinguished Danish botanist Professor Christen Raunkiaer, the young Barclay assisted his father on various research projects, including an expedition to Tunisia in 1909, and quickly developed his own interest in economic geography and agronomy.

At this time the Royal Geographical Society of Denmark was beginning to consider the possibility of mounting an expedition to unexplored central southern Arabia, as a conscious if belated successor to the historic ordeal of Niebuhr and his companions in the 18th century. Raunkiaer was asked to undertake a preliminary reconnaissance of the little-known east coast of Arabia to select a possible base for the planned expedition. Permission was obtained from the Ottoman authorities to travel in al-Hasa, and Raunkiaer left Denmark in November 1911, travelling to the Gulf via Istanbul, Mersin, Damascus, Fallujah and Baghdad. He carried a modest amount of scientific equipment, later noting:

In view of the extreme fanaticism and dislike of foreigners existing in eastern Arabia, equipment with instruments was as simple as could be. The Royal Danish Geographical Society supplied instruments for mapping my route. The University Botanical Gardens provided what was needed for collecting plants and the Carlsberg Fund voted me money for photographic equipment of an excellent kind.

This outfit was modest for such a journey but nonetheless was to prove too large. After some few attempts, the collecting of plants had to be abandoned altogether, readings of thermometer and barometer
became gradually impossible, and photographic apparatus could be used only at great risk in odd, unwatched moments.

On 22 January 1912 he reached Basra. Here he was well received not only by the Ottoman authorities but also by the Russian consul, the American medical missionaries, and the German business house R. Wönckhaus and Company. But his plans to continue via Bahrain to eastern Arabia had to be changed because of unsettled political conditions in al-Hasa, and he decided instead to go on to Kuwait. There he hoped that his letter of recommendation from the Turks would persuade Shaikh Mubarak to let him travel on southwards.

He reached Kuwait by way of the caravan route through Zubair. What Kuwait was to the trade of the Gulf, Zubair was to the trade of the desert: an Arabian town, more Najdi than Iraqi, nominally within but for practical purposes outside the Ottoman sphere of influence, allowing the overland caravan trade from central Arabia to be carried on largely free of tiresome Turkish regulations such as customs dues. Once beyond Zubair he passed Safwan, a small military post with ten Turkish soldiers, "the last point under regular Turkish administration until Hasa is reached". Then he passed through Jahrah, where he remarked on the small amount of cultivation, and reached Kuwait town.

Raunkiaer's lengthy description of Kuwait town, local conditions and his meetings with Shaikh Mubarak form the most perceptive and vivid part of his whole book, and is unsurpassed by any other pre-War

report. It is disappointing that the few photographs he took at this time have deteriorated to the point of being unusable; the ones shown here are taken from the original Danish edition of his travelogue, *Gennem Wahhabiternes Land paa Kamelryg*, published in Copenhagen in 1913. He stayed in Kuwait for more than three weeks, but fell ill towards the end. He was treated by the American medical missionary Dr Paul Harrison, but the tuberculosis which was to bring his untimely death just over two years later went undiagnosed. During his journey to Buraidah, Zilfi, Riyadh and al-Hasa his condition worsened, and his narrative after Kuwait inevitably suffers.

His Turkish letter of introduction to Mubarak, who as we have seen had long since placed Kuwait's security under British protection, so far from reassuring the wily old ruler, caused him instead to be treated with suspicion and reserve. It was only through the good offices of Capt. Shakespear, who respected Raunkiaer

as a genuine explorer, that Mubarak's fears were allayed and the atmosphere lightened. Shakespear, having assisted a traveller whose connections with Germans and Turks made him automatically suspect to British officials, was subsequently hauled over the coals by Percy Cox, the Political Resident. The reprimand was understandable, though in Shakespear's defence there is no incontrovertible evidence that Raunkiaer, an avowed anglophile, acted for German or Turkish intelligence.

Indeed, Raunkiaer was quite content to remark upon British ascendancy when he had occasion to do so. In a revealing passage on Kuwait one even detects a gentle ridicule of Ottoman pretensions:

England, whose representative bears the title "Political Agent" is the only state which has an envoy in Kuweit. Of Turkey there is no visible sign. Kuweit being officially Ottoman territory, the Turks cannot very well put a consul there, but more than that, one finds no other Turkish functionary in Kuweit. Turkish pretension is only supported by Mobarek bearing the title Kaimakam *of Kuweit, and by the fact that the Government flag on the staff at the* serai *is red, with white crescent and star.*

Raunkiaer was impressed by the volume of trade at Kuwait, both by overland caravan and by sea. The number of sailing vessels he put at some five hundred. The Arab character of the port was tempered only by a few Persian merchants from Bushire, distinctive in their blue coats, white trousers and tall felt hats. Because it served not just as a terminus for trade from the Gulf and Indian Ocean, but also from the huge hinterland of central Arabia, he concluded that "beyond question Kuweit is the most important trading town on the east coast of Arabia, Muscat not excepted".

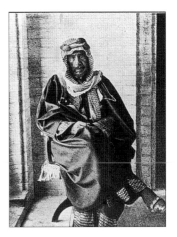

Top Shaikh Mubarak Al-Sabah poses for his portrait by Raunkiaer, 1912.

Above The bridge between two of the buildings of Shaikh Mubarak's Seif Palace on Kuwait's waterfront. *Raunkiaer 1912*

Left Inside the Seif Palace. *Raunkiaer 1912*

Lord Hardinge, 1915

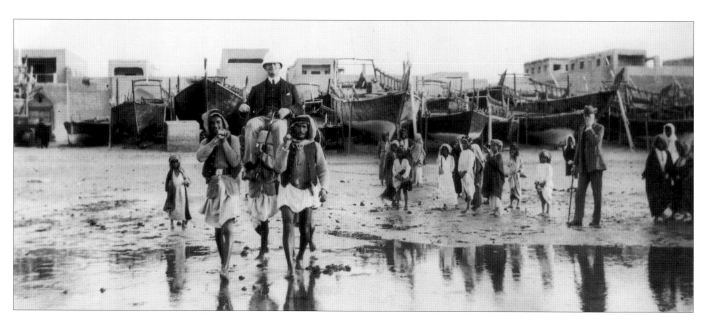

A member of Lord Hardinge's entourage, referred to only as P.S.V., availing himself of the dry embarkation service customarily offered to foreign visitors. The figure on the right with the hat and walking-stick is possibly Percy Cox, at that time Chief Political Officer of Indian Expeditionary Force "D" which was preparing to fight the Turks in Iraq.
Lord Hardinge 1915

The outbreak of the First World War in 1914 brought with it the first real clarification of Kuwait's status in relation to Britain and Turkey. The Anglo–Ottoman Convention of 1913 had been an attempt to define British and Ottoman spheres of influence in Arabia. From it Mubarak had gained recognition of a wide sphere of influence over the tribes of north-east Arabia, but had been shocked to find that there was a heavy price to pay for clarified status: it was to be formally recognised that Kuwait constituted part of the Basra *vilayet*, albeit an independent part, and that the Ottomans would be entitled to appoint an agent to Kuwait to look after their affairs. It was left to Percy Cox to pacify the irate ruler. Fortunately, the Convention was never ratified: the outbreak of war saved face on both sides. The British, predicting that Turkey would enter the war on the German side,

prepared to invade Mesopotamia by sea, and Mubarak placed "his efforts, his men and his ships at Great Britain's disposal". In return for Mubarak's support of the war effort, the British Government finally and unequivocally recognised Kuwait as an independent government under British protection.

Recognition of Mubarak's support soon followed. One of the few foreigners to leave photographs of Kuwait during the First World War was Lord Hardinge of Penshurst, the Viceroy of India from 1909 to 1916. He arrived aboard HMS *Northbrook* on 31 January, and was received by HMS *Dalhousie*, BIS *Kasara* and the Shaikh's yacht. On shore the flagstaffs of the British Political Agency and the Shaikh's palace were dressed with as many flags as they could carry, and the town itself had been specially decorated with

triumphal arches. Once arrived, Lord Hardinge received an official visit of welcome from Shaikh Jabir and Shakespear's successor as Political Agent, Lt-Col Grey, following which he took a short walk out to the eastern end of the town.

The next day saw the first official ceremony when, at 11a.m., Shaikh Mubarak and Shaikh Abdullah of Bahrain boarded the *Northbrook* to receive their respective honours from the Viceroy – a token of appreciation from the King Emperor of their co-operation. That afternoon the Shaikh received Lord Hardinge at the palace, attended by a guard of honour of Royal Marines. The Viceroy was then treated to a sight-seeing tour of the *suq*, returning by way of the Political Agency. His visit ended the next morning with a drive along the bay to inspect the Shaikh's coaling station and the new American missionary hospital. The photographs shown here are from a personal album belonging to Lord Hardinge and were most probably taken by him.

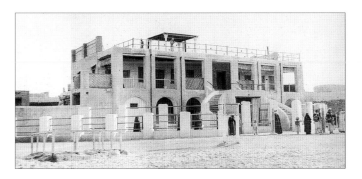

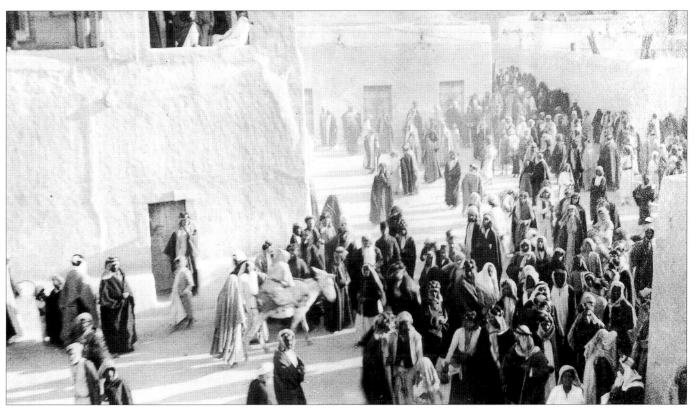

Top The British Political Agency at Kuwait, now occupied by Lt-Col Grey, at the end of January 1915. Grey's predecessor Capt. Shakespear, newly appointed as Political Officer on Special Duty, had been killed just a week before at the Battle of Jarrab in Najd, where he had joined 'Abd al-'Aziz Ibn Saud and his forces confronting Ibn Rashid of Ha'il.
Lord Hardinge 1915

Left Kuwaitis throng the streets outside Shaikh Mubarak's palace.
Lord Hardinge 1915

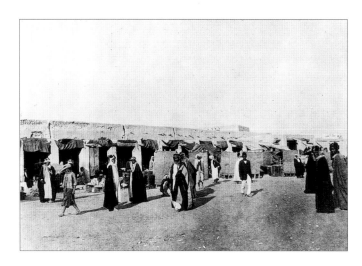

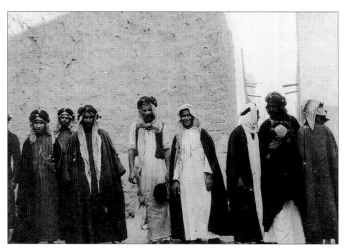

Top left The *suq*, Kuwait, with its permanent shops and temporary booths.
Lord Hardinge 1915

Top right These Kuwaitis seem to have no qualms about being photographed.
Lord Hardinge 1915

Right Kuwaitis pose in a group outside the Political Agency.
Lord Hardinge 1915

Opposite The strong white donkeys typical of the ports and oases of eastern Arabia provided most of the transport in Kuwait town, and were particularly useful along the waterfront loading and unloading dhows and harbour craft.
Lord Hardinge 1915

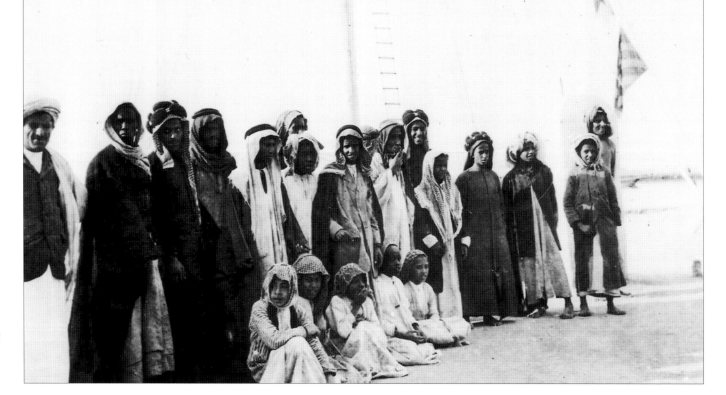

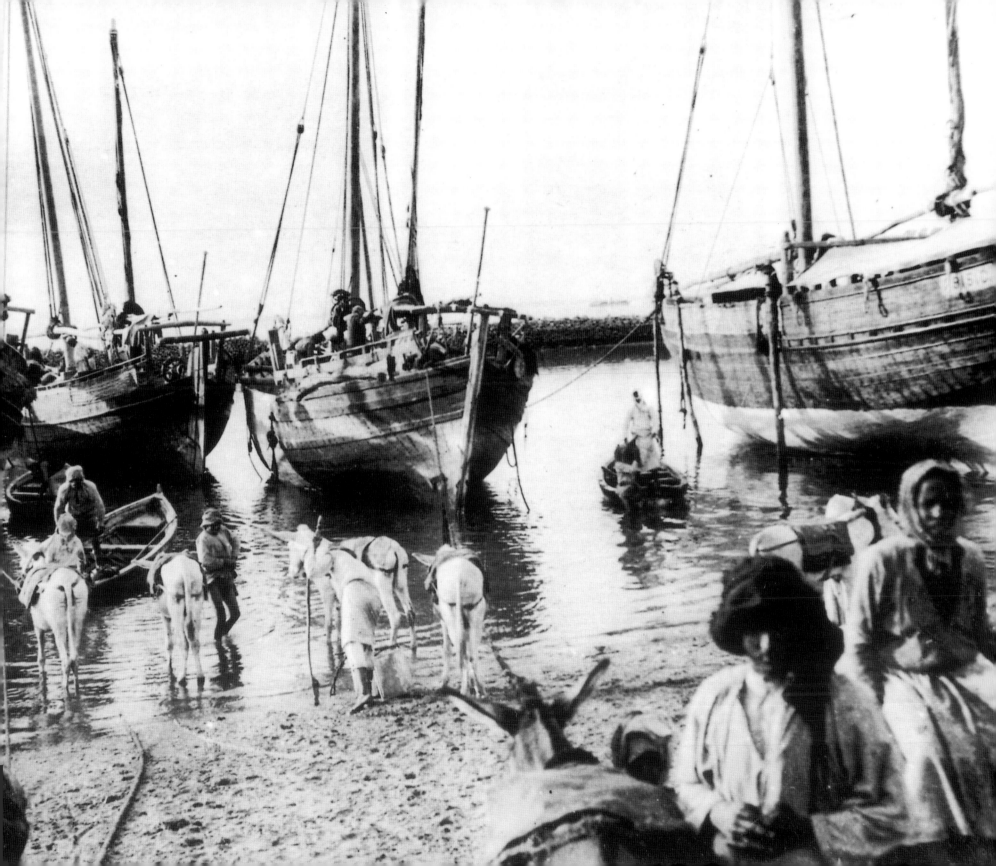

The Arabian Mission, 1910–1920s

Dr Paul W. Harrison with patients at the dispensary, Kuwait 1913. Harrison later wrote a number of books about Arabia, among them the excellent *The Arab at Home*.

One group which made constant and effective use of photography was the Christian missionaries, who travelled and settled throughout the world, and often acted as hosts and guides to other travellers and to scientific expeditions. Missionaries had always used visual media to document their surroundings, and were prolific producers of books, lectures and reports, many of which were specifically designed to raise funds from the congregations at home. They often became good linguists, and some developed an interest in ethnology, using these skills to write about and illustrate the customs of the people among whom they lived and worked.

Kuwait, and indeed most of the Arabian Peninsula, had at first remained virtually untouched by missionary effort, but during the early 1890s a few pioneers of the Arabian Mission of the Dutch Reformed Church in America began to turn their attention to this hitherto "neglected" region.

The Mission had been founded in New Brunswick in 1889 by James Cantine and Samuel Zwemer. It had been hoped originally that the new missionaries could work in co-operation with the Keith Falconer Mission which was already established in Aden, but a brief visit in 1891 convinced the two founders that the location was too hemmed in by military and political restrictions to suit their ambitious plans. They decided to look further afield, and journeyed along the southern coast to Muscat, then north along the eastern shore of the Gulf, making short journeys into the interior along the way. Basra was chosen as the site of their first medical mission station, and by 1893 two more stations had been established at Bahrain and Muscat, from which the missionaries made extensive tours looking for new opportunities.

In 1902 Samuel Zwemer visited Kuwait. He was very impressed by the thriving town and, like others before him, was quick to recognise its strategic importance. At the annual meeting of the Mission in the winter of 1903 it was agreed that Kuwait should become an outstation of Bahrain. Zwemer quickly established a salesman there, to work from a rented shop in the market, but after less than a year Shaikh Mubarak sent the man away, and for a while the Mission's prospects in Kuwait looked bleak. Late in 1909, however, Arthur Bennett, a doctor with the Basra Mission, was asked to attend Shaikh Khaz'al in Muhammarah, and while there was introduced to Shaikh Mubarak. The latter, much impressed with Bennett's surgical skills, invited him back to Kuwait to discuss the possibility of starting a dispensary there. The visit was made by Dr Bennett and Dr Van Ess in January 1910, and resulted in the missionaries receiving permission to open medical work and acquiring the lease on a house.

Dr Bennett returned with the Revd Gerrit Pennings in the following spring and, after a few months, was holding regular morning clinics and performing some operations. It was during this period that the first photograph taken by a Kuwait missionary appeared in the Arabian Mission's own quarterly *Neglected Arabia*, in an article by Pennings entitled "Work at Kuwait Re-opened" (*NA* 74 July–Sept 1910). It shows two junior members of the Al Sa'ud at the Shaikh's palace, and was probably taken by Pennings himself, since he describes meeting various members of the family in his article, which emphasises Kuwait's close connections with Najd, and its ideal situation for establishing contact with its people.

Throughout their work in the Gulf, the missionaries' purpose was to use medicine and education to open the door to men's hearts so that the Christian message might enter. They sincerely believed that charity would pave the way for conversion of Muslims to Christianity. While there is no doubting that their genuine philanthropy made a great difference to very many lives, all the evidence is that the people of both town and tribe gratefully accepted the practical treatment while dispensing with the spiritual message. The missionaries never gave up; hospitals were founded, a school was established in Kuwait, and visits to the interior from Bahrain, even to the towns of Najd, in due course were to become a reality. Their articles breathe an innocent optimism about the prospects of conversion, but real missionary success eluded them. Most detached observers would have agreed with Raunkiaer who, in 1912, wryly observed:

Passing on from the charcoal market through the main street is found on the right hand the American Mission Bible shop. On one end of a counter, covered with Arabic editions of Christian works, sits day in day out

a man who must be endowed with an immense even nearly super-human patience. All day the murmurous stream of humanity glides past him, trafficking, chattering, cheating, and but seldom does it chance that any Arab crosses the Mission threshold, and when it does happen, the last state is almost worse than the first. For religious discussion between a Christian missionary and a fanatic Wahhabi can hardly lead to any positive result whatever.
Raunkiaer *Through Wahhabiland on Camelback* p.49

As the missionaries settled themselves into their new surroundings photographs taken in Kuwait began to appear more regularly in *Neglected Arabia*, often accompanied by graphic descriptions of the town and its daily life before the new wall was constructed in 1920. In 1910 Dr Bennett wrote as follows:

The people of Kuwait are more friendly and polite than any I have met in other places of the Gulf. ... Not only are the people well behaved, but the town is kept the cleanest of any in the Gulf, and the houses built on a rising slope of sandy gravel are naturally drained, and one is not surprised to learn that here there is no malaria and other diseases are scarce as well.

The town is built on the only good harbor in the Persian Gulf, and extends from southeast to northwest about two miles along the water front. From the sea the

These two young boys of the Al Saud were photographed in 1910 in the palace of Shaikh Mubarak, probably by Revd Pennings. They are almost certainly the same two boys who appear in Shakespear's group picture of Shaikh Mubarak with 'Abd al-'Aziz Ibn Saud and members of the Al Saud in March 1910, shown on p.15.

Above left The bedouin market, Kuwait, photographed probably by Revd Pennings in 1910.

buildings extend backward in two wings for over half a mile on each side. In the center the town is not as wide because the desert extends into it and forms a market place for the Arabs. Here is where the great mass of people congregate during the day. It is the hub of the town, and from here the bazar extends down several streets leading down to the water front, while on the other side scores of Bedouin tents are pitched indiscriminately out into the desert.

Coming here in the morning we found several thousand Arabs bartering their wares in the market place. Some had brought camel loads of desert greens for sale, which seemed to be mostly docks and dandelions, others had large bundles of dried brushwood, while some of the Bedouins sold sour milk or wild desert vegetables. These latter, called chimah *or* fuggali, *are rather tasty and have much the appearance of potatoes. Here and there was a flock of black goats and sheep, and in another place fresh sea fish had been brought in to tempt the greedy Bedouin.*

Over the three years until 1913 the Mission slowly consolidated. Revd Pennings and Dr Bennett stayed on for a while to oversee medical and evangelical work, and plans were made to erect a new hospital on the highest piece of land on the seafront. In 1912, Kuwait became a full station of the Mission. Revd

Edwin Calverley and Dr Paul Harrison were assigned there full-time, to be joined later by Dr Stanley Mylrea. Revd Calverley's wife Eleanor later wrote eloquently of this time in her excellent memoir *My Arabian Days and Nights – A Medical Missionary in Old Kuwait.*

Negotiations with Shaikh Mubarak concerning a plot of land for the new hospital and physicians' residence continued, and were finally brought to a conclusion towards the end of 1913. The hospital was opened in November 1915, and in the following January was inspected by Shaikh Mubarak, who is reported to have made the ironic comment that "the making of wounds was more in his line than the healing of them".

The January–March 1915 issue of *Neglected Arabia* was devoted entirely to Kuwait. In it Revd Pennings gave a succinct account of Kuwait's trading activities:

The prosperity of Kuweit is due in part to trade with the interior, which absorbs enormous quantities of rice, tea, coffee and sugar. Practically all of Nejd is clothed in Massachusetts Sheeting, of which hundreds of bales are imported at Kuweit every year. Another activity is the transport of dates from the Busrah district to Indian, South and West Arabian and East African ports. A fleet of perhaps thirty sailing boats, of about three hundred tons burden each, leaves Kuweit each year in October, and the following August returns with firewood, ship- and house-building lumber. The third and main source of wealth is the pearl fisheries, in which thousands of the people engage every year. The ready cash realised from this last source forms the capital without which little business could be done. And yet, but for the firm, and on the whole just, government which the city has enjoyed the last few years, the present prosperity would be impossible, and the capital would have been transferred elsewhere.

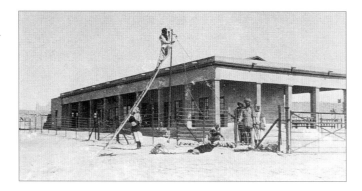

The Mission hospital, Kuwait, was opened in 1915 which is probably when this picture of it was taken.

In the same issue, Dr Mylrea described being called out to treat 'Abd al-'Aziz Ibn Sa'ud and some of his men, at that time encamped at Jahrah. Ibn Sa'ud was quickly persuaded of the value of modern medicine, and toyed with the idea of inviting Mylrea to Riyadh, saying sternly "You are welcome, but on one condition, that you leave my people alone in matters religious". He prefaced his further remarks on Islam in Najd with the categorical words "Ours is the true religion". American medical missionaries eventually did reach Riyadh (Dr Harrison was the first, in 1917, travelling from Bahrain): their medical work was much appreciated, but naturally a close watch was kept for any attempts to proselytise.

The missionaries were virtually the only non-official foreigners to remain in Kuwait during the First World War, when the Shaikhdom was often out of communication with the other major ports of the Gulf. Despite the difficulties involved, their work continued apace: in 1916 construction work began on a second Mission residence, and a women's hospital was completed in 1919. During the 1920s doctors began to make weekly tours outside the town, and there were also moves made towards establishing a mission school in the town itself.

There is no doubt that the records left by these pioneering men and women comprise an extremely valuable source for the history of Kuwait. The early photographs mostly show the missionaries

Left The second missionary residence in Kuwait, shown here, was completed in March 1917 and occupied by the Calverleys. *Heims 1924*

Below left Dr Mylrea, who was English by birth and known to the local people as "Myrilee", is shown here with bedouin patients outside the Mission residence, c.1920.

Below Mrs Mylrea and Dr Eleanor T. Calverley conduct a gospel service at the dispensary, c.1920.

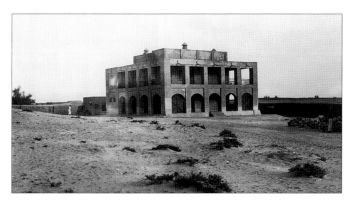

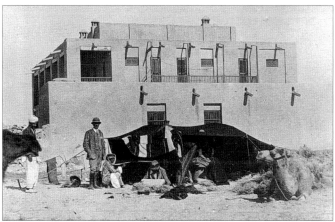

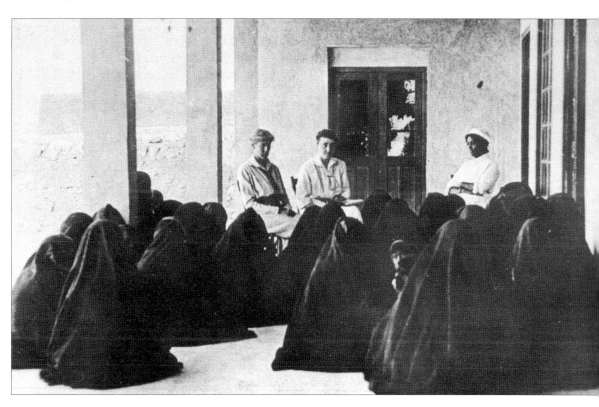

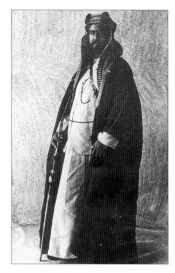

Above Shaikh Ahmad Al-Sabah, Ruler of Kuwait 1921–50, in the early 1920s. This picture was taken by one of the missionaries, and appeared in Harrison's *The Arab at Home,* published in 1924.

Right An extremely rare view of the inside of one of Kuwait's mosques, c.1926.

Far right Warriors of the Ikhwan in Kuwait, early 1920s. They are wearing the characteristic Ikhwan attire of short *thawb* and cotton headband wound around the headcloth. Kuwait was a vital trading port for the interior, and the Ikhwan of Najd and eastern Arabia came to buy necessities there like any other tribesmen. This photograph appeared in Harrison's *The Arab at Home,* published in 1924.

themselves, either at work, or formally portrayed in Arab dress. But there are also a few pictures of Kuwait's streets, market and waterfront. Sadly, the photographers themselves are rarely identified, although the differing formats and relatively poor quality of the images suggest they must have been taken with several different cameras of the more popular and inexpensive type likely to have been favoured by the missionaries themselves. Samuel Zwemer, Gerrit Pennings and Edwin Calverley are all known to have used cameras, but until the original photographic collections held among the archives of the Reformed Church in America are properly identified and catalogued, little more can be said at this stage.

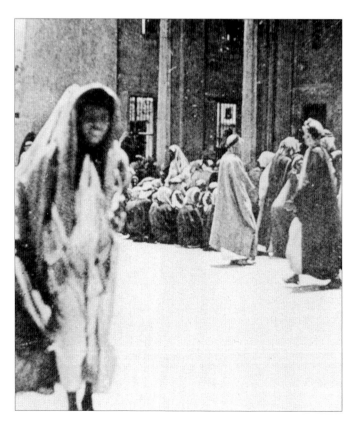

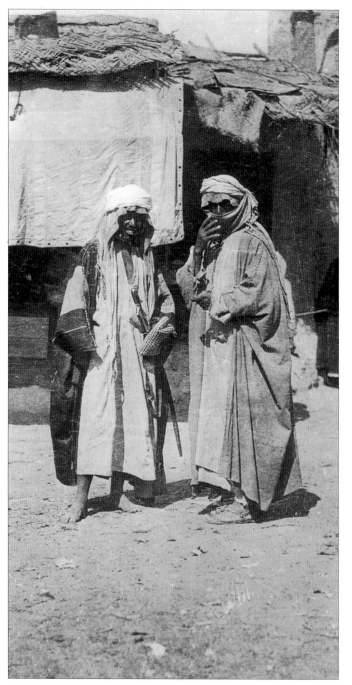

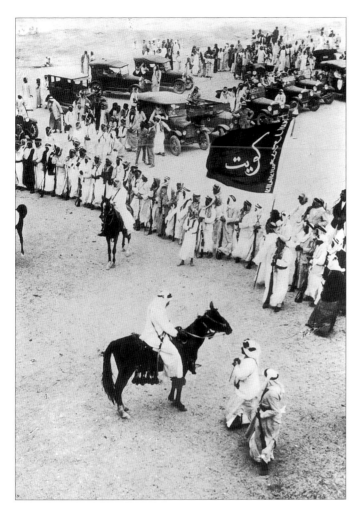

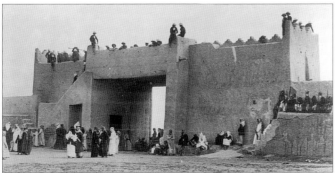

Far left This picture is entitled "Race meeting, Kuwait, 1920s", but looks more like a military review or even a mobilisation. It may therefore be dated to 1928, the year of the *Emerald* incident. The picture was taken by Dr Van Ess, who first visited Kuwait in 1910 and later lived there from 1919 until 1950.
Van Ess

Below left "The city gate, Kuwait, Mobilisation Day 1928" – this is almost certainly February–March 1928, when British troops manned the city wall of Kuwait against an expected assault by the Ikhwan.
Van Ess 1928

Left Shaikh Ahmad bin Jabir Al-Sabah looks proud of his son, Jabir, then just three years old – as well he might, for today the boy is Kuwait's Ruler, HH Shaikh Jabir Al-Ahmad Al-Sabah.
Van Ess 1929

Arnold Heims, 1924

Above Arnold Heims, photographed in June 1924, probably on Bahrain.
Heims 1924

Right Heims travelled in the old-fashioned way, his camel (shown here) complete with wooden saddle tree, woven harness and tasseled bags, and sheepskin cover.
Heims 1924

Opposite Kuwaiti pearling boats in April, in readiness for the start of the pearling season in mid-May.
Heims 1924

Arnold Heims studied geology at Eidgenössische Technische Hochschule (ETH) and the University of Zurich, completing his studies in 1905. After further study in Berlin, Paris and Edinburgh, he undertook expeditions to North Africa and Greenland, returning to Zurich in 1908 to take up the post of Professor of Geology at ETH and the University. Two years later, at the age of 28, he decided to leave the academic world for a career as an oil geologist, and began to travel again in Europe, East Asia and Mexico. At first his future in this field looked gloomy – North American oil was flooding the world market, demand for oil was not strong, and what little exploration work there was had to be won against strong British, Dutch and American competition.

As a result, Heims decided to go back to teaching, and announced a series of lectures on petroleum geology for the summer of 1924. In February of that year, however, the London-based Eastern and General Syndicate asked him to undertake an exploratory expedition in eastern Arabia. The Syndicate was less an exploration company than a speculative dealer in oil concessions, options in which it hoped to sell on to oil companies once prospects had been defined. Heims agreed, and on 2 April 1924 set off on a five-month contract.

Having crossed the Syrian desert from Haifa to Baghdad in the company of the Revd S.M. Zwemer, in a convoy of cars organised by the new Nairn Transport Company, he went to Basra to meet up with Major Frank Holmes, the entrepreneurial mining engineer who had been working with Eastern and General in the Gulf since 1920. Holmes had already successfully negotiated the Syndicate's first concession with 'Abd al-'Aziz Ibn Saud; this was the so-called Hasa concession, finalised in May 1923, which included all oil and mineral deposits in an area of around 100,000 square kilometres along the eastern Arabian coast. Negotiations for further concessions had continued, and while Heims' expedition was in progress 'Abd al-'Aziz Ibn Saud and Shaikh Ahmad awarded the Syndicate an option in the area proposed as a neutral zone between their territories at the 'Uqair Conference in 1922. In addition a good deal of progress had been made towards a concession agreement dealing specifically with the Shaikhdom of Kuwait.

Heims was conveyed in Major Holmes' motor boat from Basra to Kuwait, which was to be the starting-point of his expedition. Following an audience with Shaikh Ahmad bin Jabir, he had his first meeting with his new travelling companions: twenty-five men of Ibn Saud's guard and almost as many slaves, who

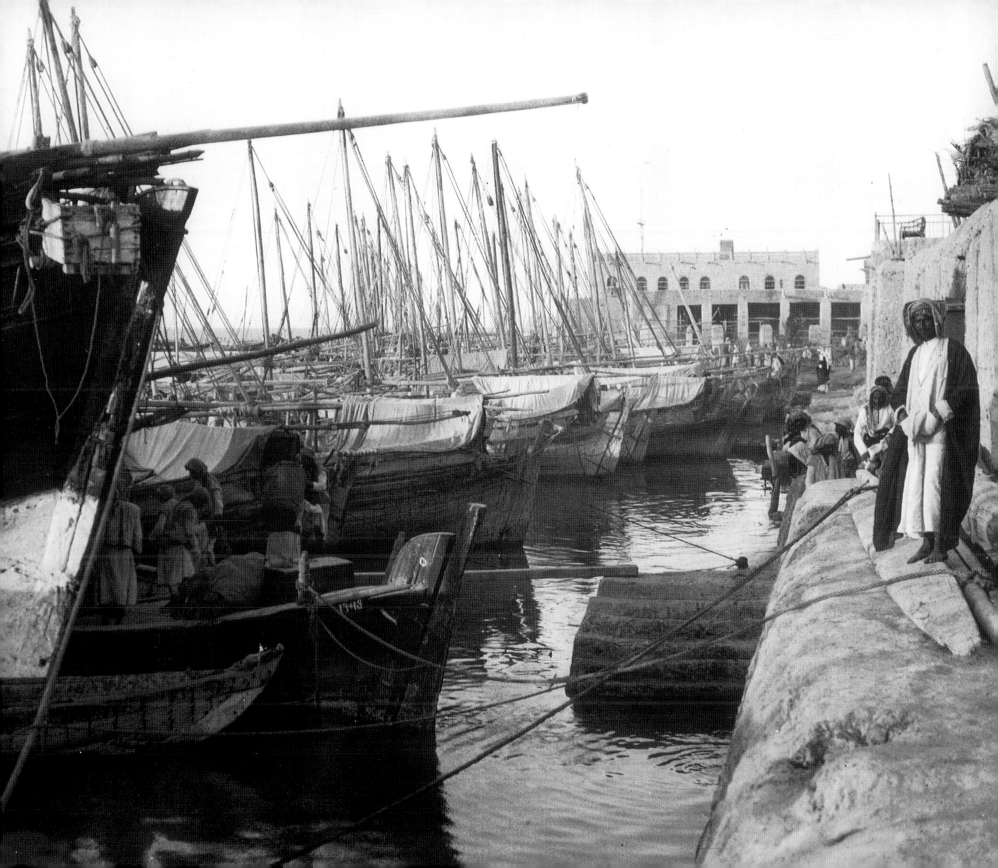

presented themselves in formation, rifles at the ready. Afterwards they assembled in a carpeted tent, where Heims accepted the usual hospitality and awaited the arrival of their caravan, which was made up of thirty bedouin engaged by Holmes and sixty-eight camels specially purchased in al-Hofuf. To complete the team, there was Heims' assistant, the British mining engineer John L. Popham, who had travelled ahead to buy equipment and to find an interpreter and servants.

The expedition travelled due south from Kuwait attempting to cover every mound and every place where oil seepages had been reported. They traversed Burgan on 29 April, and reached the Ikhwan

Right Heims' companions included twenty-five men of Ibn Saud's guard, eight of whom are shown here, to escort him through al-Hasa (the Eastern Province of Saudi Arabia).
Heims 1924

Far right, top Heims' very considerable entourage is seen here packing up camp between Burqan and 'Ain al-'Abd at the start of May.
Heims 1924

Far right, centre Bedouin children pose for the camera near Kuwait town, 28 April 1924.
Heims 1924

Far right, below Kuwaiti bedouin carrying *arfaj* brushwood to market. In 1918 the medical missionary Dr Stanley Mylrea wrote in *Neglected Arabia* that "this desert brushwood is a wonderful provision of nature; it is to be found growing almost everywhere in Arabia and furnishes pasture for the camels and firewood for man. In Kuwait it is the most popular form of firewood."
Heims 1924

settlement of the Mutair tribe at al-Naqirah on 5 May. By 10 May they were at Murair, well within Saudi territory. The distance covered each day was between 25 and 50 kilometres, daytime temperatures could reach 45 °C and there were frequent winds which, to Heims' vexation, filled his camera with sand – which explains the patchy quality of some of his otherwise superb photographs. Several times a day Heims would take rock probes to ascertain information about the geological layers, and all the data

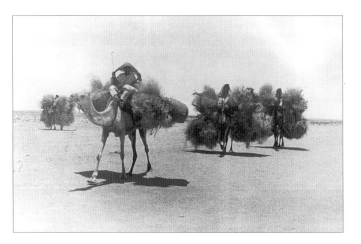

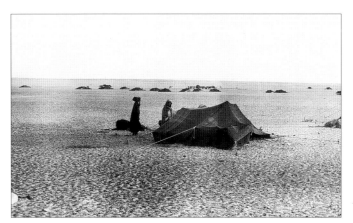

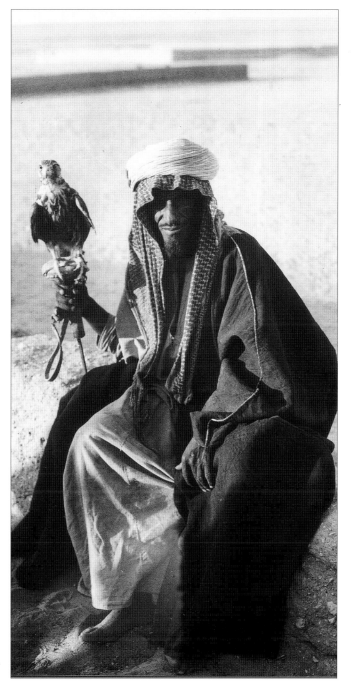

Far left, top Heims and his men reached al-Naqirah on 5 May, at that time (with neighbouring Nuqair) a settlement of the Ikhwan of the Mutair tribe. Until 1922 al-Naqirah had been within Kuwait's recognised sphere of influence.
Heims 1924

Left The shaikh of al-Naqirah, who wears the characteristic headband of the Ikhwan, clearly has no problem about sitting for his portrait. His falcon shows more suspicion.
Heims 1924

Far left, centre Women and children of al-Naqirah prepare food.
Heims 1924

Far left, below A good example of a bedouin encampment, al-Naqirah.
Heims 1924

Top The palace built by Shaikh Khaz'al of Muhammarah, Shaikh Mubarak's good friend, for his visits to Kuwait was one of the most distinctive buildings in the town. It continued to be lived in after Shaikh Khaz'al's death by a young widow, whom Freya Stark went to see in 1937.
Heims 1924

Centre Shaikh Ahmad bin Jabir's inland residence, the Dasman Palace – isolated from the town but still within the main wall at its eastern end.
Heims 1924

Below The oil seepage at Bahrah, north of Jahrah, which Heims investigated at the end of June, looks promising, but it seemed to him not to hold out hope of commercial production. Bahrah was also to dis-appoint expectations in 1936 when a rig was erected here. It is now of course at the centre of the large and productive Bahrah oil field.
Heims 1924

Opposite Bedouin men at ease in al-Safat, the huge open space within Kuwait's walls where tribespeople could meet in peace and protection to trade and exchange the news.
Heims 1924

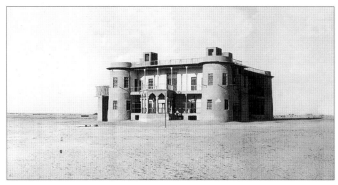

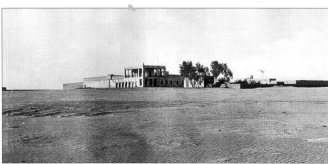

collected was painstakingly written up in a series of geological field books. After fourteen days of thorough searching, however, he was unable to find any evidence of oil deposits.

On 11 May the expedition saw the first notable settlement since Kuwait appearing on the horizon, the oasis and fishing settlement of al-Jubail. Their onward journey from there took them to Bahrain, Tarut, al-Qatif, Dammam, al-'Uqair and al-Hofuf in Hasa Oasis, but in none of these places did Heims identify signs of oil deposits. In despair, he decided that there was no point in travelling on south of al-Hofuf, and returned to Bahrain alone to pursue a survey of water sources, leaving Popham and the caravan to make their way back to Kuwait overland by a different route, prospecting for oil along the way. In the event, Heims' stay in Bahrain and, indeed, the whole expedition, was brought to an end when Popham and the caravan arrived there only two days later having been overcome by illness.

They returned to Kuwait by steamer. Heims explored and photographed around the town while awaiting Shaikh Ahmad's return, for he now planned to prospect for oil to the north of Kuwait Bay. Having received the Shaikh's consent, he set out at the end of June. His only guide and travelling companion was a local man who had recently discovered an oil seepage at a place called al-Bahrah, and had been bringing in the small quantities he had collected to sell in Kuwait town.

After an arduous journey they arrived at the spot where oil was seeping out in threads at a rate of about one litre per day. Heims was forced to admit that the phenomenon was geologically incomprehensible to him, and after a small detour to Jahrah returned to Kuwait town to bid farewell to the Shaikh. Heims' failure led to the Eastern and General Syndicate deciding to try to sell its concessions in eastern Arabia on to other oil companies without delay. Today we judge Heims' expedition less by its oil prospecting results than by his contribution to Bahrain's water supply and, of course, by his legacy of superb photographs.

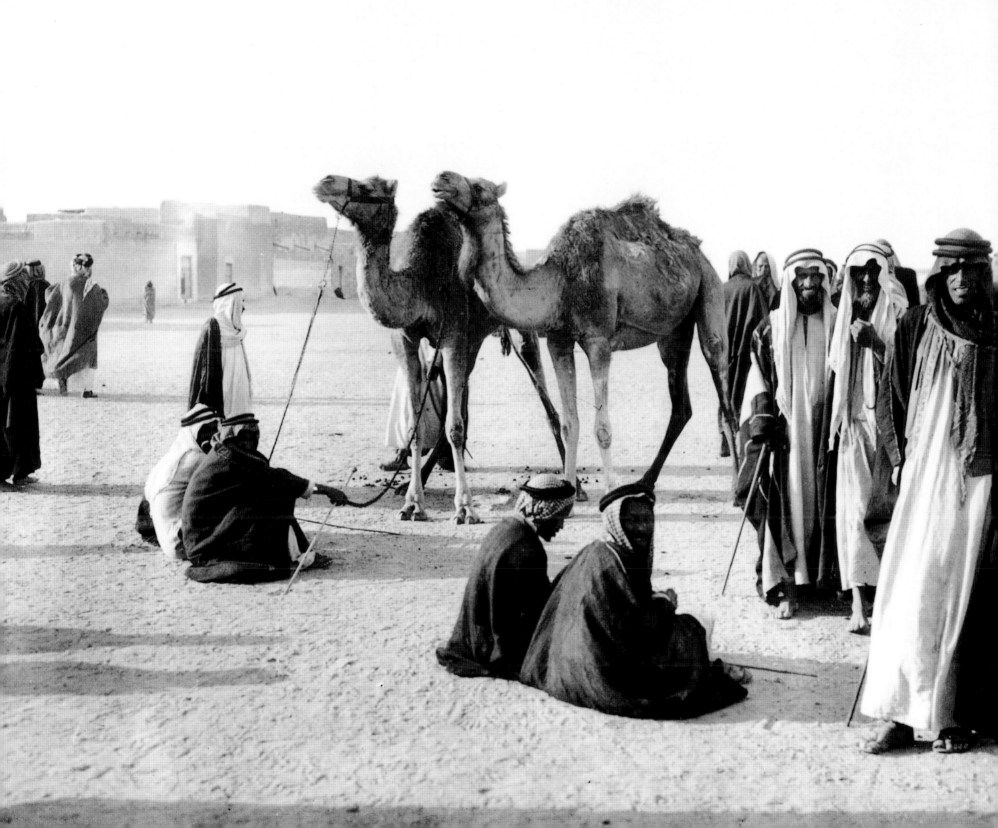

This page Buyers and sellers throng the streets of Kuwait's labyrinthine market.
Heims 1924

Opposite A fine cargo-carrying *baghlah* or *ghanjah* between two large cargo *boum*s, all propped for an overhaul. In June when this picture was taken these vessels would have been recently arrived home from their trading runs to India and East Africa. The small boat to the left is a *shu'ai* or *sambouk*, probably used for shorter trading runs within the Gulf.
Heims 1924

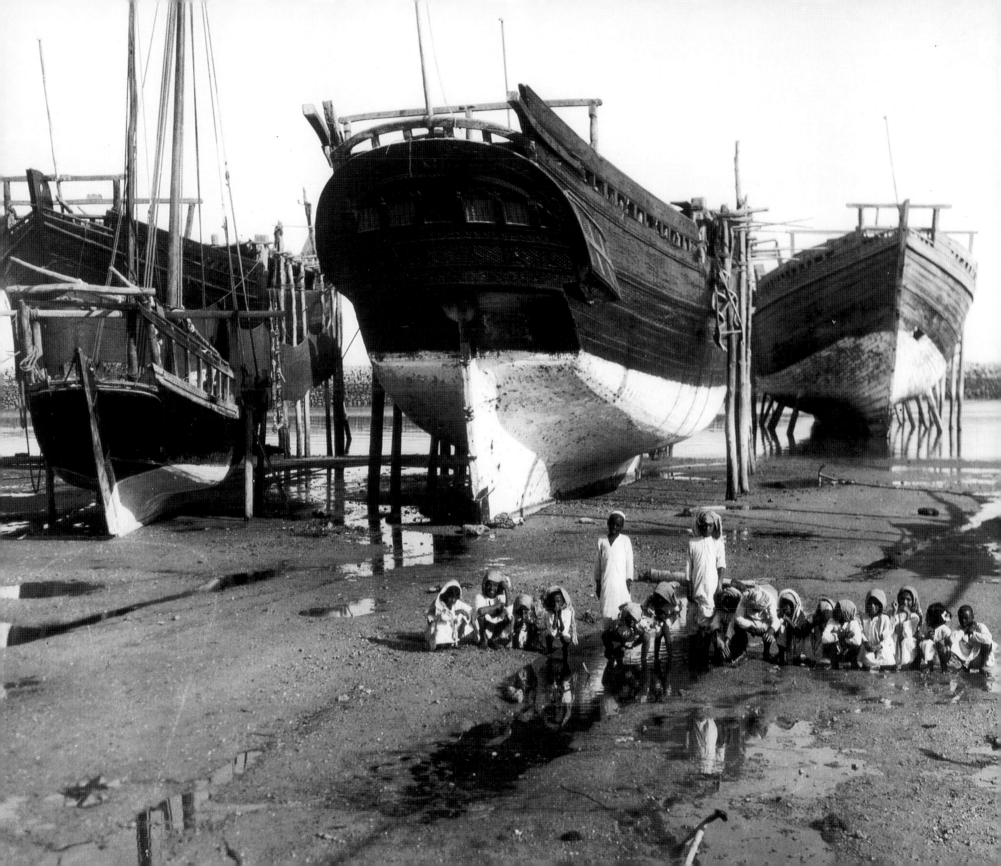

Defending an ally: the British, 1920–1929

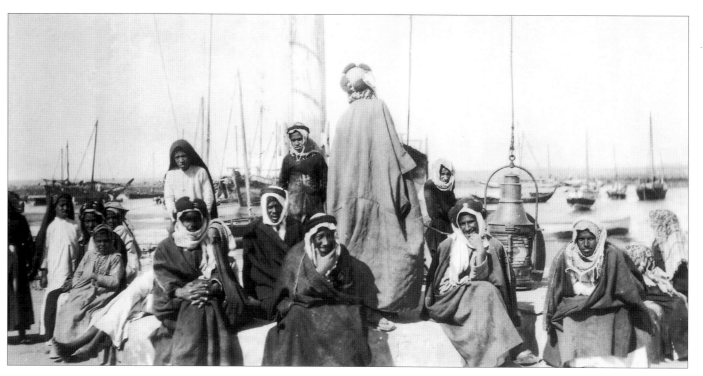

Right A group of Kuwaitis relaxing on the waterfront, February 1920. The flagpole and circular base suggest that they are outside the British Political Agency. This picture was taken by a member of the crew of HMS *Highflyer*, then on a brief call at Kuwait. *Highflyer* was presumably keeping an eye on a volatile situation for, later in this year, between May and October, Kuwait was threatened with invasion by the Ikhwan of Najd, leading to the building of Kuwait's wall, the celebrated stand-off at Jahrah, and the final withdrawal of the Ikhwan in the face of a display of force by British warships, planes and armoured cars.
Fellowes 1920

Opposite British troops join forces with Kuwaitis to defend the town in 1928, in this picture simply captioned "Allies".
HMS Emerald *1928*

HMS *Highflyer* pays a second visit

The 1920s were a turbulent time for Kuwait chiefly because of disturbances beyond its hinterland in what was still known as Najd, and which was yet to settle down, after 1932, as the heartland of the Kingdom of Saudi Arabia.

In 1920 the frontiers between Kuwait and Najd had not been formally settled and there was inevitably dispute over what was Kuwaiti territory. Shaikh Salim (r. 1917–21) naturally wished to retain as territory the wide sphere of influence assigned to his father Mubarak under the unratified Anglo–Ottoman Convention of 1913; not unnaturally the emergent power in Najd saw things somewhat differently.

In February 1920 HMS *Highflyer*, the ship which had brought Admiral Bethell to Kuwait in 1912, arrived for another visit. One of its officers, named Fellowes (later 3rd Baron Ailwyn), had a camera and a dozen of his rather poor pictures of Kuwait have survived. They show Kuwait in a fairly relaxed mood: the atmosphere does not yet seem to have been threatening, as officers went for a camel-borne picnic in the desert. Just three months later, things were to change dramatically as the dispute flared up in May and autumn 1920 when forces of the Ikhwan invaded Kuwait.

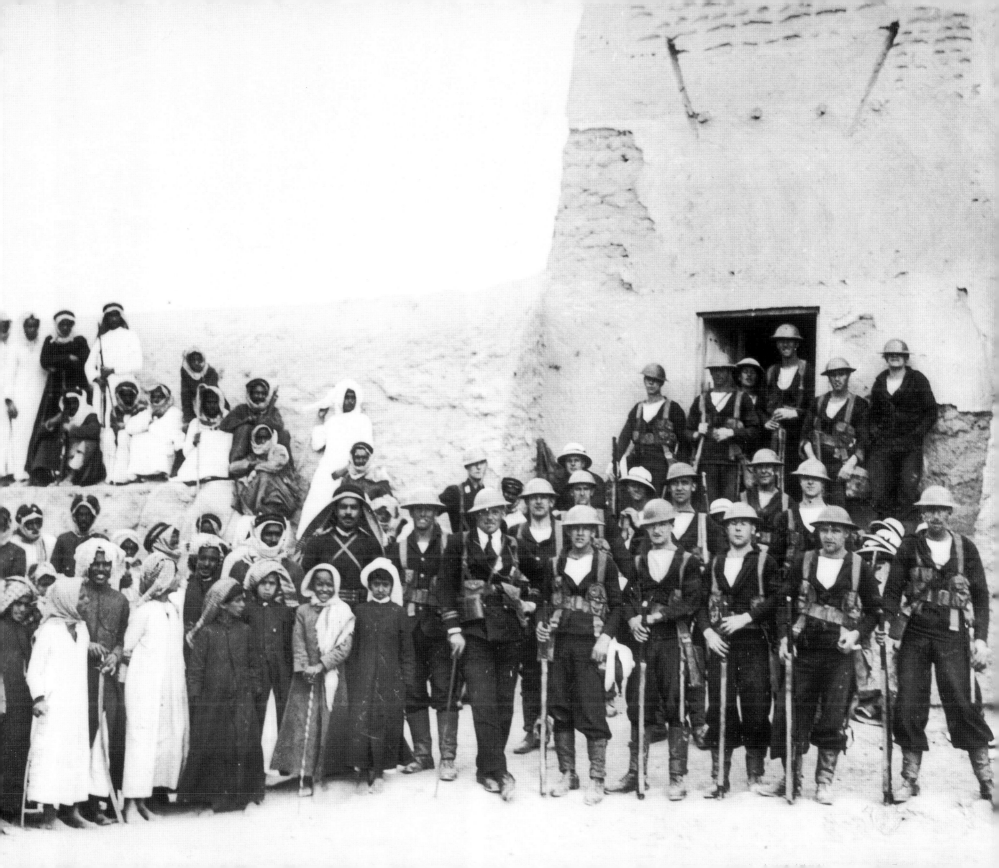

The *Emerald* Incident, 1928

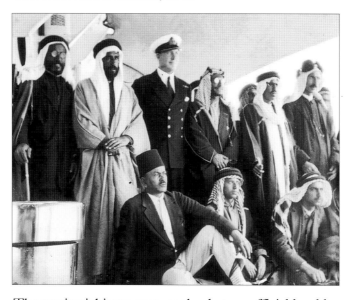

The captain entertains Kuwaiti shaikhs on board HMS *Emerald*.
HMS Emerald *1928*

The territorial issue was resolved at an official level by Sir Percy Cox at the 'Uqair Conference in 1922. Official agreements did not necessarily impress the Ikhwan, however, and later in the 1920s they threatened Kuwait once again. By 1927 some of the more fanatical Ikhwan tribal leaders had moved into open revolt against curbs imposed by King 'Abd al-'Aziz who, in the light of his recovery of the Hijaz and new frontiers to his domains negotiated with the British, was bent more on consolidation than expansion. Groups composed chiefly of Mutair, 'Ujman and 'Utaibah tribesmen attacked bedouin encamped in Kuwaiti territory and raided into Iraq and Transjordan. The threat to Iraq and Kuwait called for British intervention once more. Glubb, who as early as 1924 in Iraq had been engaged in repelling Ikhwan raids across the new frontier, again raised a force to patrol the Iraq and Kuwait border; with RAF backing and a fleet of armoured Fords he was to have considerable success. In January 1928 the Battle of Riqai was fought in the south-western corner of

Kuwaiti territory. Then, on 16 February 1928, amid fears of further Ikhwan raids, HMS *Emerald* arrived at Kuwait and landed a force of Royal Marines and other troops. This force was to stay in Kuwait until 4th April, when the *Emerald* was relieved by the *Enterprise*.

As the market buzzed with rumours of the Ikhwan leader Faisal Ibn Duwish's latest moves, the *Emerald*'s troops prepared to defend the town, and got down to rehearsals with enthusiasm:

The setting for the rehearsal was romantic in the extreme. The men were split up into sections for manning the towers and gateways. The intervening gaps would be filled by Arabs in the event of an attack. Standing on top of the Main Gate, armed and tin-hatted, gazing out across the desert one felt like a character from "Beau Geste". The Commander was in charge of the force, and, mounted on a fiery Arab steed, attended by two midshipmen also on horseback, added to the picturesqueness of the scene. … Hundreds of photos were sent home. These, accompanied by accounts of anxious vigils on the walls, waiting to be attacked by countless hordes of savage raiders from the desert, could not fail to make our people proud of us!
V.N. Surtees *HMS Emerald* pp.108–9

On 29 February a flight of aeroplanes and a squadron of armoured cars arrived and pitched camp just outside the east gate. The soldiers and sailors set up camp onshore within the wall, and two more ships, the *Crocus* and the *Lupin*, arrived with reinforcements, bringing the troop strength up to about two hundred men. Meanwhile the ships ensured that they had a good field of fire onshore at either end of the town wall. The Kuwaiti forces, of whom there were by now about two thousand in the town, put on war displays, and joint exercises were conducted. Despite

the impressive show of force, the British were short of ammunition: it was estimated that they had enough to keep up continuous fire for only five minutes. However, more ammunition and some machine-guns were borrowed from the RAF. Shaikh Ahmad was jovial and hospitable. He and the Political Agent, Major J.C. More, and the Senior Naval Officer were often to be seen inspecting arrangements. The sight of the sailors taking exercise inspired the Shaikh to follow their example in the evenings, when he would "sprint for about two hundred yards with his unfortunate companions panting in the rear".

However, the alarms came to nothing and March went by with no disturbances other than self-inflicted entertainments. These included a Naval Tattoo in fancy dress which the locals watched in silent bemusement. The Kuwaitis laid on wild martial displays and reviews which were much admired by the British. There were war dances and the firing of rifles into the air, with occasional casualties. The British soldiers enquired about one Kuwaiti wounded in this way, to be told that he was progressing very well, but that the man who had shot him was still very bad – which illustrates the state of the local firearms, only about forty per cent of which, it was estimated, were serviceable.

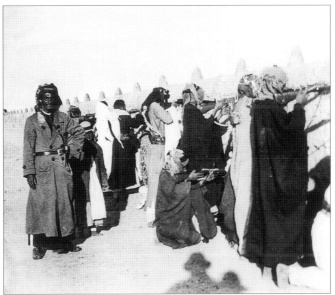

Above The Kuwaitis put on a frenzied war dance for the *Emerald*'s crew.
HMS Emerald *1928*

Left Kuwaitis man the walls in training for defence. The young man looking at the camera is referred to as "Abdullah". This may be the same young man mentioned by Surtees: "Sheik Abdalla … a young man of twenty-four and remarkably intelligent. He was widely read and it was difficult to believe from his knowledge and questions that he had never been to England."
HMS Emerald *1928*

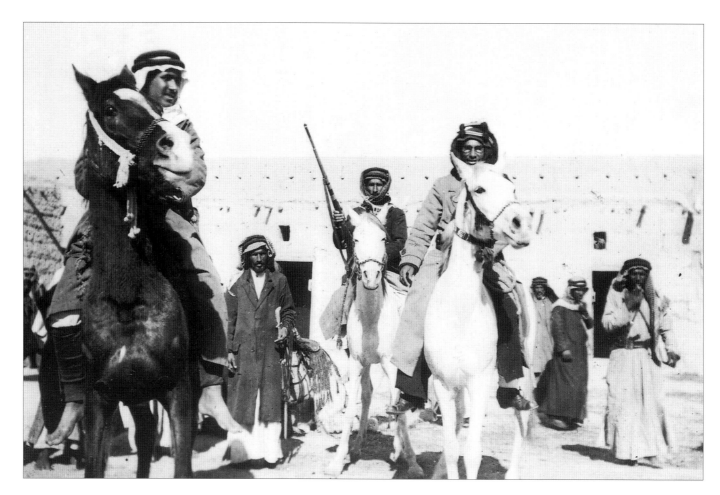

Right Young Shaikh
Abdullah and comrades
set out on their Najdi
Arab horses on a round
of inspection.
HMS Emerald *1928*

Below left The Red Fort
at Jahrah, commanded by
Shaikh Abdullah in 1928
and the scene of fierce
fighting in 1920.
HMS Emerald *1928*

Below right Kuwaitis
hurrying to battle stations.
HMS Emerald *1928*

Opposite Small boys turn
out in force to exhort their
fathers manning the wall.
Kuwait's wall, thrown up
hurriedly in 1920, had
thirty-one towers and four
gates, and a firing-step all
the way along. It was about
three and a half miles in
length.
HMS Emerald *1928*

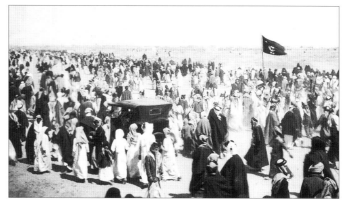

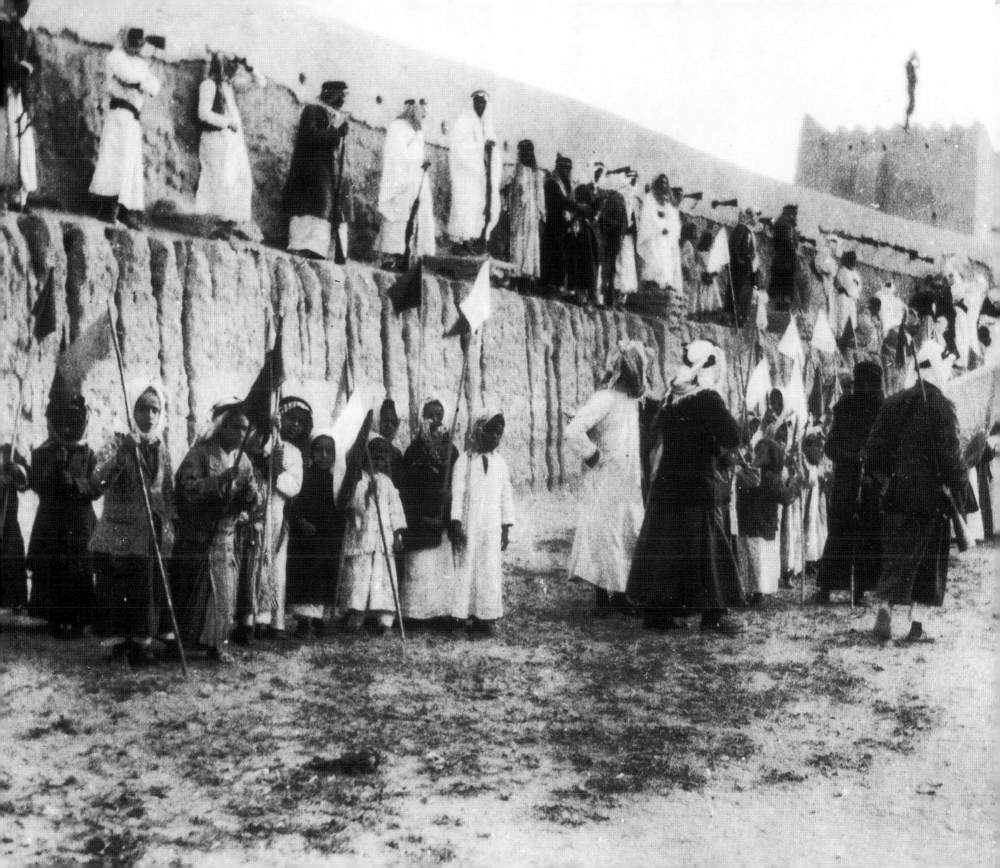

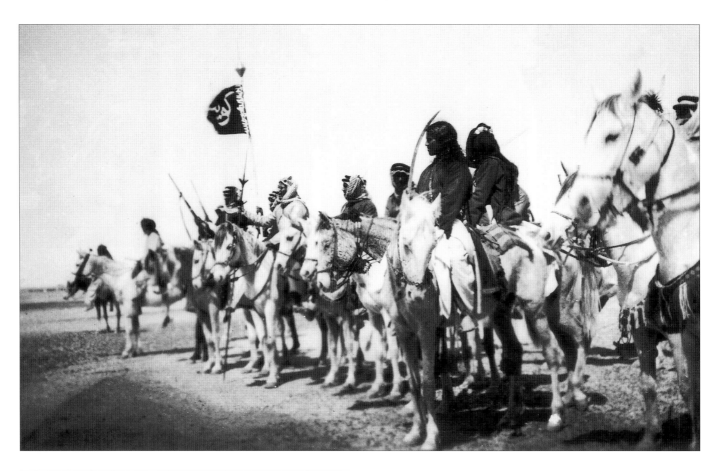

Top Kuwaiti cavalry on parade.
HMS Emerald *1928*

Below left A cool, dark arcaded café near the market.
HMS Emerald *1928*

Below right Women and children, Kuwait town.
HMS Emerald *1928*

Opposite Bedouin tribespeople throng al-Safat selling fodder and brushwood for fuel.
HMS Emerald *1928*

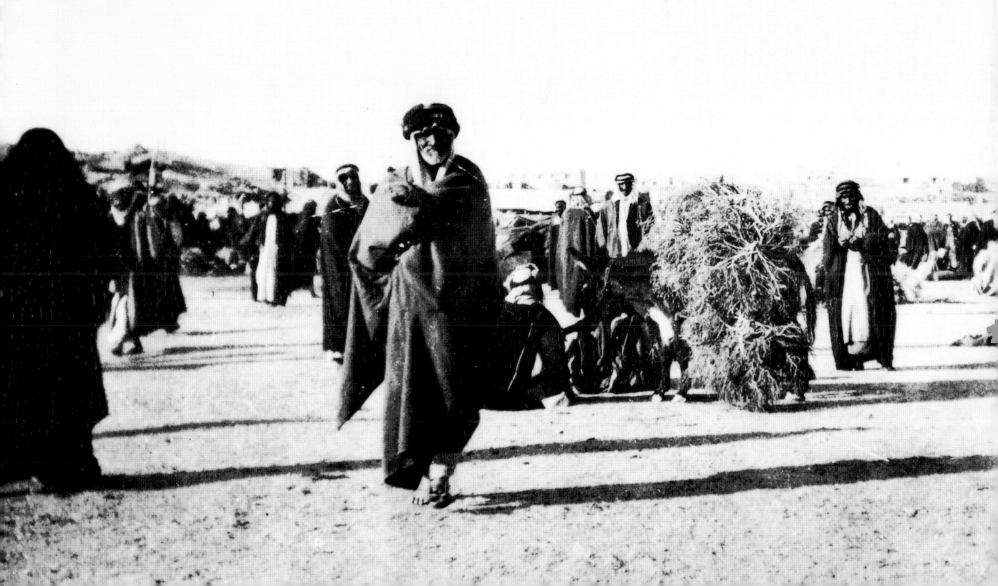

Gerald Selous (1930) and G. Ward-Smith (1933)

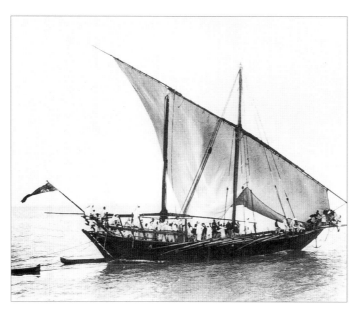

Right A Kuwaiti pearling dhow in late September 1933, at the end of the season. The oars were an essential part of every pearler, used for rowing the vessel from bank to bank and as spars to which the the divers were attached while diving. The official pearling season lasted from mid-May to mid-September. Before the First World War there were some 700 Kuwaiti pearling boats with crews totalling from 10,000 to 15,000 men, but when this picture was taken the trade was in deep decline owing to the worldwide slump and the Japanese introduction of cultured pearls. It never recovered, and it was a stroke of good fortune for the Gulf shaikhdoms that oil was discovered to replace the loss of revenue.
Ward-Smith 1933

Far right The carved stern of the *battil* shown in the opposite picture, with its captain's chair.
Selous 1930

British officials and naval officers who photographed Kuwait in the early 1930s are well represented by three individuals. Gerald Selous was a diplomat and Arabist who, while serving as British Consul at Basra from 1929 to 1932, visited Kuwait and took some of the best pictures ever taken of the harbour. On the naval side, Lt-Commander H.R. Vaughan was typical of British seamen who took an interest in the native craft among which they found themselves. Serving in the Gulf in 1928–30, he managed to photograph virtually every type of local craft from the Shatt al-'Arab to Oman, but his pictures of Kuwait preserved in the National Maritime Museum are few and of poor quality, and are not included here. Little is known of Captain G. Ward-Smith, except that he was a naval officer who served in the Gulf in the early 1930s and came into contact with Harold Dickson.

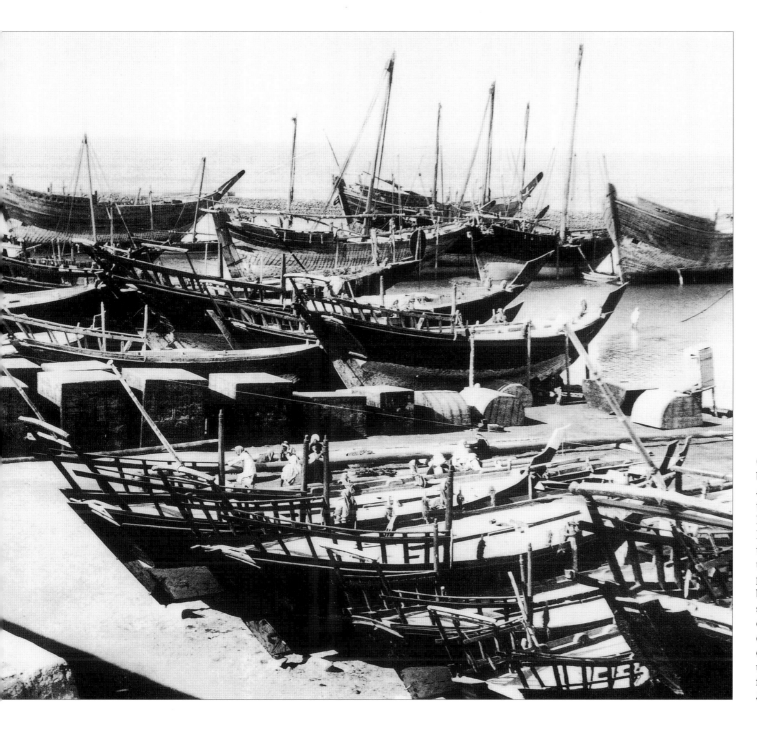

Cargo *boum*s provide a background to smaller *shu'ai*s and *sambouk*s in the foreground along part of Kuwait's waterfront in 1930. Between them lies one of the famous *battil*s which used to lead the Kuwaiti pearling fleet to the pearl banks every summer. The square and rounded wooden casks were for water in the dhows, and it was in such casks that the town's water used to be fetched by dhow from the Shatt al-Arab.
Selous 1930

Harold and Violet Dickson, 1929–1936

Above Harold Dickson in a studio portrait taken in 1934 while he was Political Agent at Kuwait.

Top right Harold Dickson with a group of tribesmen. The Dicksons' favourite pastime was to spend time in the desert with their bedouin friends.
Dickson 1930s

Centre right Kuwait *suq* c.1935.
Dickson c.1935

Below right A bedouin family and tents in the Kuwait hinterland. The typical tent was divided in two by an elaborately woven curtain, with the male, public side to the right and the female, family quarters to the left.
Dickson 1930s

Harold Dickson was born in Beirut in 1881and spent much of his boyhood in Jerusalem. His feeling of special affinity with the Arabs of the desert can be traced to infancy in Damascus, where for a time he was provided with a bedouin wet nurse by Shaikh Mijwal al-Mizrab of the 'Anizah, the desert chieftain who had married Lady Digby in the 1860s. This led to him being regarded by the tribespeople as almost one of them, which was to help him greatly in his dealings with them later in life.

Having joined the Indian Army in 1908, Dickson's knowledge of Arabic led to his appointment to Mesopotamia in 1914. There he served under Sir Percy Cox, whom he greatly admired, and assisted in the organisation of a civil administration in southern Iraq. At the end of the War he was appointed Political Agent, Bahrain, and in 1920 returned as Political Officer to Iraq, serving during the uprising of that year. He was present at the 'Uqair Conference of 1922, where he met 'Abd al-'Aziz Ibn Saud for the second time. After a spell in India he returned to the Gulf as secretary to the Political Resident. In 1929 he took the post of Political Agent, Kuwait, replacing Major J.C. More.

Dickson and his wife Violet were to devote the rest of their lives to Kuwait, becoming loved and respected friends of its Rulers and people. He was a fluent Arabic-speaker, with a deep feeling both for Kuwait's people and for the tribes over the border in Saudi Arabia. Trusted and respected by all sides, he was able to bring outstandingly skilful diplomacy to his dealings. The most notable example occurred during the Ikhwan troubles of 1927–30. In 1929 and 1930,

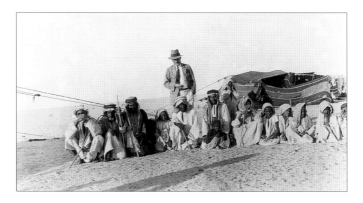

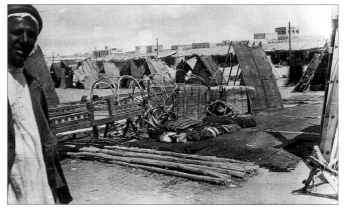

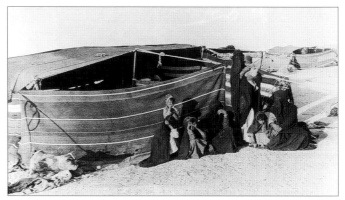

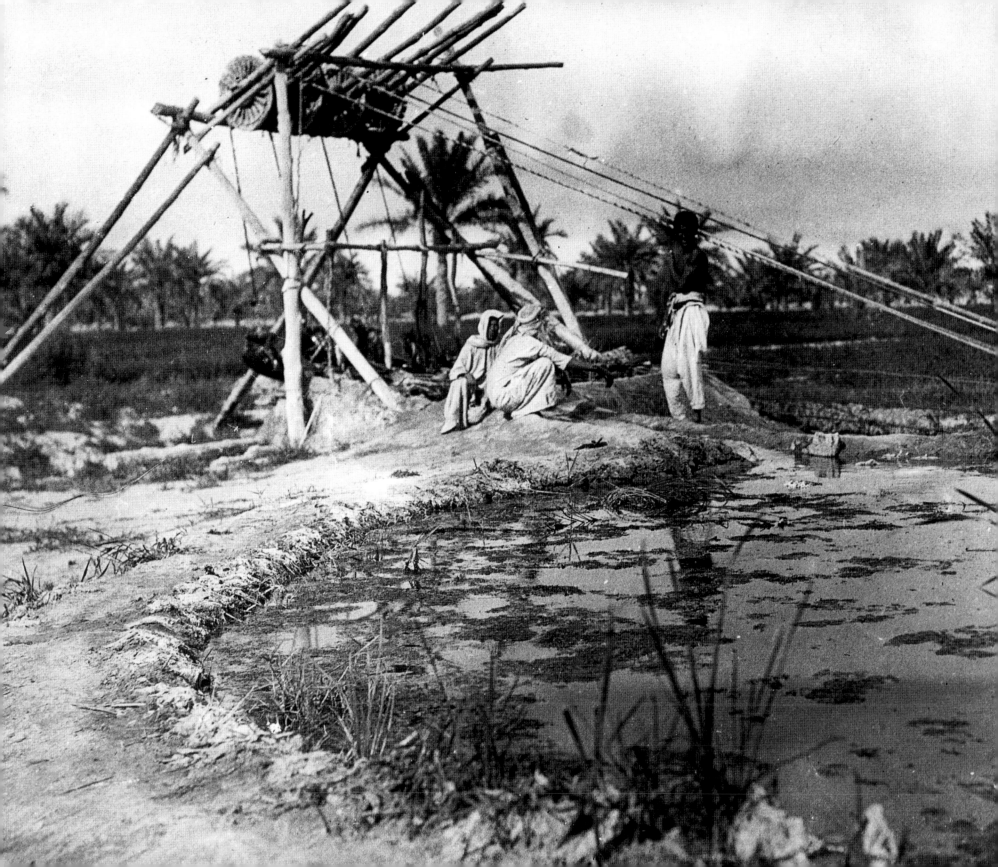

Right Amsha and Hassa, two bedouin ladies of the Muzayyin, were good friends of the Dicksons who would spend part of the spring in their encampment. Amsha passed on to Violet Dickson her extensive knowledge of desert plants and their uses.
Dickson 1930s

Previous page Kuwait's only serious cultivation was to be found at Jahrah, at the western corner of Kuwait Bay. Water was drawn up in leather buckets by donkeys walking down a ramp, hidden in the right of the picture. A lower rope tipped the buckets automatically into a holding pool, shown in the foreground. The water was then led away to the gardens in irrigation channels. The method is the same as that used all over Najd and eastern Arabia, the only difference being that a timber frame, rather than a mud or masonry structure, held the upper wheels.
Dickson 1935

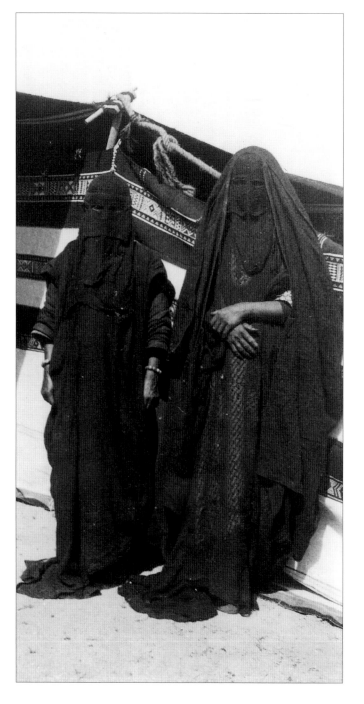

Dickson personally negotiated with the Ikhwan leader, Faisal bin Duwish of the Mutair, to bring an end to the incursions into Kuwait territory. Finally, in desperate straits, trapped between British ground and air forces on one side and Ibn Saud's troops on the other, Ibn Duwish delivered himself into British hands before being handed over to Ibn Saud. As he did so, he entrusted his womenfolk and children into Dickson's care.

Dickson retired as Political Agent in 1936, but at Shaikh Ahmad's request he was taken on as chief local representative by the new Kuwait Oil Company, and remained with KOC for the rest of his life. He and his wife lived on in the old Political Agency. Both Dicksons were skilled observers who recorded their impressions in diaries, photographs, drawings and, occasionally, watercolours. Although few of their photographs are of more than snapshot quality, they nevertheless record valuable glimpses of their travels and of life in the desert where they loved to spend time with their bedouin friends.

Harold Dickson died in 1959, having published two monumental works, *The Arab of the Desert* and *Kuwait and Her Neighbours*. Violet Dickson lived on in Kuwait for some thirty years more, producing during that time her valuable memoir *Forty Years in Kuwait*. Tragically, she lived to witness the Iraqi invasion of 1990. She was evacuated to England, where she died in 1991.

C.J. Edmonds, 1934 and 1937

C.J. Edmonds was a British official who spent almost all his working life in Iraq, following his appointment as Assistant Political Officer Mesopotamia in 1915. In 1922 he moved to Kirkuk and Sulaimaniyah province, where he remained for many years. During the 1930s he served on a number of Middle East boundary commissions, work which enabled him to travel extensively throughout the region. He remained in the Middle East until 1950, when he returned to England to take up a post as lecturer in Kurdish studies at the University of London.

Edmonds took a very large number of photographs throughout his career, and left more than 4,000 negatives. The wide coverage of this collection, which covers Palestine, Iraq, Syria, Lebanon and Iran, makes it a valuable contemporary record. It includes fifty pictures taken during Edmonds' two visits to Kuwait in 1934 and 1937, when he stayed first with the Dicksons and later with Gerald de Gaury. The pictures cover Kuwait's buildings, harbour and markets.

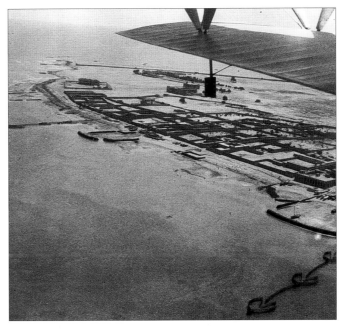

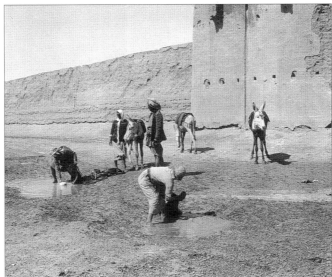

Left This aerial photograph shows the eastern end of Kuwait town: the end of the wall can be seen with the Dasman Palace just inside it, while the building farthest along the shore is the new British Political Agency, completed in 1935. A typical tidal fish-trap made of the spines of date palm leaves shows up well in the foreground.
Edmonds 1937

Below left Rainpools outside the wall of Kuwait, February 1937.
Edmonds 1937

Far left Hajji Williamson (left) with Harold Dickson (centre) and Violet Dickson (right), March 1934.
Edmonds 1934

Opposite Kuwaiti boys pose for the camera in front of two *boum*s, propped ready for overhauling.
Edmonds 1937

George Rendel, 1937

The distinguished British diplomat Sir George Rendel visited Kuwait in February 1937. As Head of the Eastern Department of the Foreign Office he had been invited by King 'Abd al-'Aziz to visit Saudi Arabia with his wife. As a prelude to his crossing of Saudi Arabia from al-'Uqair to Jiddah via Riyadh later in the spring, he took the opportunity to visit Iraq, Kuwait, Bushire and Bahrain on official business.

On arrival at Zubair from Basra he and his wife were met by the Political Agent Gerald de Gaury, and escorted to Kuwait via Jahrah. He took only a few photographs of Kuwait, but they are of interest as they show the town on the very eve of the discovery of oil in commercial quantities in 1938. Rendel's entertaining memoirs place the pictures in context:

… at the time of my visit work on the oilfield had not yet begun and Koweit was still an unspoilt medieval Arab city. As we approached it, its complete circle of reddish walls with their well-defended gates stood out strikingly from the pale blue sea to the north and from the flat dun-coloured desert to the south, and gave it a curious almost dream-like quality. We found the town in high festival, celebrating the close of the pilgrimage. Every dhow in the harbour was beflagged, the large market-place was thronged, and the Sheikh himself was watching a ceremonial sword dance by his bodyguard which he invited us to witness in his company. My wife sat beside him, unveiled, on a high settee, politely but unsuccessfully trying to conceal her legs, for we were still in European clothes.

One of the four main gates of Kuwait, February 1937. The four were named the Jahrah Gate, the Naif gate, the Briasi Gate (also known as the Sha'ab Gate) and the Dasman Gate, also known as the Sabah Gate. There was also one smaller northern gate.
Rendel 1937

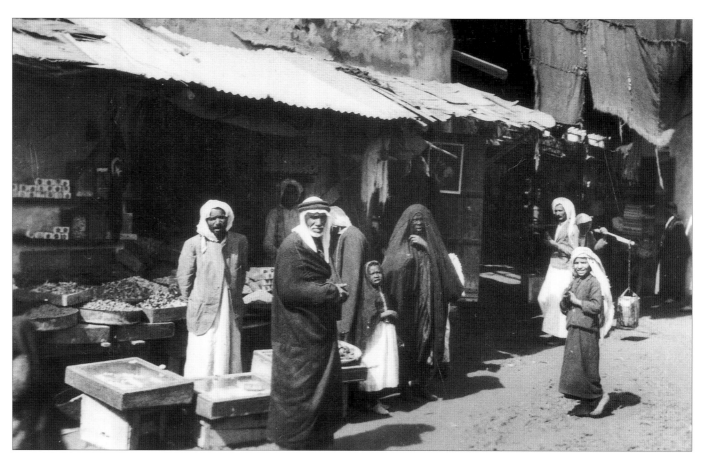

A scene from the *suq*.
Rendel 1937

At the time of our visit Koweit was still dependent on its two main traditional activities, smuggling and the pearl trade. The smuggling activity was giving us an infinity of trouble but was highly lucrative. Pearl fishing was sinking into a state of deep depression, though it still retained a number of picturesque ceremonies mainly connected with the official opening and ending of the pearling season. We saw a good deal of the Sheikh ... [He was] *personally most friendly and gave us a very pleasant quasi-European dinner in a drawing-room in his palace almost entirely filled with cuckoo clocks. Elaborate arrangements had been made for our entertainment, and on our second day we were to have attended an Arab feast in the desert, but to our disappointment it proved to be one of the wet days in the year. The Sheikh however was radiant at what he called our "green coming". I was less cheerful. My friend, Hughe Knatchbull-Hugessen, when he had visited Koweit from Persia a year or two earlier, had also brought rain with him and been congratulated. But the rain had not stopped, the town, which was largely built of mud, had begun to disintegrate, and in the end he had been obliged to make a large contribution towards a rebuilding fund. I was thus not sorry to leave Koweit before our own rain could do any serious harm.*
George Rendel *The Sword and the Olive* pp.101–2

In Kuwait his aim was to try to define and modernise the relations of the shaikhdom with Britain, which were still conducted as of old through the Resident at Bushire, to whom the Political Agent at Kuwait reported, and the Political Department of the Government of India. "Our position", he wrote in his memoirs, "seemed to me to be ... anachronistic and ill-defined. The Sheikh was a more or less sovereign ruler, though he had agreed by treaty with us to refrain from piracy, gun-running and the slave trade, and to put his foreign relations in our hands." In 1933 Rendel had proposed that Kuwait be made a formal protectorate, but the plan had come to naught, and little was to come of his present visit except that, immediately afterwards, the British promoted Shaikh Ahmad from "His Excellency" to "His Highness". British Political Agents in the Gulf continued to be drawn from the Indian civil service or army until Indian independence in 1947.

Throughout his travels Rendel was an avid photographer, for which students of Saudi Arabia in particular must be thankful. In the 1930s he used one of the wide range of small Zeiss Ikon cameras then available – a popular choice among travellers not only for their compactness but also for their excellent lenses and versatility. He took just twenty-eight pictures of Kuwait, including some lively scenes of the harbour, the market, bedouin with camels and sheep, and the wall.

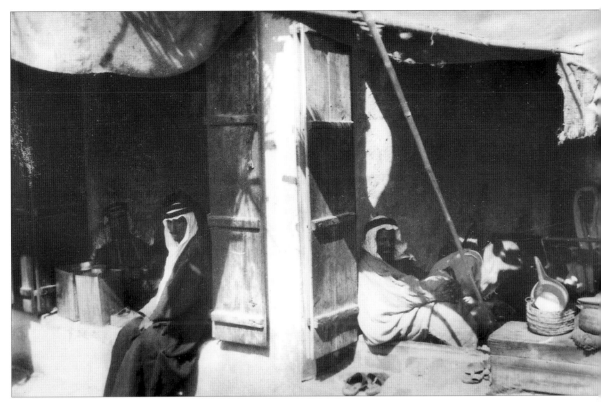

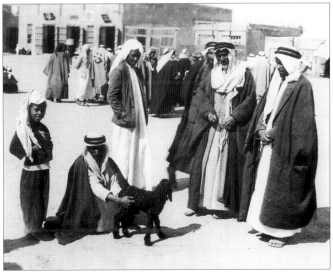

Scenes from the *suq*.
Rendel 1937

Freya Stark, 1932 and 1937

The shrine of Mar Elias, also known as the shrine of Al-Khidr, on Failakah island. Since Freya Stark's visit, Failakah has been identified as an island of major archaeological importance, with sites reaching back to the 3rd and early 2nd millennia BC and demonstrating much contact with ancient Sumer and Akkad. The Islamic sage Al-Khidr is a somewhat hazy figure: his name means something like "The Green Man", and he appears in the *Arabian Nights* as the guardian of the Fountain of Life and of the Water of Immortality. Some say that he traces his lineage to the Sumerian Noah-figure Atrahasis/ Ziusudra (the Akkadian Utnapishtim), the survivor of the Flood whose abode was in Dilmun.
Stark 1937

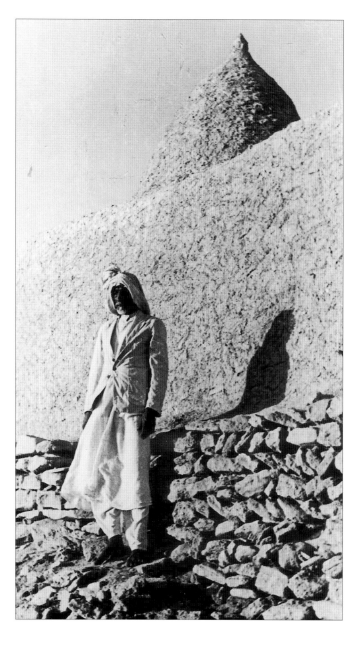

The famous writer and traveller Freya Stark needs little introduction here. She was a prolific photographer throughout her adult life, amassing a collection of thousands of pictures, taken mostly with her trusty Leica camera. Her photographs reflect the fact that her main interest was the people she met along the way; even her remotest landscape shots have a human form somewhere in the picture.

She made two brief visits to Kuwait during the 1930s. The first took place in the spring of 1932, when she travelled with Sir Hubert Young and his wife. She recorded her impressions of the place in her first book, *Baghdad Sketches*:

> *On three sides the town of Kuwait is surrounded by walls and towers … In the darkness through which one feels nevertheless the transparent whiteness of sand, the Arabs on guard are waiting for us …*

> *The streets are solitary and windowless … with wooden gutters shooting out over them from the mud houses. The wooden doors have carved centre posts and small posterns let into the panels, fastened with locks and bars. And the figures that move about are mostly clothed in white or black, with a touch of red for the head or sleeve …*

During her excursions round the town she was captivated by the beauty and variety of the local craft in the harbour, but was also drawn to the bustle of the bazaars, admitting that she and the other women in her party "went quite mad with so many fascinations".

When she returned as guest of Gerald de Gaury in 1937, aeroplanes had begun to land alongside Kuwait's town wall, and a "modest brass plate on a house on the seafront" announced the arrival of the Anglo–American Kuwait Oil Company, presaging the great changes that were to come. She was depressed by these developments, and also by the fact that Kuwait's economy was continuing to suffer from the collapse of its traditional mainstay, the pearl trade, as well as from the land blockade by Saudi Arabia. All gloomy thoughts were dispelled, however, by a brief visit to the island of Failakah where, as she wrote in *The Coast of Incense*, "there is no motorcar on the island, no paper, post, or gramophone: a blessed place. I wish one could buy it and keep it so". Her writings are characterised by this kind of lyrical nostalgia.

It has to be admitted that Freya Stark's photographs of Kuwait are not among her best and most interesting pictures. Though her excellent article entitled "Kuwait" in the *Geographical Magazine* of October 1937 was accompanied by numerous outstandingly good shots, most of these are credited to a certain H.I. Cozens, whose work has yet to be traced.

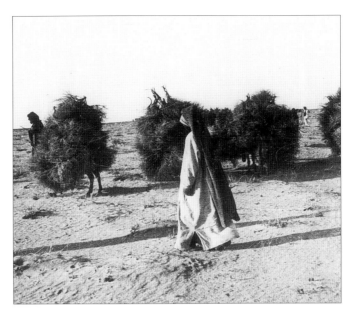

Left Brushwood gatherers of the Mutair.
Stark 1932

Below left Mending fishing nets, Failakah.
Stark 1932

Below The *warjiyyah* was a fishing boat of great antiquity which used to be common along the Arabian coast of the Gulf. It was made of the spines of date palm leaves lashed together. This one belonged to an old Najdi bedouin, the keeper of the lighthouse on Ras al-Ard erected by the British.
Stark 1937

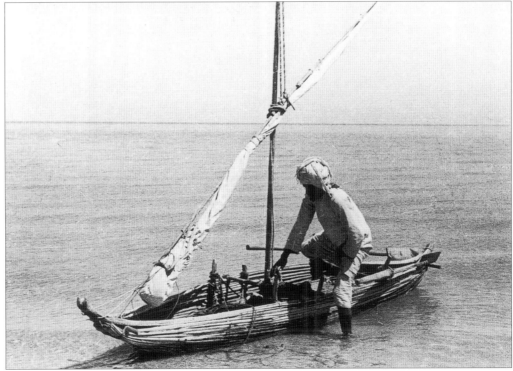

Gerald de Gaury and the Lindts, 1936–1939

Right Shaikh Ahmad Al-Sabah and Gerald de Gaury relax on board the Shaikh's steam launch.
Villiers 1939

Below right Al-Safat, the large open space adjoining the market, photographed from the wall. Bedouin came here to sell their animals and animal products and to buy supplies, and to settle up their debts and customs dues from previous years. Large caravans could be accommodated with ease. A major item of exchange here was the news: news and rumours from all over northern, central and eastern Arabia mingled with that of Kuwait's townsfolk and seafarers.
De Gaury late 1930s

Gerald de Gaury's involvement with the Arab world began by accident: wounded both in Gallipoli and France during the First World War, it was while he was convalescing that he first began to learn Arabic from a book left at his bedside.

In 1924 he went to Iraq, where he was engaged in intelligence work for the army and the Royal Air Force. He was in Kuwait in 1927 and 1928 on intelligence and liaison duty during the Ikhwan crisis, and it was from this visit that he kept some photographs taken, perhaps by himself but more probably by a British naval officer, during the *Emerald* incident.

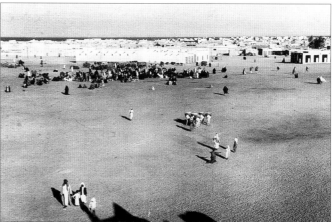

In the early 1930s he served for a time on the British Minister Sir Andrew Ryan's staff in Jiddah, and travelled across Arabia to Kuwait. In 1935 he accompanied Ryan's mission to Riyadh, and in 1936 he was appointed Political Agent, Kuwait, succeeding Harold Dickson and remaining in Kuwait until 1939. This was an uneasy time for him: by trying not to get involved with either side of the political debate leading up to the internal trouble of 1939, he paid the price of neutrality by being accused by both Shaikh Ahmad and the opposition of withholding his support. During the Second World War he served as Special Envoy to Riyadh.

Though de Gaury wrote little on Kuwait, he had a special feeling for Saudi Arabia, particularly its Najdi traditions, which he sensed – with regret – were about to vanish under the onslaught of the new. His books embody the romantic view of tribal Arabia and its old way of life which sees the Arabs as picturesquely mediaeval – a view which he shared with his friend Freya Stark, whose host he was in Kuwait in 1937. That is not to belittle his writing, for he could conjure up scenes of life in Riyadh and old Arabia with a genuinely evocative power.

De Gaury left a large photographic collection in which, like the Dicksons', it is often hard to tell whether the pictures are his own or taken by someone else. Saudi Arabia brought out the best in him as a photographer, and there are only a few of his own pictures of Kuwait. However, at some time during his time as Political Agent, he played host to Susan and A.R. Lindt, about whom little is known, but who made him a present of an album of their interesting photographs of Kuwait, some of which are reproduced here.

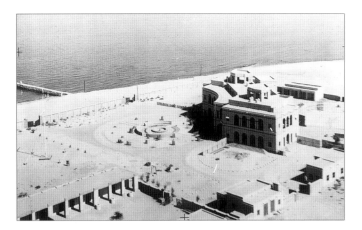

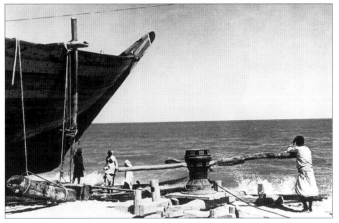

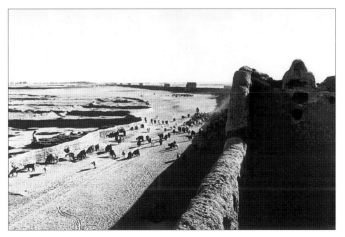

Left The new Political Agency, thought to have been designed in Lutyens' office in Delhi. Completed in 1935, it is now the British Embassy. The Dicksons sensibly insisted that the balcony should be widened from 8 to 20 feet. They lived in it for just one year, 1935–6, when they moved back into the old Political Agency on Harold's retirement. It was then taken over by Gerald de Gaury.
De Gaury 1937

Centre left Capstans like this were used for launching dhows in the boatyards, like this *boum* on the left.
A.R. and S. Lindt 1936-7

Below left Freya Stark wrote: "In the late afternoon the flocks of goats return with their goatherds, pour like black velvet through the nail-studded door, across the empty open space with the sunlit wall and its towers behind them, until they reach the appointed place where their several owners (who pay three annas a month for this service) come to disentangle and take them to their homes". It was said that the animals would find their own way home if their owners did not appear.
A.R. and S. Lindt 1936–7

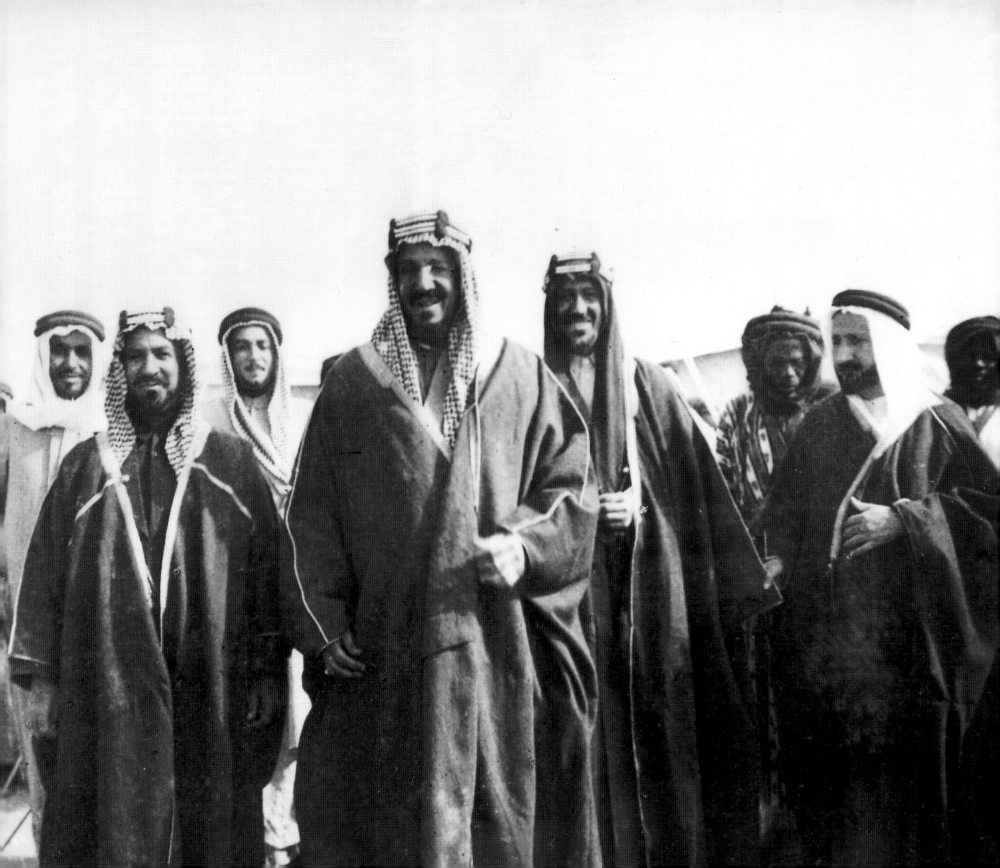

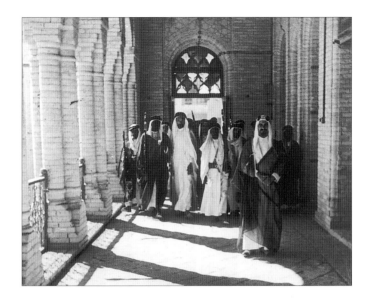

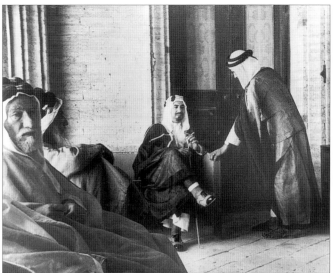

Far left Shaikh Ahmad bin Jabir Al-Sabah makes his way to his *majlis* in the Seif Palace, in the town by the seashore.
A.R. and S. Lindt 1936–7

Left In the *majlis*: Shaikh Ahmad receives petitioners.
A.R. and S. Lindt 1936–7

Below Bedouin women at Kuwait.
A.R. and S.Lindt 1936–7

Opposite Shaikh Ahmad bin Jabir, Ruler of Kuwait, with King 'Abd al-'Aziz and the Amir Saud bin 'Abd al-'Aziz. King 'Abd al-'Aziz visited Kuwait in February 1936, while Shaikh Ahmad paid a visit to Riyadh in 1939.
De Gaury 1936 or 1939

Over page Life on board a pearling boat was cramped and grindingly hard: this is the space these divers had to live in for weeks on end, punctuated only by occasional short trips ashore near the pearl banks. Many of the divers were bedouin from the desert putting the long hot summer to good use, and sailors home from trading voyages. Most were in permanent debt to their captains. The life of the Kuwaiti pearl diver was graphically described by Alan Villiers in his classic *Sons of Sindbad*.
A.R. and S. Lindt 1936–7

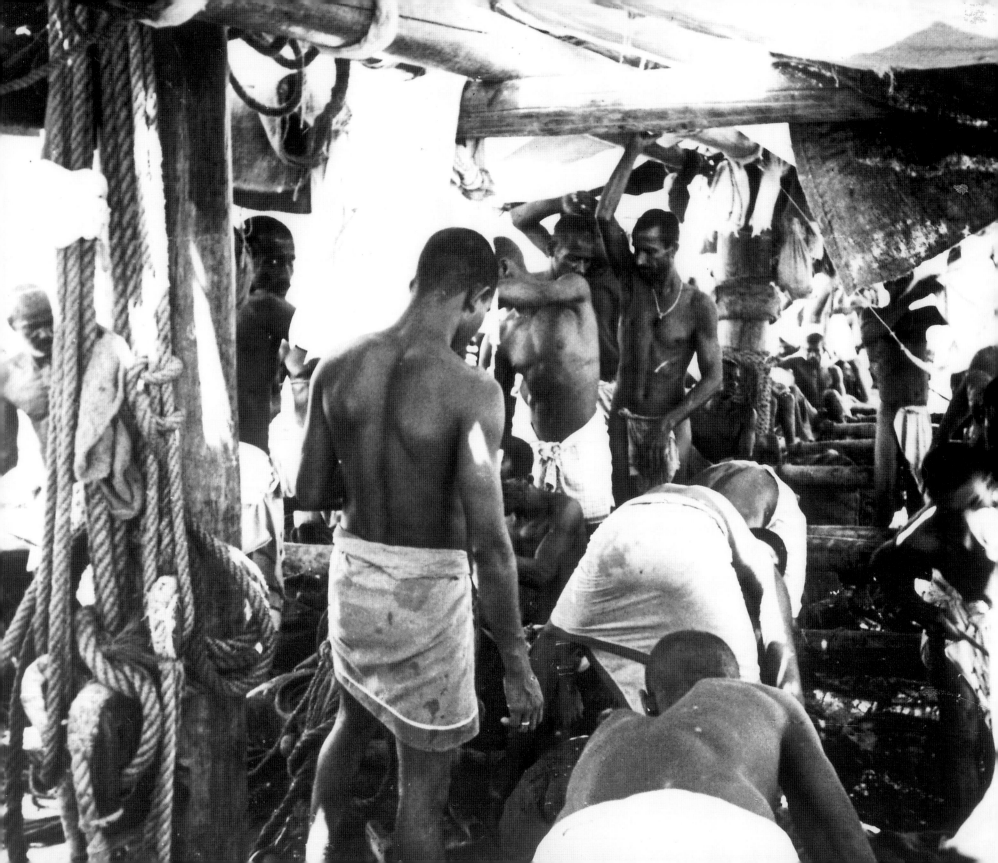

Alan Villiers, 1939

The most extensive and impressive photographic record of old Kuwait is that made in 1939 by the distinguished Australian seaman and pioneering photojournalist Alan Villiers. His collection is now held by the National Maritime Museum in London, whose photographic archive Villiers was instrumental in founding.

Villiers' interest in dhow sailing and the trading exploits of Gulf seamen stemmed from a lifelong interest in traditional sailing techniques. He was able to bring a mass of comparative experience under sail to his voyage aboard a Kuwaiti *boum*: for example his time with the Finnish four-master *Lawhill* in 1921; his long voyages under sail in 1928–32 aboard *Herzogin Cecilie*, *Grace Harwar* and *Parma*; and his pioneering work in sail training on the *Joseph Conrad*. He first sailed with a camera on board the *Sir James Clark Ross* whaler in the Antarctic in 1922, and bought his own camera to take on *Herzogin Cecilie* in 1928. From this latter trip he wrote his best seller *Falmouth for Orders*, the classic account of his voyage from Australia round Cape Horn to Britain.

As European sail died away Villiers became keen to investigate non-European methods of traditional seafaring. It seemed to him, after two decades spent at sea, that "as pure sailing craft carrying on their unspoilt ways, only the Arab remained". So, through a contact with Harold Ingrams in 1938, he began his enquiries in Aden. Ingrams passed him on to Captain T. Hickinbotham, who had a dhow of his own at Aden and was a good friend of the al-Hamads, a Kuwaiti dhow-owning and merchant family with an office in Aden. Having made a short voyage into the

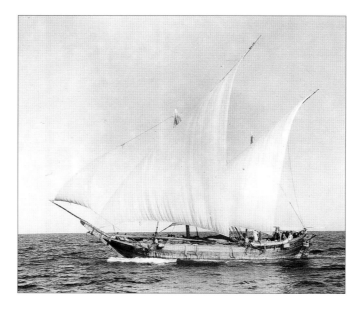

Red Sea in a Yemeni *zarouk*, Villiers returned to Aden and was introduced to 'Abd al-Karim bin Mishari Al 'Abd al-Razzaq al-Najdi, a young Kuwaiti captain with a seaworthy *boum* of about 150 tons which was making the traditional nine-month trading round-trip between Kuwait and the East African coast.

Villiers joined al-Najdi's *boum* the *Triumph of Righteousness* in December 1938 for the voyage to Mukalla, then down the East African coast to Mombasa, Zanzibar and the Rufiji delta, and back again with the early breezes of the south-west monsoon season to Matrah, Bahrain and, finally, Kuwait. He arrived in Kuwait in early June 1939. At the beginning of August he joining a pearl buyer for a dhow trip amongst the divers on the pearl banks of the northern Gulf, returning to Kuwait for a short time before leaving for Basra and the War in September.

A laden *boum* making good headway under full sail. It is either the *Triumph of Righteousness* itself or one of the Kuwaiti dhows which Villiers encountered on the voyage back to Kuwait.
Villiers 1939

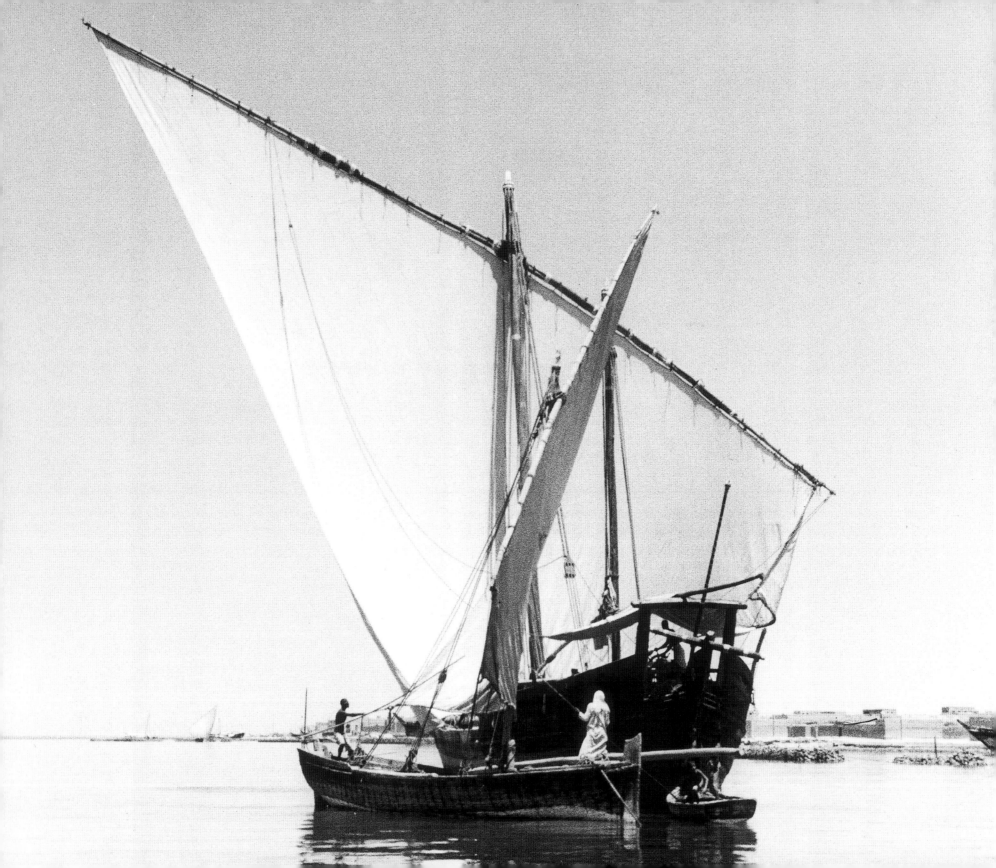

These voyages are immortalised in his seafaring classic *Sons of Sindbad*. To a Kuwaiti mariner of the old school it is, of course, merely an account of everyday life at sea, but to a Western reader it is a stirring tale of maritime adventure combined with a uniquely detailed description of the life, sailing techniques and business methods of the Arab seafarers of the Gulf. There is something in it for everyone: those who simply want to read a good travel story, historians and sociologists of Indian Ocean trade, nautical buffs, and anyone with an interest in Arab and Kuwaiti culture and mentalities.

The comparison with Thesiger is a compelling one. Thesiger not only described but also lived the hardships of bedouin life in the sands, a life that was on the brink of extinction. Villiers joined the *Triumph of Righteousness* to observe and live the life of the ordinary dhow sailor at a time when sails were on the verge of being replaced by engines. Like Thesiger, Villiers wrote in a vivid style and was an accomplished photographer.

But perhaps the most telling similarity of all is that Villiers approached the men amongst whom he voyaged with a deep respect for their way of life and with no sense of superiority. This never left him throughout his time with the Kuwaitis. Though he occasionally had reason to feel that their attachment to the old ways blinded them to simple practical improvements that might be made, he chiefly felt humbled by their capacity for hard physical work, by their endurance of the privations of life at sea, by their easy, natural sense of brotherhood, by their simple expectations of life, and by their seamens' instincts which more than compensated for their lack of formal navigational learning. He constantly put himself in their position, and usually found himself wanting. His Kuwaiti companions were puzzled by his interest in

them, but tolerated him with a good spirit. "The Arabs treated me well," he writes, "and I owe them a debt of gratitude. I found myself wondering, sometimes, what it might be like for an Arab to ship out with us, in our ships, in order to gather material for a book about them. We should look on him rather dubiously, I fear; but I hope we should treat him well."

Though he hardly mentions his photography in his book, Villiers' photographs, both of his voyage and of Kuwait itself, number in the hundreds and depict this maritime community as no other collection does. In addition to the still cameras with which he took 35mm and large format pictures, he also had a movie camera with which he shot footage of life on board. The only objections to his photography that he encountered were occasional fears of the evil eye. Less serious ones were from the sailors of the *Triumph of Righteousness*, who complained that his portraits of them were not good enough. Villiers describes them in Zanzibar, when the sailors wanted photographs of themselves to send home:

Often my subjects did not recognise themselves when they were handed the finished results, and the lamentations were loud and long. They had a great conceit of themselves, and very firm ideas as to how they should appear. Any falling short of their standard they declared at once to be my fault. It was useless to explain that I could only photograph them as they were, not as they imagined themselves to be.

I found their importunities in this respect sometimes hard to bear, but when I saw the childish delight with which they bought themselves cheap picture frames in the suq *at Zanzibar, and watched them going to the unheard of length of employing public letter-writers to write letters home in which to enclose these things, I*

Opposite Cargo *boum*, small *jalibut* and harbour boat make a composition worthy of a Dutch master as the *boum* makes ready to sail just outside the breakwaters of Kuwait. *Villiers 1939*

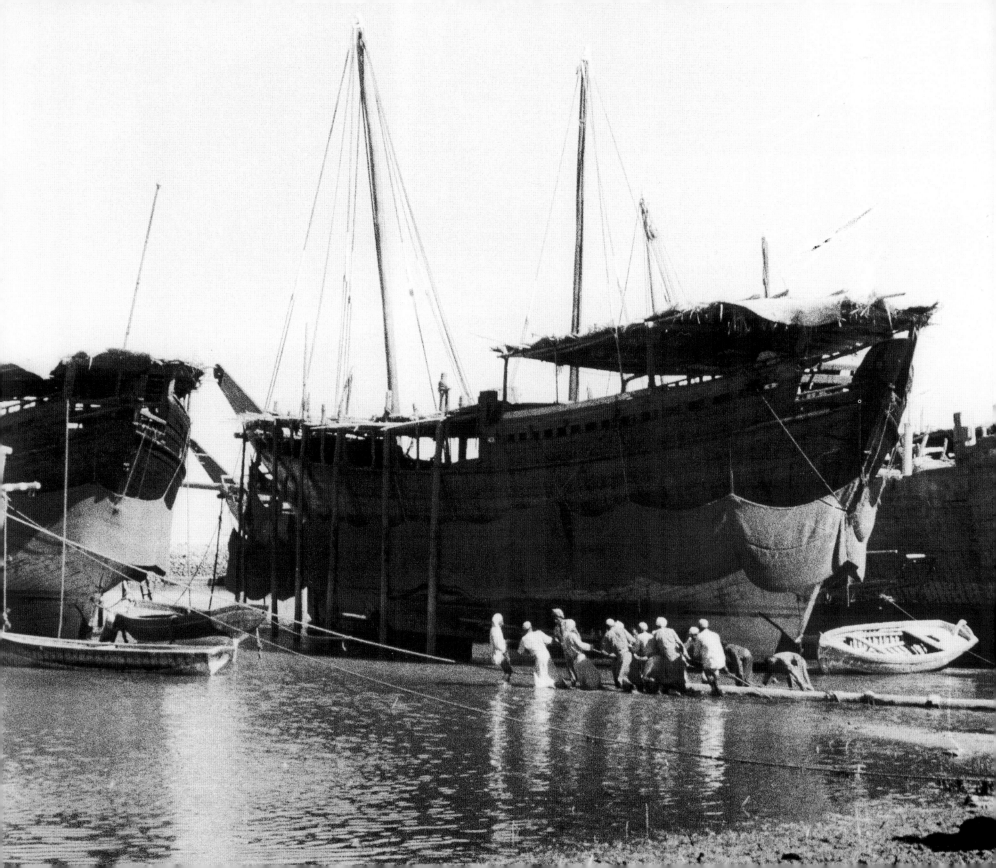

*forgave them and tried to photograph my failures
again. The photographs were handed round among all
the Kuwaitis in the harbour ... to be admired, and I
soon found sailors from other ships hailing me in the
street and coming out to the ship to be photographed.
This, however, was an honour I declined.*

To the end of his life in 1982 this remarkable man
travelled, sailed, and photographed, gave advice and
lectured about the vanishing world of traditional sail.
His photographs and writings form arguably the
single most important surviving documentation of the
last days of sail. That his steps should have been led
aboard a Kuwaiti *boum* on that day in December
1938 is a stroke of good fortune for which all those
interested in Kuwait's heritage must be grateful.

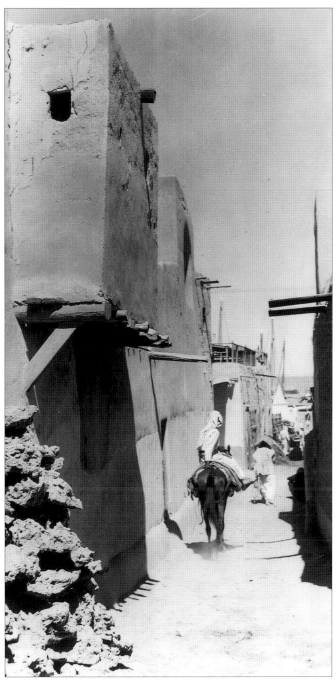

Left A typical lane leads
directly down to the
harbour.
Villiers 1939

Far left Hull planks were
set edge-to-edge and bent
to shape from stem to stern
before the internal ribs were
added. Temporary ribs on
the outside were used to
maintain the lines of the
vessel. All building was
done by eye. This method
of building, common to the
boatyards of Arabia, Persia
and India, was the exact
opposite of the usual
European method, by which
the ribs were set first and
clinker-built planking was
set onto them afterwards,
all with the aid of drawings.
Villiers 1939

*Opposite Boum*s stand
propped in shallow water
in Kuwait harbour for their
annual overhaul as men
drag a mast through the
shallows to one of them.
Villiers 1939

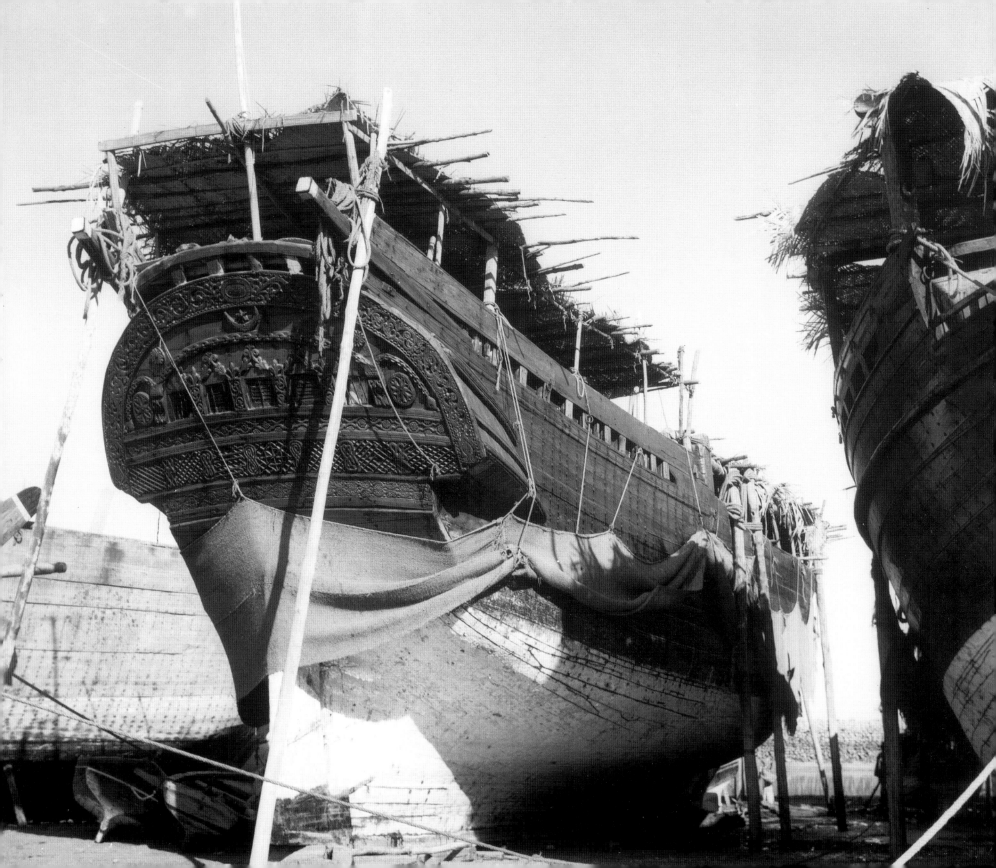

Left Starting a new dhow in a typical Kuwaiti boatyard: first the keel was laid, then the stem and stern posts were set into it.
Villiers 1939

Opposite A beautiful old cargo *baghlah* or *ghanjah*, with its carved poop reminiscent of a Portuguese galleon, is propped on Kuwait's densely packed waterfront. In the summer when this shot was taken the cargo vessels would be at home being overhauled, while the pearling fleet would be on the pearl banks. Villiers noted that such fine old vessels were already quite rare in the late 1930s, even at Kuwait.
Villiers 1939

Top Making sails, like most other activities in old Kuwait, was a social affair.
Villiers 1939

Left Fishermen mend their nets in a street in old Kuwait.
Villiers 1939

Right One of the streets in the *suq* was given over to boat equipment: spars, rigging and various spare parts.
Villiers 1939

Opposite A vital part of the summer overhaul was the recaulking of the hull planking: ramming oiled fibre between the planks to make the boat watertight.
Villiers 1939

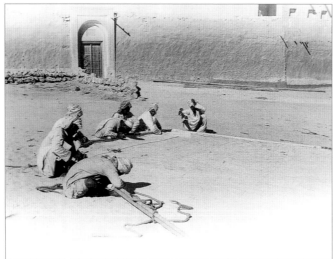

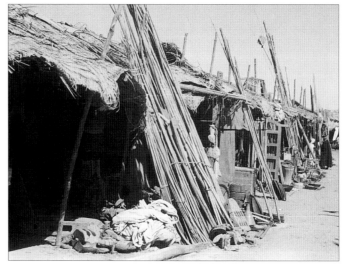

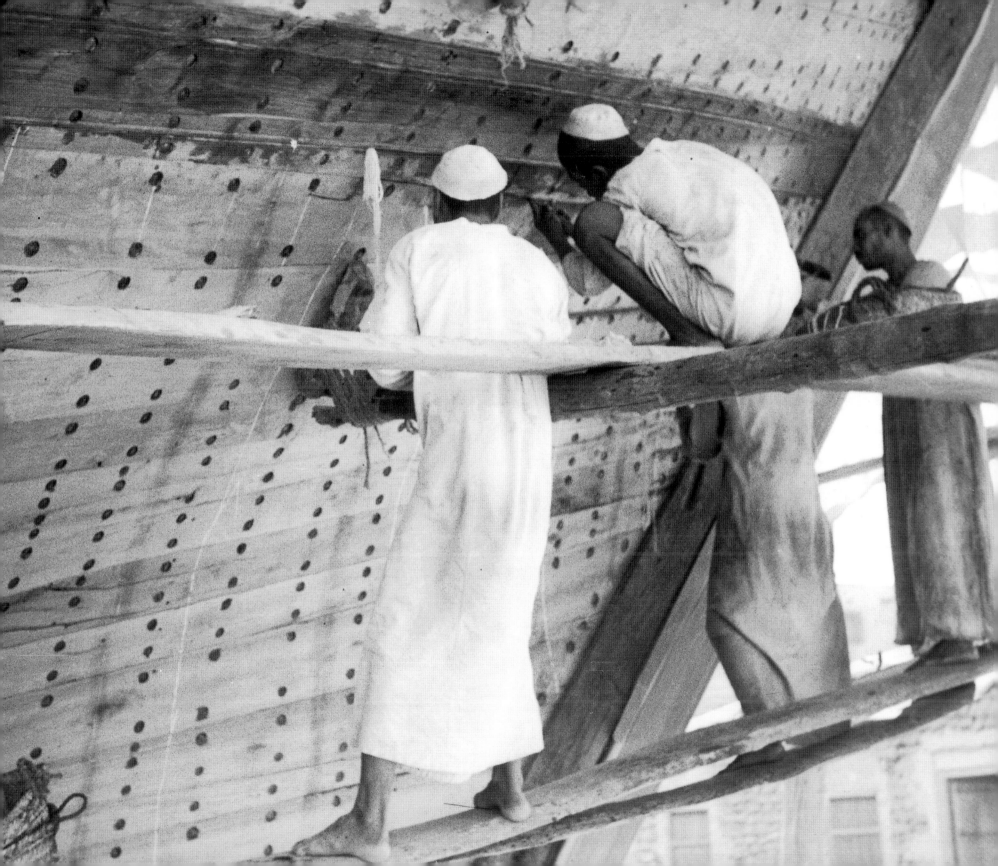

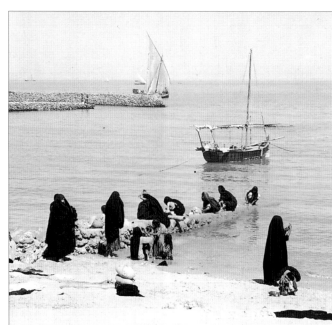

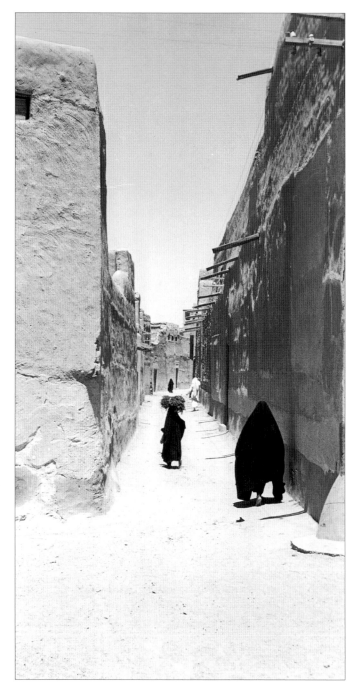

Top left A pearl dealer negotiates for pearls on board a dhow on the pearl banks. The set of graded sieves, the small balance, the chest and the cloth were the essential items in the standard pearl merchant's equipment.
Villiers 1939

Below left Women use a stone breakwater as a handy place to do the laundry.
Villiers 1939

Far right Women hurry home through the streets in the midday heat, with the sun almost vertically overhead.
Villiers 1939

Opposite Water-carriers and donkeys meet a water dhow from the Shatt al-'Arab to fill up their cans and skins to hawk them round the streets.
Villiers 1939

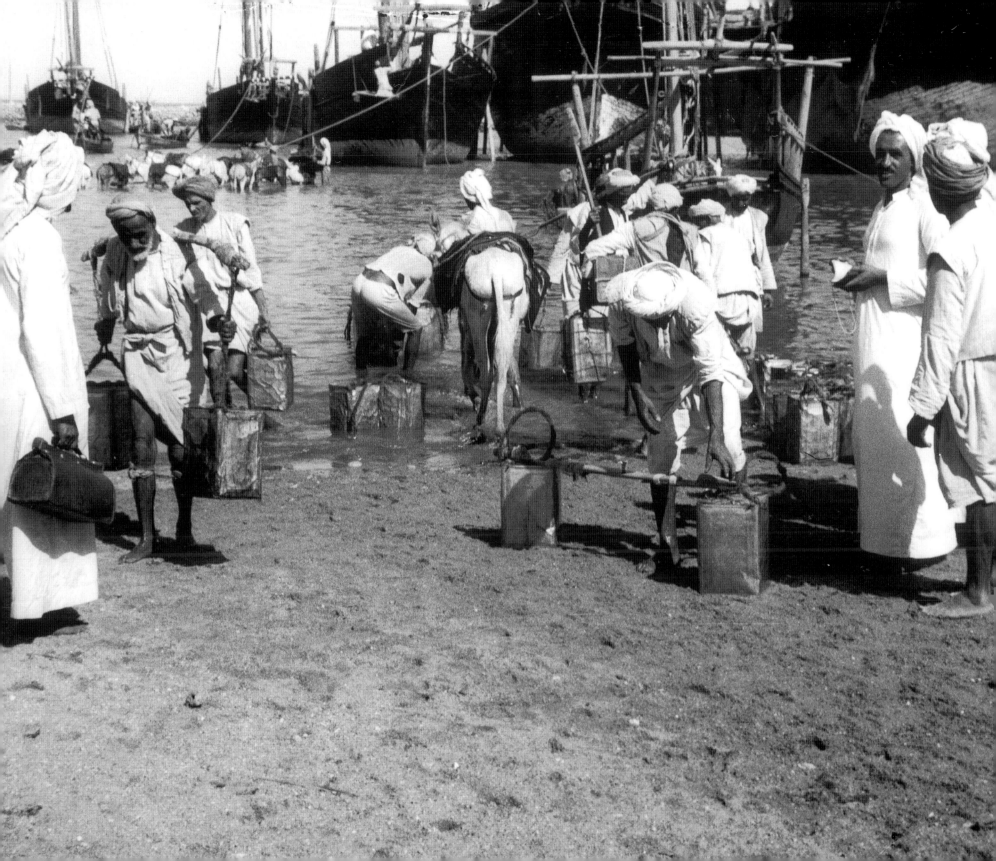

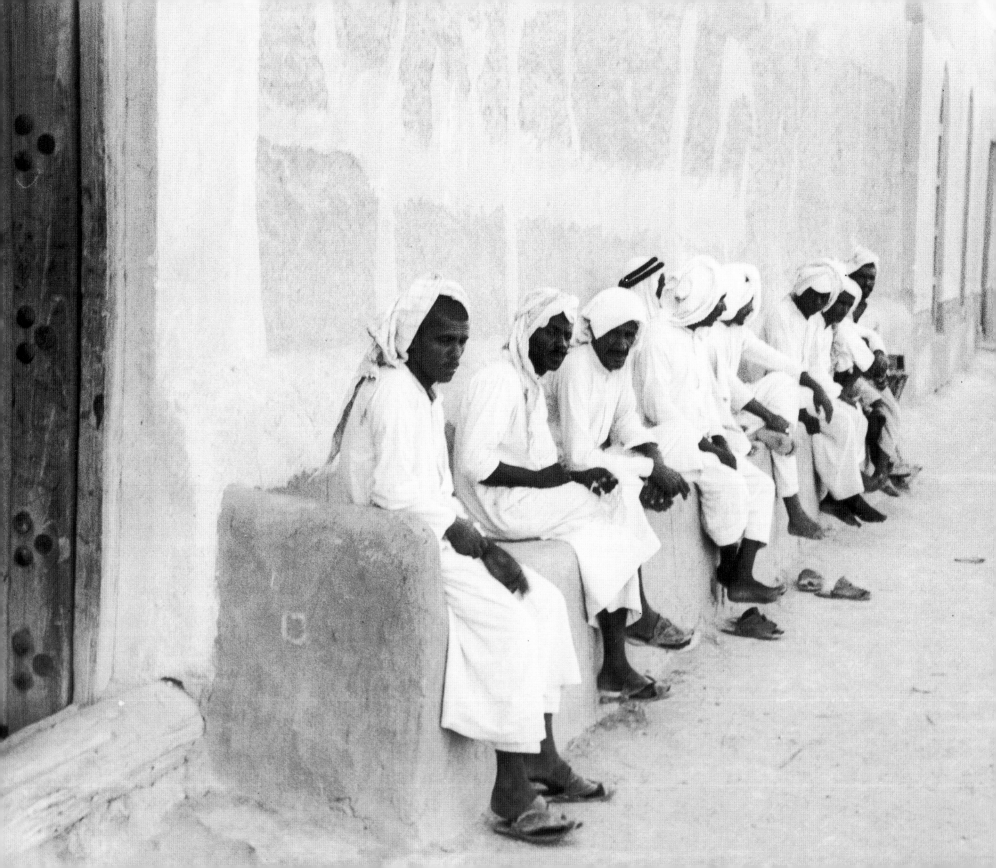

Left Pretty arches like this one gave Kuwait's streets a distinctive atmosphere.
Villiers 1939

Opposite After the rigours of the nine-month trading voyage to India or East Africa, Kuwaiti seamen liked to spend time in company, exchange the news with other crewmen, find out who was planning what, and cement old relationships with merchants and ships' captains. Here a group relaxes in the shade outside a wealthy man's house.
Villiers 1939

A courtyard of a well-to-do household in Kuwait, looking towards the men's *diwaniyyah* or reception room located just inside the main door to the house from the street (seen left). The diamond-shaped device on a stand is a radio antenna. Houses were organised round court-yards, in the middle of which was to be found a well either dug into the brackish groundwater, or giving access to an under-ground cistern which collected rainwater from the roof.
Villiers 1939

Each neighbourhood of the town had its small local mosque, a neighbourhood in a Muslim town being defined by the area over which the muezzin's call to prayer could be clearly heard.
Villiers 1939

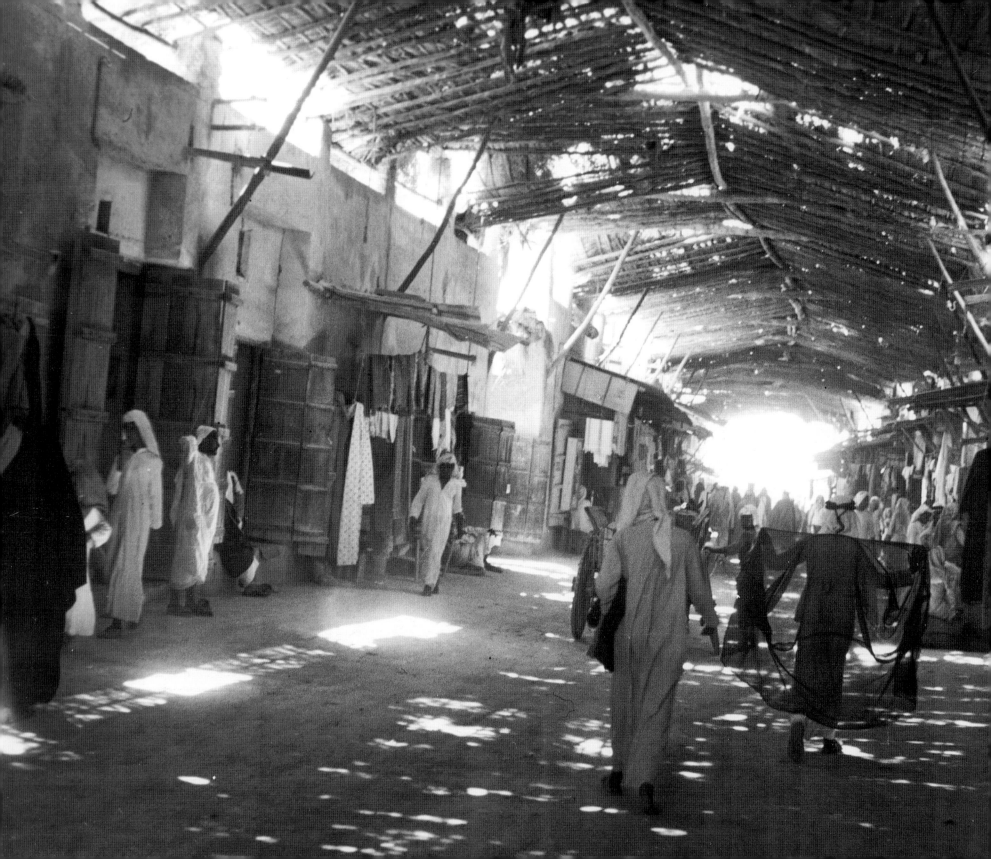

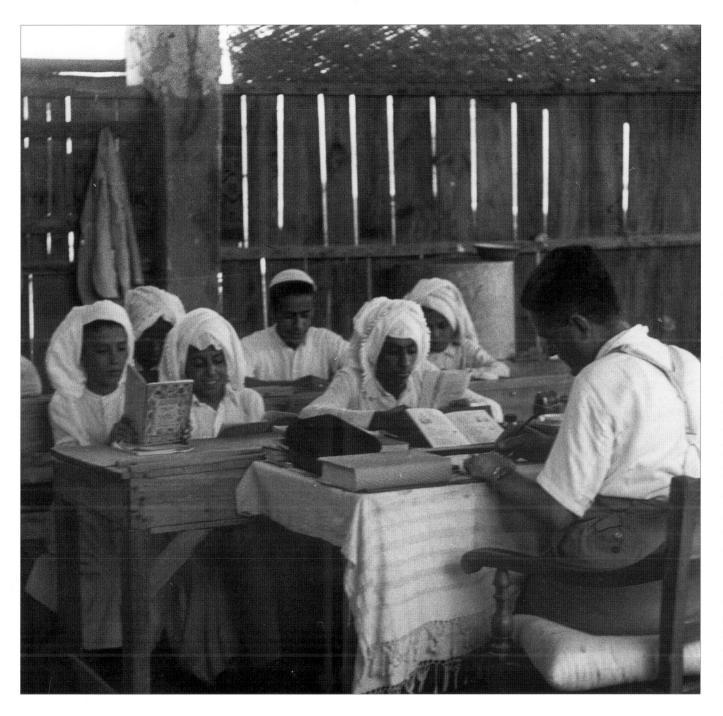

Left The Mubarakiyyah School, opened in 1911, was named after Shaikh Mubarak. The new school improved on the basic instruction available until then to only a few in reading, writing and arithmetic. In 1921 another school was opened, the Ahmadiyyah School. The sons of shaikhs and merchants attended the Mubarakiyyah School: pupils included the present Ruler HH Shaikh Jabir Al-Ahmad Al-Sabah. In this picture they seem to be having an English lesson. In 1936 Kuwaiti education had been put on a new footing and made generally available, and in 1937 the first girls' school was started. *Villiers 1939*

Opposite The covered *suq* with its dappled sunlight and small dark shops was much like all other Arabian *suq*s, although this one employs an ambitious roof-spanning system. *Villiers 1939*

Top Bedouin tents outside Kuwait.
Villiers 1939

Below Bedouins enjoying having their picture taken.
Villiers 1939

Opposite Camels parked in al-Safat.
Villiers 1939

Second World War photography, 1940 and 1944

As Villiers left for the War, Kuwait entered upon a period of hardship greater even than in the 1930s. The Second World War nipped the infant oil industry in the bud, and there were times when clothing, medicines and even food were almost unobtainable. At the same time Kuwait under Shaikh Ahmad proved a useful ally to the British, who were allowed to station aircraft there to counter troubles in Iraq. Shaikh Ahmad's contribution to the war effort was recognised in 1944 by the award of the Order of the Knight Commander of the Star of India (KCSI). This event was photographed by an army photography, Sgt Berman.

The outbreak of hostilities meanwhile led to the evacuation of the families of KOC personnel. The Dicksons and the ladies of the American Mission stayed on throughout the War, however, and much of the Dicksons' time was spent bringing assistance to the bedouin, many of whom the War had brought to the brink of starvation. Dickson himself was reappointed as Political Agent for a few months in 1941, as a stand-in between Major Galloway and Major Hickinbotham.

Right One of the many streets leading down to the harbour.
M. O'Connor c.1940

Opposite A boy stands with his hoop in the street that ran between the houses and the waterfront – a scene which captures the essence of old Kuwait. It has yet to be established who Mrs O'Connor was, nor is it known why or precisely when she visited Kuwait.
M. O'Connor c.1940

114

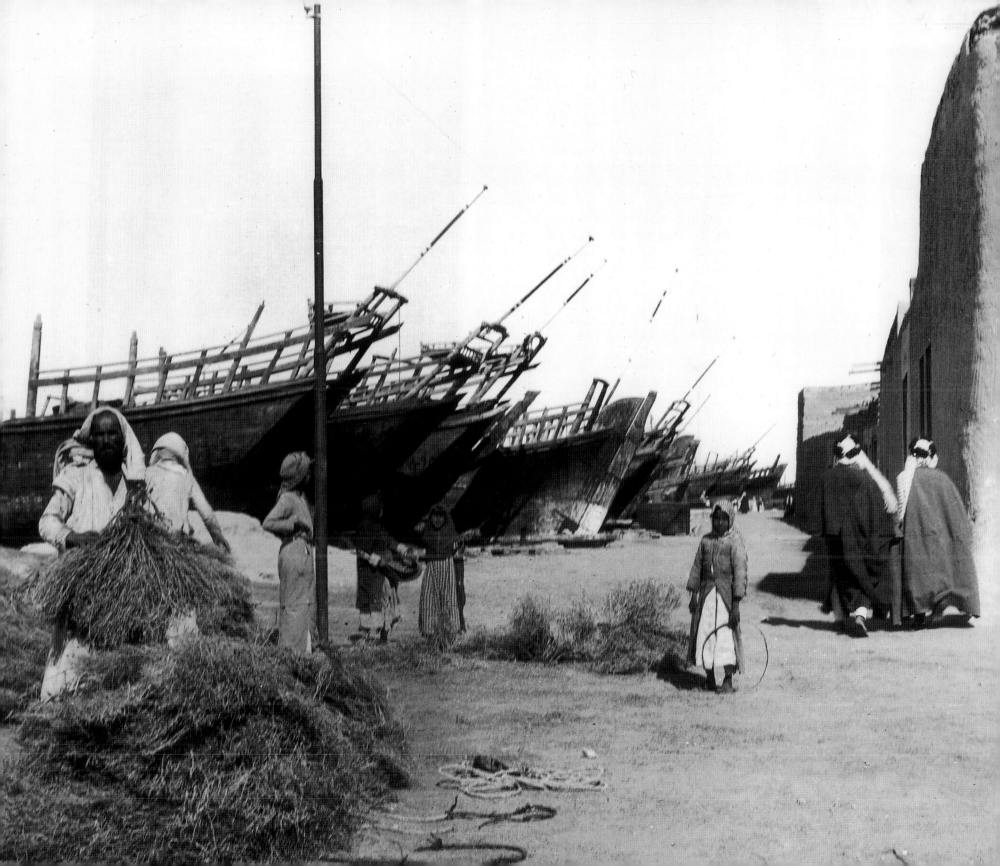

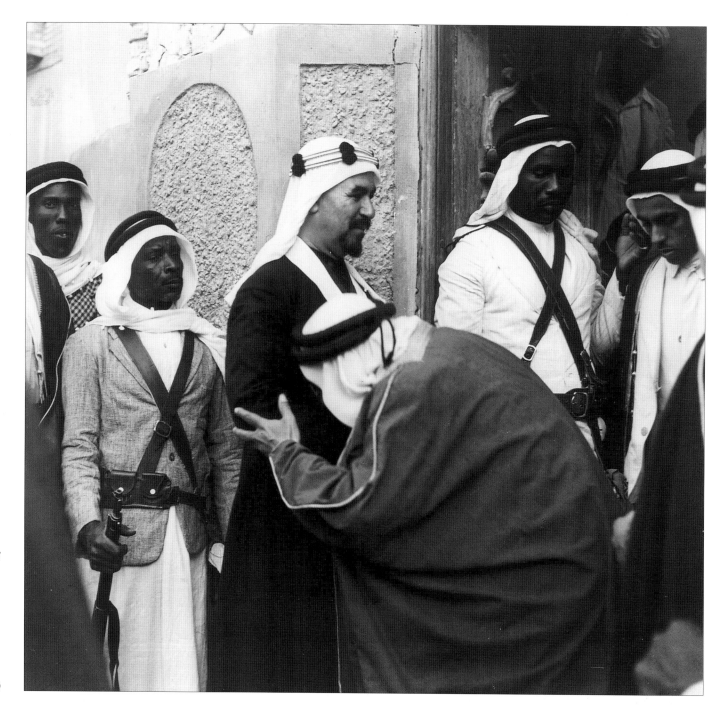

Right HH Shaikh Ahmad receives the congratulations of Kuwaitis after his investiture with the KCSI. These occasions had the effect of increasing the Ruler's prestige among his people.
Berman 1944/ IWM E28443

Opposite Shaikh Ahmad's car arrives at the Seif Palace for his investiture with the KCSI by Sir Geoffrey Prior, British Political Resident in the Gulf, on 16 May 1944.
Berman 1944/ IWM E28440

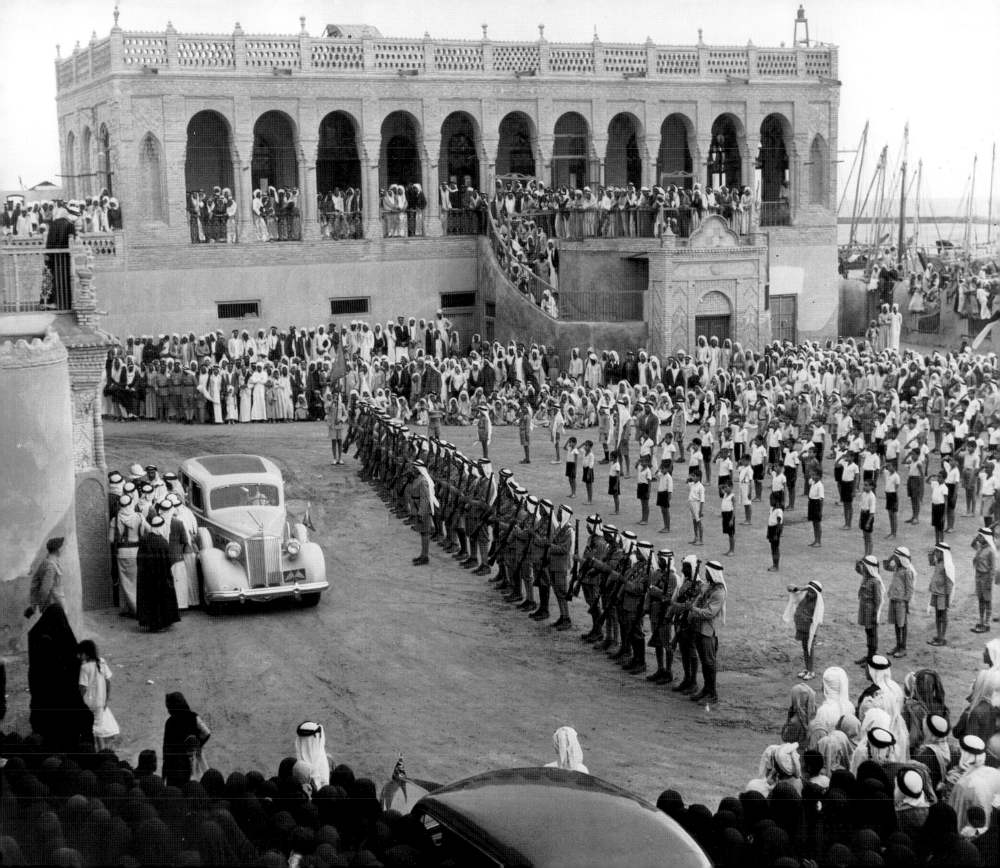

His Highness Shaikh Ahmad bin Jabir Al-Sabah, Ruler of Kuwait, poses for the camera after his investiture with the KCSI. The formal attire of the British officials with him lent to the occasion what in those days was deemed an air of appropriate solemnity and importance which today, however, seems distinctly Gilbertian. On Shaikh Ahmad's left stands Sir Geoffrey Prior, on his right Commodore Howson, Chief Naval Officer in the Gulf, with C.J. Pelly, the Political Agent at Kuwait, on the left of the picture.
Berman 1944/ IWM E28442

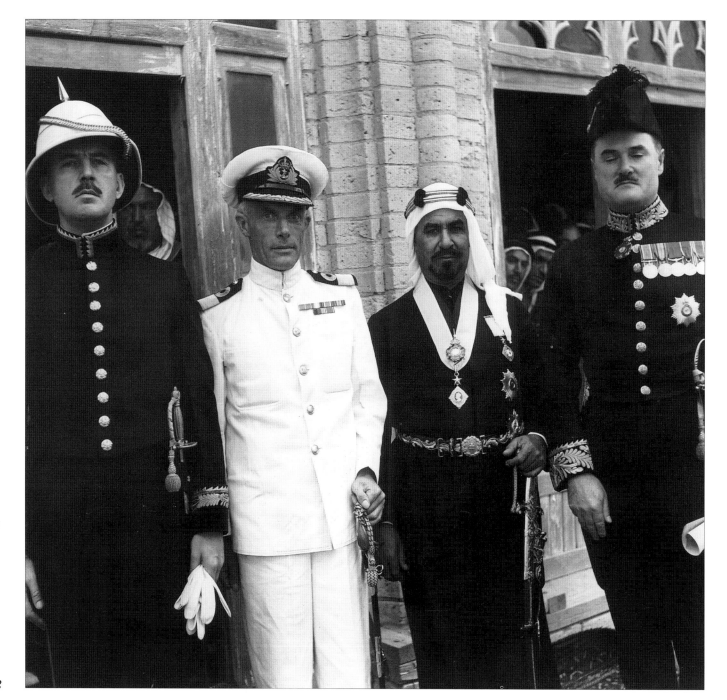

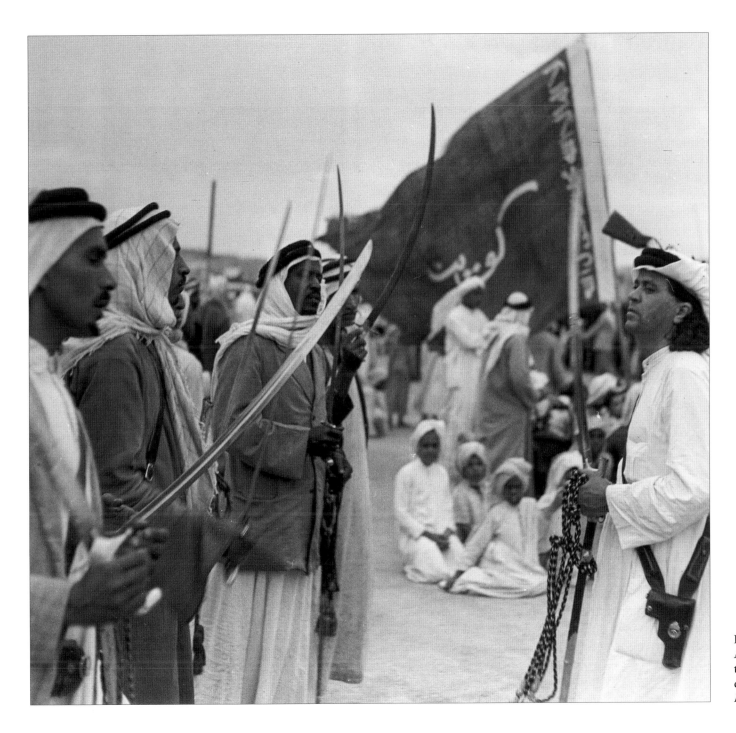

Kuwaitis celebrate Shaikh
Ahmad's investiture in the
traditional way, with a
decorous war dance.
Berman 1944/ IWM E28448

Wilfred Thesiger, 1945 and 1949

Wilfred Thesiger made his first visit to Kuwait in 1945. By then he was already an experienced explorer, having made his first important journey in the Danakil region of Abyssinia in 1933. In 1935 he had joined the Sudan Political Service and, in 1940, the Sudan Defence Force. From there he went to Jabal Druze in Syria, and went on campaign with the Special Air Service (SAS) in the Western Desert, returning to Abyssinia in 1945. In Addis Ababa he met O.B. Lean, the desert locust specialist of the Food and Agriculture Organisation in Rome. Lean was looking for someone to travel to the Rub' al-Khali to collect information on locust movements. Thesiger jumped at the chance and, in 1945, joined a team under Desmond Vesey-Fitzgerald which was to carry out investigations in Saudi Arabia.

He arrived in Kuwait in a convoy of jeeps and lorries led by Vesey-Fitzgerald which had made its way across Arabia from Jiddah. While there he was ill with fever, and was put up by the Dicksons. The Dicksons recognised a kindred spirit for, as Violet Dickson wrote, "This was the beginning of another lasting friendship. Thesiger belonged to a new generation of lovers of Arabia".

Like Villiers' voyages, Thesiger's journeys belonged to the last phase of old-fashioned exploration. His accounts are marked by self-examination, humility and a willingness to make unfavourable comparisons between his own culture and abilities and those of the Arabs among whom he travelled. He took the Arabs as he found them, without preconceptions about the bedouin's supposed heroic love of freedom, patriarchal lineage or bloodthirsty rapacity, which

Right A shipwright uses the age-old method of drilling a hole – with a bow drill, a vital part of the shipwright's tool-kit.
Thesiger 1949

Opposite A line of donkeys comes ashore from a water *boum* from the Shatt al-'Arab. Dhows still plied this trade even though in 1947 four small tankers had started to bring water in from the same source. It was not until 1953, when Shaikh Abdullah Al-Salim installed a desalination plant, that this method of obtaining water died out.
Thesiger 1949

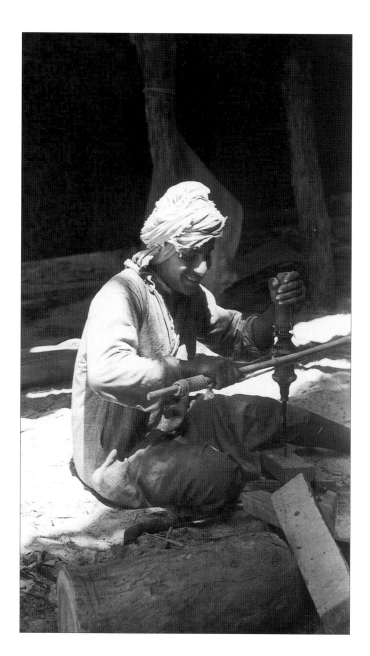

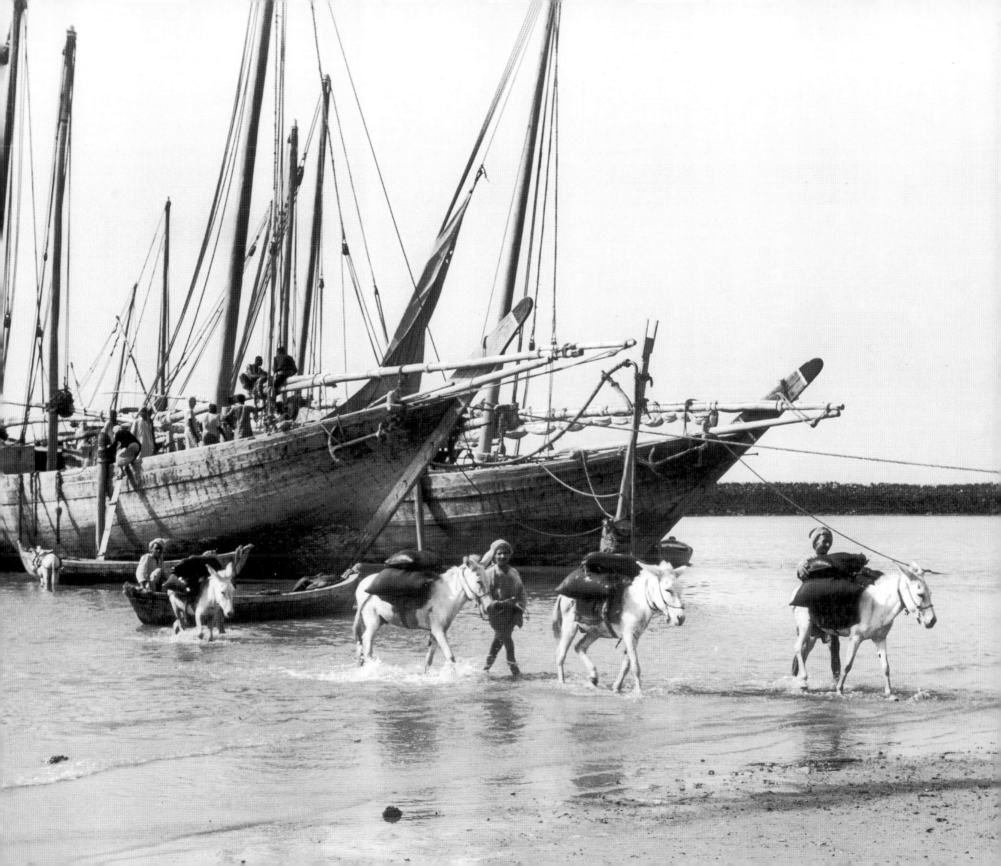

had coloured Victorian writers' views. Both men were refreshingly free of of the old romantic attitude, best represented by T.E. Lawrence, that saw a special affinity between the English and Arabia, giving the former a privileged insight into the latter, and engendering a belief in some mysterious entitlement to organise its affairs. Stripped of such presumptions, their accounts leave us with a more genuine understanding of Arabian hardihood, simplicity, hospitality and occasional ruthlessness. Poignancy is added by their own awareness that they themselves, simply by being there, were instrumental in drawing down the curtain on the virtues they so admired.

Between Thesiger's first visit to Kuwait and his next in 1949 he made the two great crossings of the Rub' al-Khali which brought him fame as an explorer, as well as other lesser known but in some ways equally important journeys in the southern Hijaz, 'Asir and southern Arabia. He called in at Kuwait in 1949 en route to Bushire and travels in Iran. Although his stay was again brief, he took some superbly composed pictures which record old Kuwait just before the rapid modernisation of the 1950s.

He had first acquired a Leica II camera in 1934, since its strong, compact design made it ideal for his arduous journeys. This was the camera he used until 1959, including his Arabian travels, where he found that the ideal way to protect it from sand was to keep it in a goatskin bag, as the bedouin did with their rifles. He later wrote that, at first, he had not taken his photography seriously, and that it was only on his first visit to southern Arabia in 1945 that he began to appreciate the value of the medium. He worked at first with a standard lens and yellow filter, adding an Elmarit/90 portrait lens and an Elmarit/35 wide-angle lens in the 1950s. By the late 1950s photography had become the chief means by which he recorded his

journeys, and he found his extensive collection of earlier photographs an essential tool in his later writings.

Although Thesiger always expressed a preference for portraiture, the most telling pictures for the historian are those which capture the old way of life, now gone. Thesiger's Arabian photographs show him not only to be a master at this, but an artist too. He brings a strong, instinctive sense of composition to his scenes of everyday life, of customs and regular activities, and so builds up a striking picture of many of the timeless and abiding features of old Arabia, its people and their relationship with their demanding land: weekly markets in their setting, bedouin in camp and on the move, drawing water from desert and oasis wells, livestock, cultivation techniques, villages, towns and ports, wildlife which is now extinct, and life aboard a dhow, to take a few examples. Thesiger's pictures of Kuwait, although few in number, exhibit these qualities.

It is easy to detect Thesiger's sophisticated eye for a photograph as an artistic composition in the way he talks about black-and-white photography, to which he has maintained a lifelong loyalty. "I have never taken a colour photograph," he wrote in 1987, "nor have I ever felt the urge to do so. This may be due in part to my preference for drawings rather than paintings, my appreciation of line rather than colour. ... With black-and-white film ... each subject offers its own variety of possibilities, according to the use made by the photographer of light and shade."

Opposite A woman inspects pots for sale while men relax in a café.
Thesiger 1949

Over page Two boys tie waterskins onto their donkey, in a scene which typifies Thesiger's sensitive eye for subject, light and composition.
Thesiger 1949

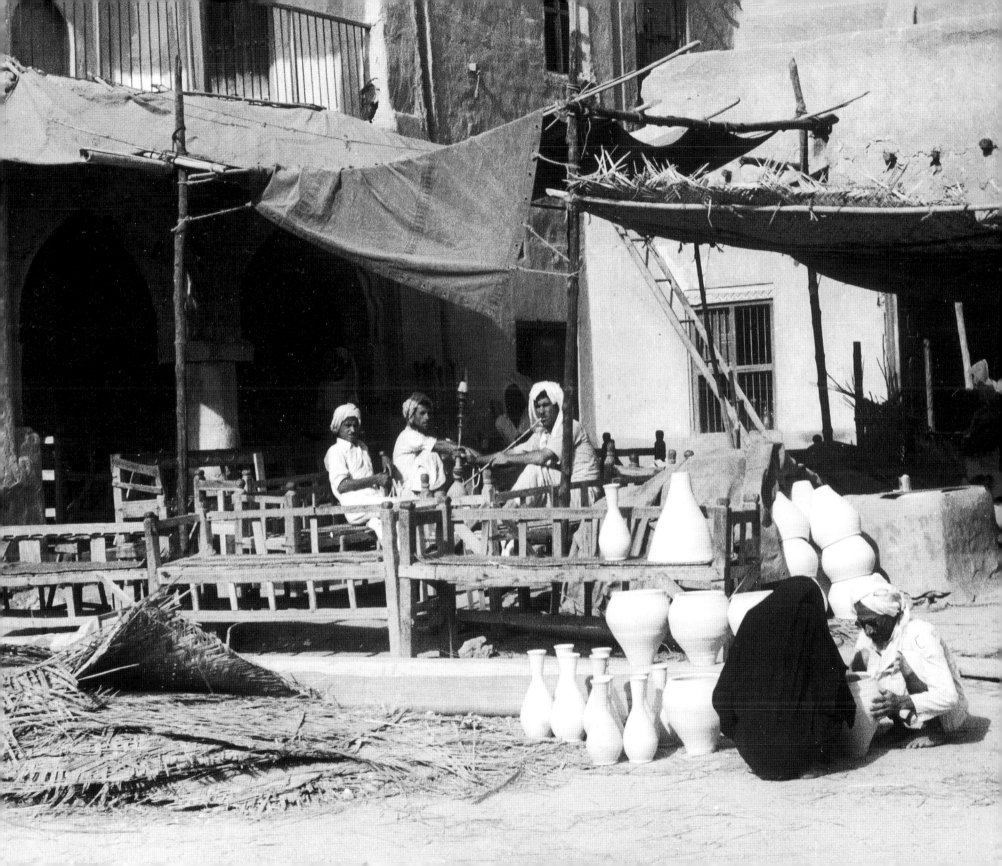

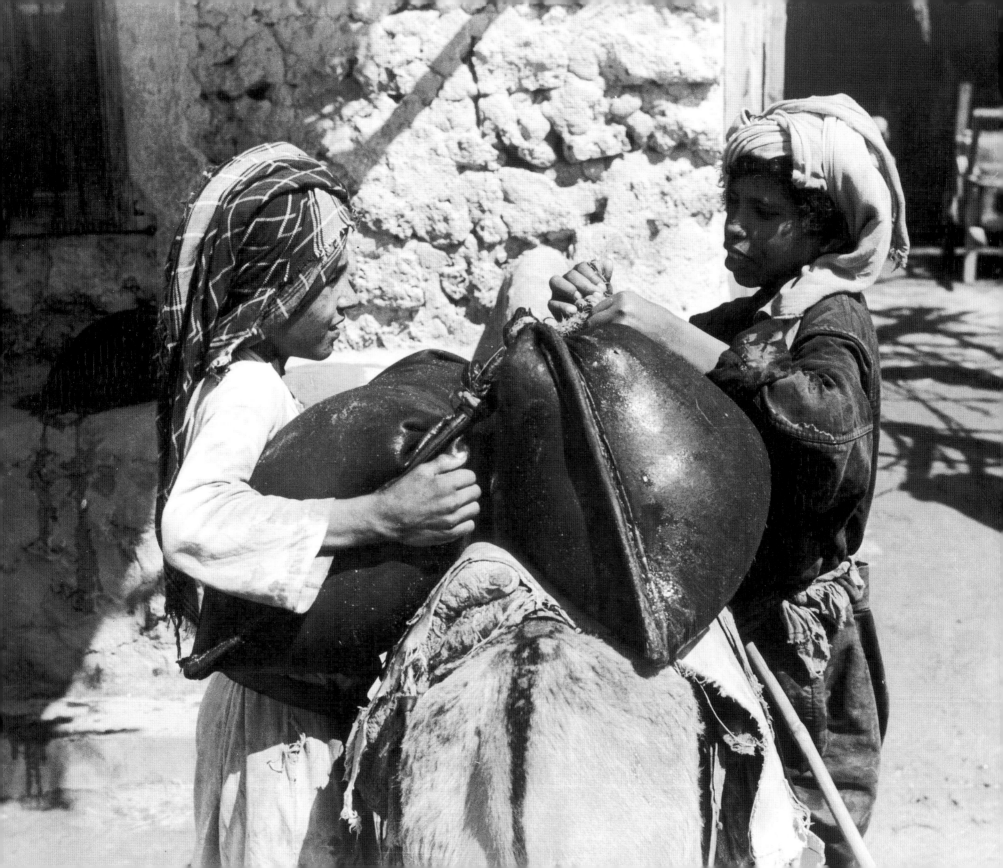

Bibliography

Abu Hakima, A. *History of Eastern Arabia. The Rise and Development of Bahrain and Kuwait.* Beirut 1965.

— *The Modern History of Kuwait, 1750–1965.* London 1983.

— *Eastern Arabia – Kuwait: Historic Photographs 1900–1936.* London 1986.

Anthony, T.A. "Documentation of the Modern History of Bahrain from American Sources (1900–1938)", *Bahrain Through the Ages: The History,* ed. A.K. Khalifah and M. Rice. London 1993.

Barney, Revd F.J. and de Witt, Revd A. *History of the Arabian Mission.* New York 1926.

Bidwell, R. (ed.) *The Affairs of Kuwait 1896–1905.* Cambridge 1965.

Bidwell, R. *Travellers in Arabia.* London 1976.

Brett, O.L. "Commander Alan John Villiers". *Sea History,* Summer 1984.

Burchardt, H. "Ost-Arabien von Basra bis Maskat auf Grund eigener Reisen", *Zeitschrift der Gesellschsft für Erdkunde zu Berlin.* Berlin 1906.

Calverley, E.T. *My Arabian Days and Nights. A Medical Missionary in Old Kuwait.* New York 1958.

Carruthers, D. "Captain Shakespear's Last Journey", *Geographical Journal* May 1922. London.

Chevedden, P.E. *The Photographic Heritage of the Middle East.* Malibu 1981.

— "Making Light of Everything: Early Photography of the Middle East and Current Photomania", *Middle East Studies Association Bulletin,* Dec. 1984.

Chisholm, A.H.T. *The First Kuwait Oil Concession Agreement. A Record of the Negotiations, 1911–34.* London 1975.

Çizgen, E. *Photography in the Ottoman Empire.* Istanbul 1987.

Coe, B.W. "The Evolution of Photography", *The British Journal of Photography,* 12 May 1972. London.

Coe, B. and Gates, P. *The Snapshot Photographers: The Rise of Popular Photography 1888–1939.* London 1977.

Cottrell, A.J. (ed.) *The Persian Gulf States.* Baltimore 1980.

Cursetjee, C.M. *A Voyage in the Gulf: C.M. Cursetjee's* The Land of the Date, 1918. Ed. Paul Rich. Cambridge 1991.

Curzon, G.N. *Tales of Travel.* London 1924.

De Gaury, G. *Through Wahhabiland on Camelback, 1912.* (Raunkiaer's Danish original tr. and ed. de Gaury). London 1969.

— *Traces of Travel.* London 1983.

Dickson, H.R.P. *The Arab of the Desert.* London 1949.

— *Kuwait and Her Neighbours.* London 1956.

Dickson, V. *Forty Years in Kuwait.* London 1970.

Diski, J. *Skating to Antarctica.* London 1997.

Dixey, A.D. "In the Persian Gulf", *Church Missionary Review* 58. London 1907.

Earle, E.M. *Turkey, the Great Powers and the Baghdad Railway.* New York 1924.

Facey, W.H.D. *Riyadh – The Old City.* London 1992.

— *The Story of the Eastern Province of Saudi Arabia.* 1994.

Facey W.H.D. and Grant, G. *Saudi Arabia by the First Photographers*. London 1996.

— *The Emirates by the First Photographers*. London 1996.

Falconer, J. *Sail and Steam. A Century of Seafaring Enterprise*. London 1993.

Finnie, D.H. *Shifting Lines in the Sand. Kuwait's Elusive Frontier with Iraq*. London 1992.

Freeth, Z. *Kuwait Was My Home*. London 1956.

Graham-Brown, S. *Images of Women: The Portrayal of Women in Photography of the Middle East, 1860–1950*. London 1988.

Grant, G. *Historical Photographs of the Middle East from the Middle East Centre, St Antony's College, Oxford*. Leiden 1985.

— *Middle Eastern Photographic Collections in the United Kingdom*. Middle East Libraries Committee Research Guides 3, Durham 1989.

Graves, P. *The Life of Sir Percy Cox*. London 1941.

Great Britain, Admiralty, Naval Intelligence Division. *Iraq and the Persian Gulf*. London 1944.

Habib, J.S. *Ibn Sa'ud's Warriors of Islam: the Ikhwan of Najd and their Role in the Creation of the Sa'udi Kingdom 1910–1930*. Leiden 1978.

Harrison, P.W. *The Arab at Home*. London 1924.

Haarmann, U. "Early Sources on Kuwait. Murtada b. 'Ali b. 'Alwan and Carsten Niebuhr: an Arab and a German Report from the Eighteenth Century", *Hadith al-Dar*, Kuwait 1995.

Al-Hijji, Y.Y. *Old Kuwait. Memories in Photographs*. Kuwait 1997.

Hogarth, D.G. *The Penetration of Arabia*. London 1904.

Hoskins, H.L. *British Routes to India*. London 1926 and 1966.

Jeffrey, I. *Photography. A Concise History*. London 1981.

Jouannin, A. "Sur les rives du Golfe Persique. Notes de voyage 1903", *Bulletin de la Société de Géographie Commerciale de Paris* 26. Paris 1904.

Kelly, J.B. *Britain and the Persian Gulf 1795–1880*. London 1968.

— *Arabia, the Gulf and the West*. London 1980.

Kumar, R. *India and the Persian Gulf Region, 1858–1907*. London 1965.

Kunz, G.F. and Stevenson, C.U. *The Book of the Pearl. History, Art, Science and Industry of the Queen of the Gem*.

Lewcock, R. and Freeth, Z. *Traditional Architecture in Kuwait and the Northern Gulf*. London 1978.

Lewin, E. *The German Road to the East. An Account of the* Drang nach Osten *and of Teutonic Aims in the Near and Middle East*.

Lienhardt, P. *Disorientations. A Society in Flux: Kuwait in the 1950s*. Reading, UK 1993.

Longhurst, H. *Adventure in Oil. The Story of British Petroleum*. London 1959.

Lorimer, J.G. *Gazetteer of the Persian Gulf, 'Oman and Central Arabia*. 2 vols., Calcutta 1909–15.

Mansel, P. *Sultans in Splendour. The Last Years of the Ottoman World*. London 1988.

Neglected Arabia. Quarterly Reports and Letters of the Arabian American Mission. Nos. 1–183, 1892–1938. Archive Editions, Gerrards Cross 1988.

Newhall, B. *Airborne Camera. The World from the Air and Outer Space*. London and New York 1969.

Obolonsky, C. *The Russian Empire: A Portrait in Photographs*. London 1980.

Oppenheim, M. von, *Vom Mittelmeer zum persischen Golf, durch der Hauran, die Syrische Wüste und Mesopotamien.* Berlin 1899–1900.

Palgrave, W.G. *Narrative of a Year's Journey through Central and Eastern Arabia (1862–3).* 2 vols, London 1865.

Perez, N. *Focus East: Early Photography in the Near East (1839–1885).* New York 1988.

Al-Rasheed, M. *Politics in an Arabian Oasis. The Rashidis of Saudi Arabia.* London 1991.

Al Rashoud, C.F. *Dame Violet Dickson. "Umm Saud's" Fascinating Life in Kuwait 1929–1990.* Kuwait 1997.

Raunkiaer, B. *Gennem Wahhabiternes Land paa Kamelryg.* Copenhagen 1913.

Rezvan, E. *Russian Ships in the Gulf, 1899–1903.* Guildford 1993.

Rosenblum, N. *A World History of Photography.* New York 1984.

Rush, A. *Al-Sabah. History and Genealogy of Kuwait's Ruling Family 1752–1987.* London 1987.

Ruthven, M. *Freya Stark in Iraq and Kuwait.* Guildford 1994.

Slot, B.J. *The Origins of Kuwait.* Leiden 1991.

— *The Arabs of the Gulf 1602–1784.* Leidschendam 1995.

Sontag, Susan *On Photography.* Harmondsworth 1978.

Stanford, P. "Alan Villiers: 'Here in the Battered Bark All Men Mattered'." *Sea History*, Summer 1984.

Stark, F. "Kuwait", *Geographical Magazine* Oct. 1937. London.

— *Baghdad Sketches.* London

— *Beyond Euphrates. Early Travels 1928–1933.* London 1951.

— *The Coast of Incense. Autobiography 1933–1939.* London 1953.

Surtees, V.N. *HMS Emerald.* 1928

Thesiger, W. *Desert, Marsh and Mountain. The World of a Nomad.* London 1979.

— *Wilfred Thesiger's Photographs, "A Most Treasured Possession".* Pitt Rivers Museum catalogue introduced by E. Edwards. Oxford 1993.

Tidrick, K. *Heart Beguiling Araby.* London 1981.

Tournier, M. *The Golden Droplet.* London 1988. (First published as *La goutte d'or*)

Tuson, P. *The Records of the British Residency and Agencies in the Persian Gulf.* India Office Library and Records, London 1979.

Vaczek, L. and Buckland, G. *Travellers in Ancient Lands: A Portrait of the Middle East, 1839–1919.* Boston 1981.

Villiers, A. *Sons of Sindbad.* New York 1940.

Webb, V.-L. "Missionary Photographers in the Pacific Islands: Divine Light", in Edwards, E., ed., *History of Photography: Anthropology and Colonial Endeavour.* Oxford 1977.

Whigham, H.J. *The Persian Problem.* London 1903.

Wilson, A.T. *The Persian Gulf.* London 1928.

Winstone, H.V.F. *Captain Shakespear.* London 1976.

— *Leachman: "O.C. Desert".* London 1982.

— *The Illicit Adventure.* London 1982.

Winstone, H.V.F. and Freeth, Z. *Kuwait: Prospect and Reality.* London 1972.

Zwemer, S.M. *Arabia: the Cradle of Islam.* New York 1900.

— *Childhood in the Muslim World.* London 1915.

Index